Romanesque Art

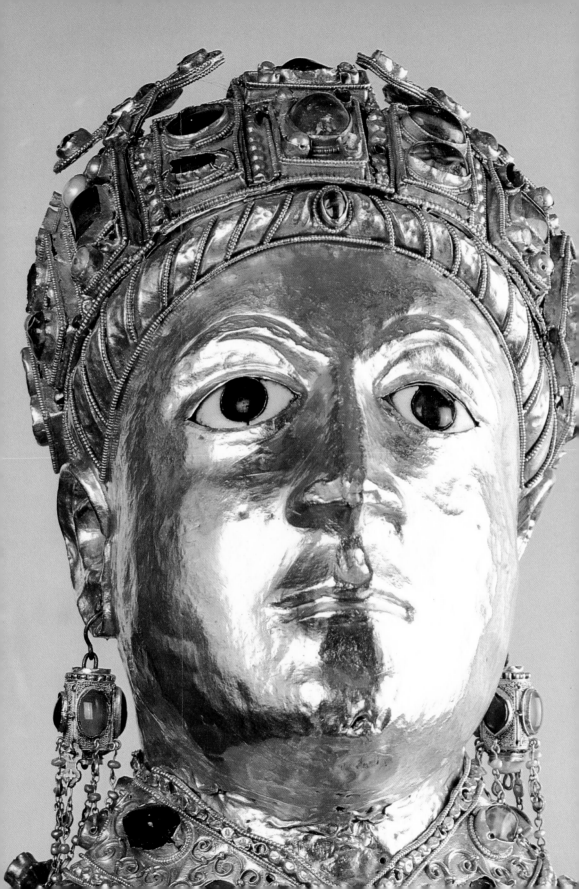

Romanesque Art

Andreas Petzold

The Everyman Art Library

First published in Great Britain in 1995 by
George Weidenfeld and Nicolson Ltd
The Orion Publishing Group
Orion House
5 Upper St Martin's Lane
London WC2H 9EA

A catalogue-in-publication record for this book is available from the British Library.

ISBN 0297 83364 2

Copyright © 1995 Calmann and King Ltd
This book was produced by Calmann and King Ltd, London

Designer Karen Stafford, DQP, London
Picture Editor Susan Bolsom-Morris
Printed and bound by Toppan, Singapore

Frontispiece Reliquary effigy of St. Foy, page 118 (detail)

Contents

INTRODUCTION *The Definition of Romanesque Art* 7

Early Influences 11 The Political Geography of Romanesque Europe 17
Themes in Romanesque Art 18

ONE *The Romanesque Artist and Patronage of the Arts* 25

The Role of the Patron 36

TWO *Stone, Mosaic, Enamel, and Glass: Developing Forms
of Romanesque Art* 45

Architectural Sculpture 46 Mosaic 56 Champlevé Enamel 61 Stained Glass 66

THREE *Romanesque Art and Society* 71

The Role of the Church 76 The Warrior Class 79
The Imagery of Power: Roger II and Henry the Lion 85
The Peasant in Romanesque Art and Society 93

FOUR *Romanesque Art and the Church* 101

Monasticism and Cluny 101 Cistercian Art and Architecture 109
The Pilgrimage Route and the Cult of Relics 115 The Cult of the Saints 119

FIVE *Women and Romanesque Art* 123

Biblical Archetypes 123 Women as Creators and Consumers of Art 133
Christina of Markyate 135 Hildegard of Bingen 137 Herrad of Hohenberg 138

SIX *Romanesque Art and Alien Cultures* 141

The Heritage of Antiquity 142
Romanesque Art in Relation to Islam 146 The Jews 155

The Legacy of the Romanesque 161

MAP 166 TIMELINE 168 BIBLIOGRAPHY 170
PICTURE CREDITS 172 INDEX 173

The Definition of Romanesque Art

1. *The Deesis* from the
Melisende Psalter, 1131-43.
Illumination on parchment,
8¹/₂ x 5¹/₂" (21.6 x 14 cm).
British Library, London.

The psalter was made for
Melisende, Queen of
Jerusalem (d. 1161), from
whom it takes its name. It is
the finest twelfth-century
illuminated book to have been
made in a Crusader state. An
inscription states *Basilius me
fecit* ("Basilius made me"). In
spite of his Greek name, the
artist is thought to have trained
in a Western workshop,
although he was obviously
influenced by Byzantine art.
The illustration shows the
Byzantine devotional subject
of the Deesis, which consists
of Christ flanked by the Virgin
Mary and St. John the Baptist.

From a distance, the facade of St. Gilles-du-Gard in southern France recalls a Roman arch of triumph (FIG. 2). The arch nearby at Orange, or the fourth-century Arch of Constantine in Rome (FIG. 3) spring to mind. The date of the facade has been the subject of considerable controversy, but the general consensus is that it was under construction by 1150, and probably completed by the end of the century. This may seem a very long time, but it is not untypical for medieval buildings, and it should be remembered that similar projects, begun in a medieval spirit in the twentieth century, such as the Anglican cathedral in Liverpool or the Sagrada Familia in Barcelona (the church conceived by Gaudí at the end of the nineteenth century and still under construction) have taken even longer.

In viewing the facade of St. Gilles, with its Roman-looking triple-arched entrance, pilasters, freestanding columns, and sculptural friezes, it is easy to understand why the term "Romanesque," meaning "in the manner of the Romans," was coined by nineteenth-century art historians; initially used to describe just the architecture of the pre-Gothic period, it has been extended to encompass all media and generalised to denote the style of the period. For the purposes of this book, the term "Romanesque" is used to describe both the art and architecture of western Europe from 1050 to 1200. The preceding fifty years are understood as a

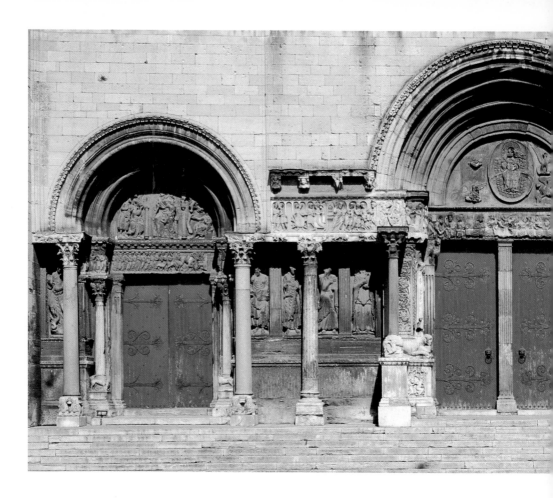

2. West facade of St. Gilles-
du-Gard, 1150-1200.

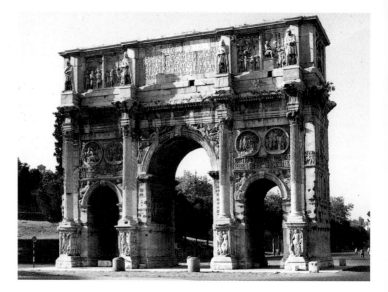

3. Arch of Constantine, Rome,
AD 315.

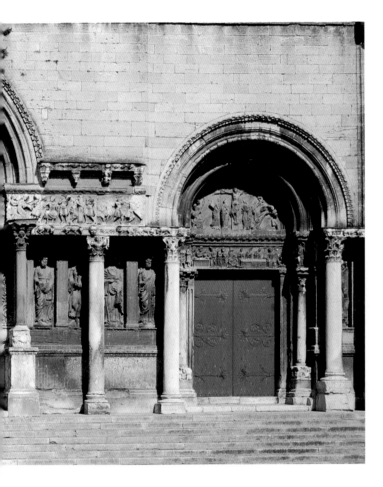

period of preparation; and the earliest manifestations of the Gothic style, which by the 1140s had begun to emerge at St. Denis, and later at Chartres, in the Ile-de-France region, are excluded.

The Gothic and Romanesque styles in fact existed in parallel for a considerable period of time. As the construction of St. Gilles-du-Gard demonstrates, even after the first examples of Gothic architecture in the Ile-de-France, the Romanesque style continued to be practised in many regions of Europe throughout the second half of the twelfth century, and in certain areas, such as Tuscany, Lower Saxony, and Dalmatia, it survived well into the thirteenth century. The situation is further complicated by the term "Transitional style," which has been used by art historians not to describe, as might be expected, the art of the intermediate period between Romanesque and Gothic, but to refer to an artistic style of the last third of the twelfth century, cen-

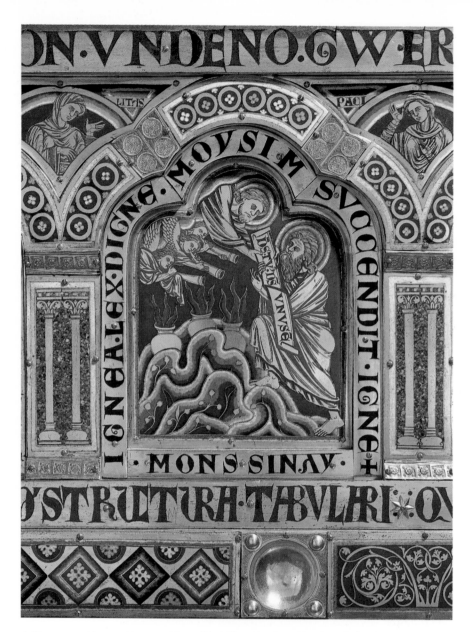

4. Nicholas of Verdun *Moses on Mount Sinai*, Klosterneuburg altar-frontal (detail), 1181. Champlevé enamel, 5³/₄ x 4″ (14 x 10 cm). Klosterneuburg abbey, near Vienna.

Above the enamel panel of Moses are to the left and right respectively personifications of humility and patience. This is one of forty-five such panels on the altar-frontal designed by Nicholas of Verdun, and exemplifies the most important characteristics of his style: monumental figures, trough-like drapery folds that indicate the movement and torsion of the figure, dramatic presentation of the theme, and sophisticated imagery (note, for example, the three trumpeting angels and the three burning torches which allude to the Trinity). The figure style ultimately recalls that of ancient Greek sculpture, and may be paralleled by developments in Byzantine art reflected at Monreale.

tered around the Mosan region (the area traversed by the river Meuse in present-day Belgium). This style, characterised by a greater naturalism and a more powerful sense of the dramatic than is found in other Romanesque art, is exemplified by the work of the goldsmith Nicholas of Verdun (FIG. 4).

The term "Romanesque," like the term "Gothic," was originally intended to be pejorative, emphasising what nineteenth-century art historians perceived as the debased and derivative nature of the style and its dependency on the art of an earlier culture. But artists of all periods have reused and reinterpreted ideas and images from classical art. Moreover, in stressing the Roman contribution, the term gives no idea of the many other influences that are now recognised as having been equally important in the formation of Romanesque art. Nor does it do adequate justice to the originality and inventiveness of that art.

Early Influences

One important, non-Roman, influence was the Nordic tradition of the sixth- to ninth-century art of the British Isles. Among the best-known examples of this Insular art, as it is called, are the Sutton Hoo treasure and the Book of Kells, both of which demonstrate the predilection of Insular art for surface patterns and dynamic line. It has been suggested that this traditionally Nordic aesthetic influenced the concept of space in Romanesque art, where areas of space are frequently orchestrated to give the impression of an interwoven pattern. For example, a carved whalebone panel of the Adoration of the Magi, which despite its strong German influence was probably made in northeast Spain in c. 1100, shows the figures of the three kings standing not on the ground, but apparently suspended in space (FIG. 5). The shapes of their feet overlap to form just such an interwoven pattern, an effect accentuated by their intersecting staffs. This liking for surface pattern even extends to the use of color in Romanesque art, with areas of identical color repeating across the picture plane, as in the illustrations to one of the most important Romanesque illuminated manuscripts, the Bury Bible (FIG. 6), which is discussed in chapter one.

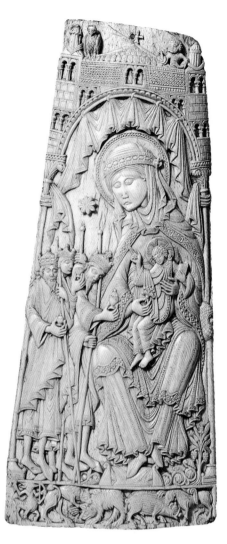

5. *Adoration of the Magi,* early twelfth century. Carved whalebone, 14³/₈ x 6³/₈" (36.5 x 16 cm). Victoria and Albert Museum, London.

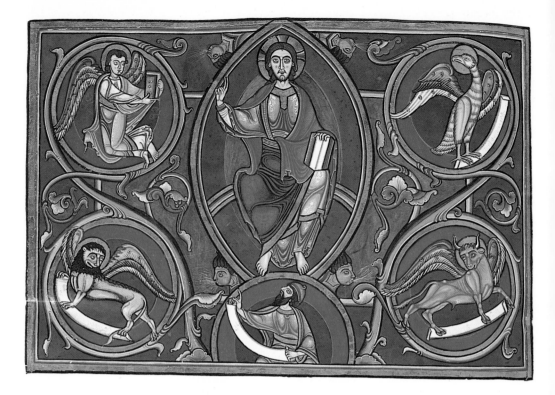

6. MASTER HUGO
The Vision of Ezekiel from the Bury Bible, c. 1135. Illumination on parchment, 6³/₄ x 10¹/₈" (17 x 25.5 cm). Corpus Christi College, Cambridge.

At the center of the illustration is the figure of Christ in Majesty, seated on a rainbow and enclosed in a mandorla. Below Christ's feet is Ezekiel himself, who is holding a scroll and gazing upwards. The four roundels contain the symbols of the four evangelists. Master Hugo's work is characterised by rich colors: royal blue, velvety green and vermilion. The faces are coherently modeled with highlights and shading. Note the *u*-shape between Christ's eyebrows, a typically Byzantine convention.

Two cultures beyond the frontiers of western Christendom were also influential in the development of Romanesque art: Byzantium and Islam. The Byzantine empire formed the eastern part of the medieval Christian world, with Greek as its language. Its capital was Constantinople (present-day Istanbul), a metropolis which in the eleventh century had a population of about six hundred thousand people. Western European contact with Byzantine culture increased during the Romanesque period, through trade and the crossing of extensive areas of the Byzantine empire by European armies taking part in the Crusades. Byzantine art retained aspects of the Hellenistic artistic tradition that had been lost in the West: a sense of the human form underneath the garment, coherent facial modeling, the accurate rendering of the behaviour of light, and a limited repertoire of formulae for representing emotion (see FIG. 1, page 6). Western Europeans marveled at the luxuriousness of Byzantine culture, but were disdainful of the elaborateness of its court ritual and what was perceived as the effeteness of its ruling class.

There were two waves of Byzantine influence on Western art: the first came in the last third of the eleventh century, when Byzantine influence seeped up through Italy; the second arrived

in the second half of the twelfth century, with Sicily and Venice as its intermediaries. The most obvious results of this influence were the revival of wall mosaic as an artistic medium, an increase in the popularity and number of religious images that contained an element of pathos (such as the Lamentation or the Death of the Virgin), and, most importantly, a transformation in Western pictorial practice. The nature of this transformation can be seen by comparing figures in the illustrations of the Bury Bible, which is dated c. 1135, with those in the Bayeux Tapestry, made probably fifty years earlier (FIG. 7). Even allowing for the difference in medium, the figures in the Bayeux Tapestry have a flat, diagrammatic appearance, while those in the Bury Bible have a real sense of the solid human form, an effect achieved by the interplay between the garment and the body underneath. This device is known as the "damp fold" convention, because the garment appears to cling to the figure as if wet. Western European artists were receptive to Byzantine artistic models precisely because they found in them an answer to their desire to represent people in a more individualistic and humanistic way – itself a response to changes during this period in both Western society and thought. However, even in the Bury Bible, for its time one of the most Byzantinising of works, the artist could not resist creating a decorative surface pattern in his treatment of highlights.

7. The Bayeux Tapestry, c. 1080. Detail of the initial scene.

The culture and religion of Islam originated in Arabia in the seventh century as a result of the teachings of the prophet Mohammed (AD 570-632). Territories under Islamic rule spread to include not only most of the Middle East, but also Sicily and large areas of North Africa and Spain, then known as Andalusia. In the eleventh and twelfth centuries the West was on the offensive against Islam, regaining substantial territories during the *reconquista* (the war waged against Islamic rulers in Spain), while Sicily was seized by the Norman French.

Although Islam was seen as its political and ideological enemy, the West nevertheless absorbed aspects of Islamic learning and technology, which was in many cases much more advanced than that to be found in western Europe at the time. One of the most obvious and far-reaching examples of this was the adoption of the pointed arch in architecture. The pointed arch – which has also been seen as one of the first characteristics of the Gothic style – was being used extensively across northern Europe by the early years of the twelfth century: Autun cathedral and the abbey church of the religious complex of Cluny III in Burgundy are conspicuous examples (see FIG. 71). It used to be

thought that the pointed arch was transmitted to northern Europe via Amalfi on the Neapolitan coast, then the main trading center with the Islamic countries, but it has recently been suggested that Sicily was the intermediary. The island was under Islamic rule until the 1070s, and the pointed arch appears to have been rapidly adopted by the Norman conquerors for use in their churches.

It would be a mistake to see Romanesque art purely as a passive synthesis of disparate influences from the remote past and contemporary cultures. Romanesque art displays great originality and variety; its capacity to absorb and transform material from various sources is indicative of the entrepreneurial and dynamic nature of the society that created it.

Even at St. Gilles-du-Gard there are elements that are original to the Romanesque and would never have been found in a building erected before the eleventh century. Among these are the three semicircular sculptural reliefs set in the arches above the triple doorway to the church. Known as a tympanum, this type of sculptural relief was one of the most important formal innovations of the Romanesque period.

Furthermore, the imagery of the tympanum of St. Gilles shows selected events from Christ's Passion. These have been co-ordinated into a coherent program to make what amounts to a public statement about the Christian message. It begins in the left tympanum with Christ's Incarnation (his assumption of human form), symbolised by the figure of the majestic, enthroned Virgin Mary with the infant Christ seated on her lap; and it culminates in the right tympanum, with the rare theme for a public monument of the Crucifixion (FIG. 8). The figures of the three Marys, carved on the lintel below, peering into the empty sarcophagus, and the angel to the right, who announces Christ's resurrection, act as a coda to the story. Unfortunately, the central tympanum is a seventeenth-century replacement, showing a demure Christ in Majesty surrounded by the four evangelist symbols, as the original was destroyed during the religious wars in France of the sixteenth century; it has been convincingly argued that the original sculpture prboably showed Christ's Second Coming, and would have formed the focal point of the composition. The twelve apostles stand guard in the niches below and to either side of the central portal thus making concrete, as it were, their role as the pillars of the church. A number of anecdotal details have been introduced into this narrative of events, some of which may have been inspired by contemporary religious drama. For example, in the lintel below the

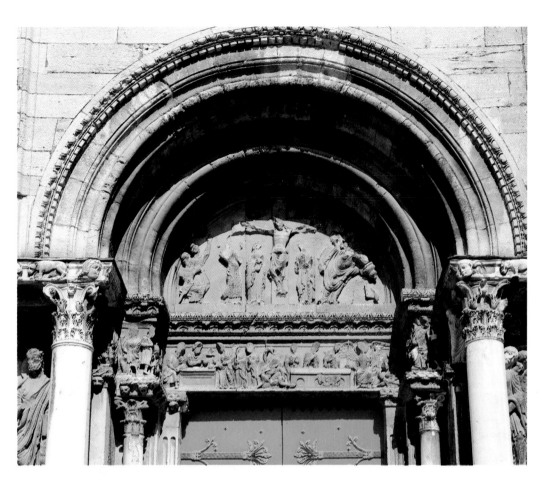

Crucifixion, the three Marys are shown buying spices from an apothecary, with which to anoint Christ's body.

The Christian religion is, in essence, based on the events of Christ's Passion, and it is one of the great achievements of the Romanesque period to have created an art, both public and private, that gave visual expression to this narrative (FIG. 9). The period also saw the rise of narrative in many other fields: historical writings; the lives of the saints; liturgical drama; the epic poems – *chansons de geste* – which celebrated valor in war; and the love poetry of the roving troubadours.

The Roman triumphal arch was invented to celebrate imperial victory over an enemy. At St. Gilles-du-Gard these associations were transposed to a Christian context, and they remind us that the art of this period is, first and foremost, that of the Church triumphant, although it also had a secular audience firmly in mind. Romanesque art was, indeed, essentially a product of monastic culture which permeated the rest of society and

8. Detail of the west facade of St. Gilles-du-Gard, showing the right portal with tympanum, 1150-1200.

9. The wooden doors of
St. Maria im Kapitol,
Cologne, c. 1065.
Height 6'6" (2 m).

These are the earliest
ornamented wooden
church doors to survive in
their entirety, and they are
an example of the use of
narrative art in a public
context. They represent
the main events of Christ's
life, beginning with the
Annunciation, in which
the Archangel Gabriel
announces to the Virgin
Mary that she is to bear
the Son of God, as
foretold by the prophet
Isaiah, and culminating in
the Pentecost, when the
Twelve Apostles were
filled with the Holy Spirit,
represented by tongues of
fire over their heads. The
facial profiles of the
figures with their beak-like
noses, are typical of
German art.

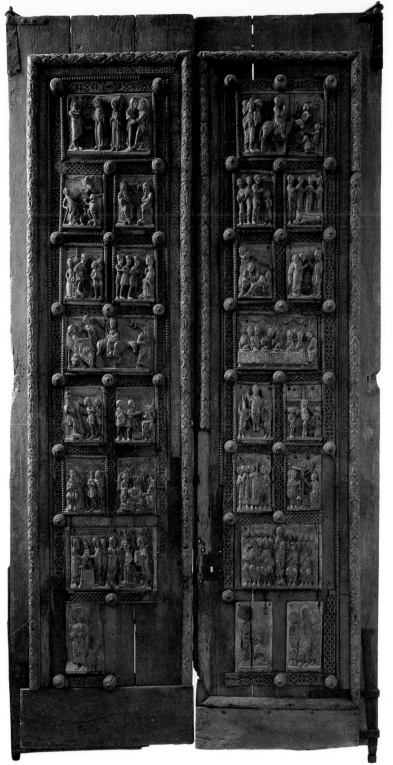

was directly reflected in the art of the period. By contrast the Gothic style, which superseded it, was associated with the urban culture of cathedrals and the embryonic universities.

The Political Geography of Romanesque Europe

In order to understand the historical framework of the period it is necessary to know about its political geography. Not surprisingly, European territorial frontiers were very different from today. Nor did these frontiers remain static during the Romanesque period. In general, though, Romanesque Europe was dominated by the Holy Roman Empire (see map on pages 166-167). This encompassed territories corresponding to present-day Germany, Burgundy, and northern Italy. It consisted of a loose confederation of principalities and duchies under the authority of the Holy Roman Emperor. This title had been first conferred on Charlemagne by Pope Leo III, and although nominally elective, came to be regarded by the German kings as part of their inheritance.

The region of present-day France was also divided up into duchies and countdoms with the kingdom of France, under the Frankish kings, centered in the Ile-de-France. It was only at the end of the period that the kingdom of France became a force to be reckoned with. In the north the duchies and countdoms included the dukedom of Normandy, the countdom of Flanders and the dukedom of Anjou. In the south were the dukedom of Aquitaine and the countdom of Toulouse, but these belonged to a different political and cultural axis, looking towards the south, and even spoke a different language: the *langue d'oc*. Spain was divided between the Christian rulers of the north and the Muslims who ruled the south. In the course of the eleventh and twelfth centuries, the Christian rulers of northern Spain regained substantial areas of the south during the *reconquista*.

In the mid-eleventh century a new force came on to the scene: the Normans. In 1066 England was seized by Duke William of Normandy, and only a few years later Norman knights gained significant footholds in southern Italy, in Apulia and Sicily. In 1154 the kingdom of England passed to Henry Plantagenet, Count of Anjou (Anjou is immediately to the south of Normandy). Two years earlier, Henry had married Eleanor of Aquitaine, whose lands comprised the entire area between Anjou and the Spanish frontier. Henry II thus became one of the most powerful rulers in Europe, with vast territories extending from the north of England to the Pyrenees.

Themes in Romanesque Art

St. Gilles introduces us to some of the main themes of this book, which aims to analyse the art of the period through the people and institutions that created it and provided its earliest audience. At St. Gilles the hands of at least five different master sculptors may be distinguished, and each of these would have had a separate team of assistants. The figure of St. Matthew has an inscription under it that states: *Brunus me fecit* ("Brunus made me"). It may be surprising to realise that many artists' signatures survive from the Romanesque period and they can provide important clues to the identities and personalities of the artists themselves. However, without the driving force provided by the artists' patrons, whether ecclesiastical or secular, it is arguable that very little Romanesque art would have been created. St. Gilles, for example, was in the territory of the counts of Toulouse, and under their direct patronage. In all probability it was they who paid for its imposing facade. The twinned theme of the artist and the patron in the Romanesque period will be discussed in chapter one; as will be seen, ecclesiastical patronage by wealthy feudal families was very common.

Chapter two examines the creation and use of Romanesque art by looking at four characteristic examples, divided into two pairs. The first pair – architectural sculpture and mosaic – represents a distinct revival from an earlier period. The second pair of techniques – champlevé enamel (in which a design is cut into a metal base and then filled with enamel colours) and stained glass – was developed during the Romanesque period to an unprecedented degree.

Of these techniques, by far the most important for the Romanesque period was architectural sculpture. Not since ancient Rome had sculpture been so lavishly used on the exterior of buildings. A prerequisite for this development was the immense increase in building activity that started at the beginning of the eleventh century and continued unabated for the next two hundred years. This was in itself a symptom of greater economic prosperity and a growth in population. In the early eleventh century the Burgundian historian Ralph Glaber speaks of "a white cloak of churches" clothing "all the earth, but especially in Italy and Gaul." Among these buildings, built of even, regular-shaped blocks of stone called ashlar masonry, were not only churches, but also secular buildings such as bridges, fortresses, and town houses. Next door to the church of St. Gilles-du-Gard is one of the most handsome town houses to

have survived from the twelfth century: three-storied, built of stone with sculptural decoration, it is as impressive as a merchant's house of the Renaissance (FIG. 10). At the same time there was an increase in other areas of artistic activity, such as wall painting, mosaic, and manuscript illumination.

Chapter three looks at medieval society in the eleventh and twelfth centuries. It examines in particular the visual imagery of three sectors of lay society: the military, landed aristocracy and the peasants. Lay society was bound together by a system of relationships known as feudalism. There were two main aspects to feudalism: first, the allegiance owed by a vassal, sworn by an oath of fidelity, to his lord in return for protection; and second, what is known as the fief, usually the granting of a piece of land by the lord to the vassal. The paucity of secular artifacts and images from this period is frequently commented on. This is, of course, partly a matter of survival: unlike secular institutions, the church has always valued and jealously guarded its artistic treasures. But it also arises from the fact that in medieval society secular and ecclesiastical interests were closely intertwined so that the influence of secular society is frequently to be found reflected in religious imagery and the enterprises of the church.

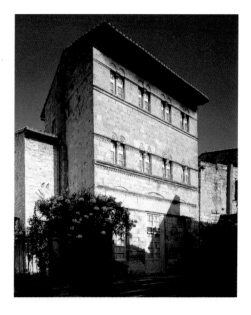

10. Twelfth-century town house at St. Gilles-du-Gard.

The church, the dominant institution of the period, is discussed in chapter four. The Romanesque church was a multinational organisation united by a single language: Latin. The eleventh and twelfth centuries were a period of reform within the church, promoted both from above by the papacy (the so-called Gregorian reform movement, named after Pope Gregory VII), and at a more grass-roots level. The papacy wanted to root out the practice of simony (the sale of clerical office) and impose celibacy on priests (clerical marriage was common, especially in Germany). In particular, the papacy wished to assert an exclusive right, against lay authorities, to make church appointments. This led to a protracted conflict between the papacy and the Holy Roman Empire. This conflict came to a head when Emperor Henry IV (1056-1106) attempted to depose the reforming Pope Gregory VII (d. 1085), who, in turn, excommunicated him. In 1077 Henry IV was forced to make a humiliating penance at Canossa in the Apennine mountains and to submit to the control of Pope Gregory.

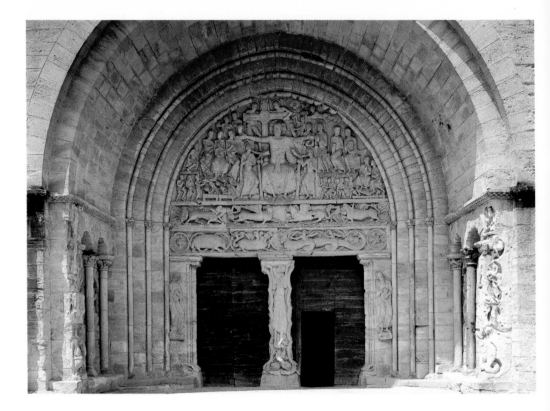

Outside the church, popular religious movements with unorthodox beliefs arose in the early twelfth century. One of these was the Petrobusians, who took their name from their leader, Peter of Bruys (died c. 1136), and condemned the trappings used in Christian worship, particularly crosses. As a provocative gesture on one Good Friday in the 1130s Peter of Bruys set up a fire in front of the church of St. Gilles-du-Gard, with the intention of publicly burning crosses. Not surprisingly, the authorities took exception to this and Peter of Bruys was himself burnt at the stake the following day (FIG. 11)

Chapter four also looks at monasticism in the Romanesque period. The monastic way of life was dedicated solely to prayer and the praise of God. It involved separation from the rest of society, the taking of vows of chastity, poverty, and obedience, and was usually regulated by a fixed rule. It had originated in the Middle East in the late third and early fourth centuries. One early form later taken up in the West was the communal way of life, with a group of monks living together under an abbot. In the sixth century St. Benedict, the founder of the monastery of Monte Cassino in southern Italy, devised a set of regulations, setting out the daily routine to be followed by monks. By the

ninth century the Rule of St. Benedict, as it has come to be known, was regarded as the standard model for monastic observance in the West.

An event of paramount importance for the development of monasticism in the Romanesque period was the foundation of the abbey of Cluny in eastern central France in the early tenth century. Cluny enjoyed the privilege of being exempt from any lay or local ecclesiastical interference and was answerable only to the pope. It was later allowed to bring other monasteries under its control, so that by the time of Abbot Hugh (1049-1109) several hundred abbeys and priories in many parts of Europe were affiliated to it and followed its observance. The abbey of St. Gilles-du-Gard itself, for example, came under Cluniac control in the early twelfth century.

The power of Cluny was reflected in its vast abbey church, built at the end of the eleventh century. This is known as Cluny III, as it was the third church to be built on the site. The Cluniacs placed great emphasis on an elaborate liturgy and promoted art, particularly architectural sculpture (as can be seen at St. Gilles), both as embellishment and as a vehicle for propaganda. In addition, the Cluniac Order also promoted the pilgrimage route to the shrine of St. James in Compostela in northern Spain, which generated much needed income from pilgrims. St. Gilles stood at the starting point of one of the routes through France and itself possessed the precious relics of St. Giles. Chapter four ends with an exploration of the cult of relics, and the development of these "pilgrimage routes" across Europe.

At the end of the eleventh century there was a reaction against traditional monasticism and the most important demonstration of this was the foundation of the Cistercian Order. The Cistercians espoused a far more austere life and aimed to follow the Rule of St. Benedict stringently. The movement grew under the charismatic figure of St. Bernard (1091-1153), abbot of Clairvaux in central France. St. Bernard was one of the most eloquent orators and writers of his age. Among his writings are a critique of traditional monastic practices and the artistic excess associated with them entitled *Apologia for Abbot William* (*Apologia ad Guillelmum abbatem*). Written in 1125, the treatise takes its name from William, abbot of St. Thierry in the diocese of Rheims, who was a friend and admirer of St. Bernard and to whom the work is addressed. The *Apologia* is one of the most perceptive contemporary documents about artistic use in the twelfth century. Monasticism also increased the opportunities for women to lead a religious life, either in "double monasteries," containing both

11. Tympanum of the Second Coming and trumeau from the porch of the church at Beaulieu-sur-Dordogne, c. 1140.

The tympanum has as its main theme the revelation of Christ's Second Coming. It is dominated by the figure of Christ, who is represented as a triumphant Roman emperor: he is semi-clothed, showing his wounds, and with outstretched arms in the form of a cross. Surrounding him are angels, who hold like trophies the instruments of his Passion, including a large crucifix. The centrality given to the cross may be a direct counter-attack on the beliefs of the Petrobusians.

The bizarre animals in the double lintel below probably refer to the apocalyptic creatures described in the Books of Daniel and Revelation. The central pier supporting the lintel is known as a trumeau. It contains a caryatid figure, who strains to hold up the lintel and tympanum above him.

men and women, or in separate convents. These are discussed in chapter five, which looks in general at the increasing importance accorded to women in the writings and visual imagery of the period. This took two main forms: first, the rise of the cult of courtly love, which began in southwest France; and second (and most importantly), the increasing veneration of the Virgin Mary. At St. Gilles the left tympanum, as has been said, is dominated by the seated figure of the Virgin Mary (defined as the Theotokos – the Mother of God), with the infant Christ on her lap, who confronts us frontally. This image of the Virgin Mary is one of the canonical images of Romanesque art, and one of the most frequently encountered.

Finally, chapter six examines the relationship of the art of western Christendom to that of three other cultures: the remote culture of ancient Rome, which for most of its history had been pagan; that of Islam, in Christian eyes the arch-heresy and an external "other"; and that of the Jews, amongst whom Christians had lived previously in relative harmony, but who came during this period to represent an internal, or domestic, "other."

St. Gilles, on the estuary of the river Rhône, was one of the main embarkation points for the Crusades, and the counts of Toulouse, to whose territories St. Gilles belonged, were among the principal sponsors of the Crusades. The first of these began in 1096, with the object of regaining control over the holy places associated with Christ in Jerusalem, then under Islamic rule. The Crusades were a seminal event of the Romanesque period, not least because the assembling of an army large enough to regain Jerusalem, and its transport to the Holy Land, constituted an extraordinary logistical feat. In 1099 the combined armies of the Crusaders entered Jerusalem, and the prominent position given to the entry of Christ into Jerusalem on the lintel below the left tympanum at St. Gilles may well refer to this event. The Crusaders established four Christian states in the near East: the Kingdom of Jerusalem, which had its own king, the Principality of Antioch, the County of Edessa, and the County of Tripoli. Once captured, however, Jerusalem proved difficult to retain, and two further Crusades had to be launched in the twelfth century, the Second Crusade in 1147 and the Third in 1189. Christian pilgrims visited Jerusalem in increasing numbers throughout this period, and in order to safeguard their physical and spiritual welfare, a new and curious hybrid was created: the knight-priests, amongst whom were the Knights Templar, whose European headquarters were, again, at St. Gilles, and the Knights Hospitallers, who cared for the sick.

To the far right of the Crucifixion in the right tympanum at St. Gilles is the figure of Synagogue, representing the Jewish people (FIG. 12). An angel attacks her with a spear and she topples to the ground. Her elaborate crown is in the form of a domed building; and it has been argued that it represents an actual building in Jerusalem, the Dome of the Rock, which in the twelfth century was thought to have been built on the site of the Temple of Solomon, and was sometimes even confused with it. (Under the Muslim occupation of Jerusalem, the Dome of the Rock was used as a mosque.) Such a negative representation of Synagogue is an example of the ideological justification developed during the Romanesque period for the persecution of the Jews. This ideology and imagery are important, if most unhappy, features of the period, and are explored in the final section of the last chapter.

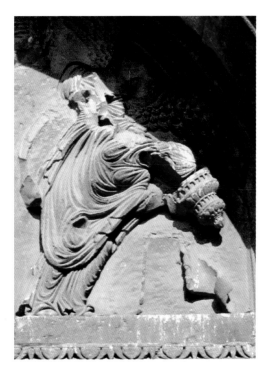

12. The figure of Synagogue from the right tympanum of St. Gilles-du-Gard.

This book deliberately avoids a diachronic approach in favour of a thematic one. One reason for this is that the dating of many of the key monuments of the period is the subject of considerable controversy; the pier reliefs at Silos in northern Spain, for example, once thought to have been carved in the late eleventh century, have been placed by recent scholarship well into the twelfth century. Another factor, which can be surmised from written documents of the period, is that what survives represents only a fraction of what was originally produced. This is particularly true of objects made of precious materials. Many examples of works of art from this period, even sculpture, have also been removed from their original settings.

These factors make the careful chronological and geographical plotting of the various stylistic phases of Romanesque art a difficult and problematic exercise in the present state of knowledge. Therefore, rather than engage with the highly specific and often intractable problems of chronology and dating (important though they are), this book aims to place the achievements of Romanesque art within their broader intellectual and social context. In doing so, as well as discussing the origins and development of Romanesque art and architecture, it also examines the Romanesque in the light of certain of the key issues of contemporary academic discourse: class, gender, and race.

ONE

The Romanesque Artist and Patronage of the Arts

13. ROGER OF HELMARSHAUSEN Portable altar of SS. Kilian and Liborius, c. 1100 (view of top). Silver (partly gilt), gilt bronze, gems, pearls, and niello, 14 x 8¹/₂ x 7³/₈" (34.5 x 21 x 18.5 cm). Diozesan Museum, Paderborn.

Bishop Henry de Werl is depicted between the bottom roundels, standing in front of an altar and holding a censer.

I n the west porch of Autun cathedral in Burgundy, the Last Judgement tympanum is dominated by the single gigantic, immobile figure of Christ in Majesty, enclosed in a mandorla (an almond-shaped frame) which extends to the tympanum's entire height (FIG. 14). All around this static core is the frenetic movement of eighty or so angelic, demonic, and human figures divided between the blessed and the damned. In the horizontal lintel below, the dead awake from their slumber on Judgement Day. At the base of Christ's feet an inscription records the name of the creator of this cacophony in stone: *Gislebertus hoc fecit* ("Gislebertus made me").

One of the many misconceptions about Romanesque art is that its artists have left no trace of their identity. Although it is true that most of them have remained anonymous, artists' signatures from the Romanesque period survive in their hundreds, particularly in France and Italy. The artist is usually identified by his or her first name only, as at Autun, although occasionally the place from which he or she originated is also given. Signatures and inscriptions from northern Italy record the names of some of the most prominent sculptors working in that region in the twelfth century: Benedetto Antelami, Master Niccolò, and one Wiligelmo, who is praised in the highest terms in a lengthy inscription on a plaque prominently placed on the west facade of Modena Cathedral: "How worthy you are of great fame and honor your sculptures now demonstrate, Wiligelmo."

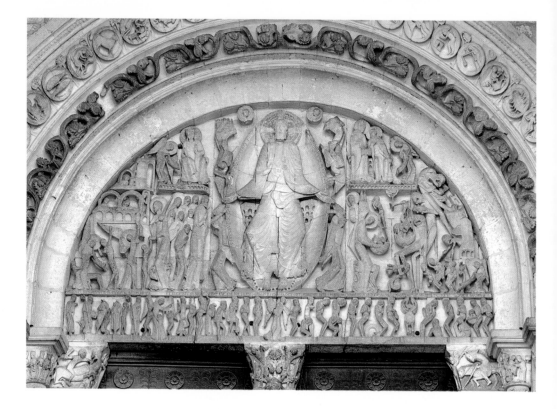

14. Gislebertus
Last Judgement tympanum in the west porch of Autun Cathedral, c. 1140.

To the right of Christ is St. Michael, who weighs the risen souls, represented as manikins, in a giant scale which a small demon is trying to tip. To the left of Christ is St. Peter, who welcomes the souls of the blessed in heaven. In and below the lintel, Adam and Eve can be identified among the blessed, together with a monk and pilgrims from Jerusalem and Santiago di Compostela. These last are identifiable by their respective emblems of a cross and a scallop shell.

Goldsmiths' work is another field in which the names of several of the most important practitioners have come down to us. They include Roger of Helmarshausen, Rainer of Huy, Godefroid de Claire of Huy, Eilbertus of Cologne, and Nicholas of Verdun. As their names indicate, most of these craftsmen came from either northern Germany or the Mosan region. Their work encompassed not only gold and silver, but also enamel and copper alloy. Goldsmiths were held in esteem and many important artistic developments were pioneered by them, but the importance attached to their work by contemporaries is often not fully appreciated today. One reason for this is that very little of it survives, as most pieces have long since been melted down. Another lies in our changed perception of goldsmiths' work as a decorative, or minor, art, a classification that arose during the Renaissance. Yet how innovative goldsmiths' work of the twelfth century could be is amply demonstrated by surviving examples such as the magnificent enameled altar-frontal in the abbey of Klosterneuburg, near Vienna, which is signed by Nicholas of Verdun and dated 1181 in an inscription (see FIG. 4).

Occasionally, an artist's signature is found in conjunction with his or her portrait. Sometimes a portrait is found on its

own. The artist is usually portrayed holding the tools of his craft. One example, which is particularly interesting in that the artist was also the donor (which may explain the portrait), is a stained-glass panel from the monastery of Arnstein near Coblenz in the Rhineland, representing Moses and the burning bush (FIG. 15). At the base of the panel the glass-painter is portrayed with the accompanying inscription: "O illustrious King of Kings, be favourable to Gerlachus." Gerlachus holds a brush in one hand and a paint pot in the other, and his dress plainly identifies him as a lay person.

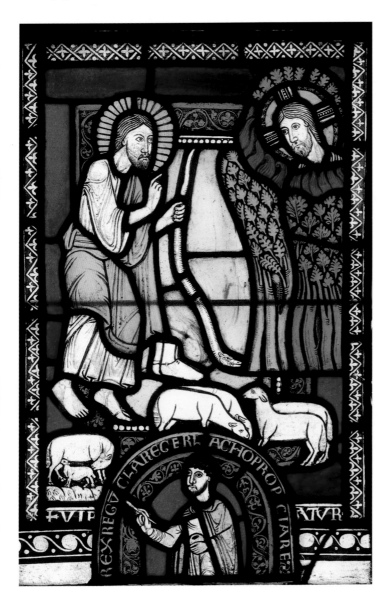

15. GERLACHUS
Stained-glass panel from the former Premonstratensian abbey at Arnstein, c. 1150, 21 x 20" (52.5 x 50.5 cm). Westfälisches Landesmuseum für Kunst und Kulturgeschichte, Münster, Germany.

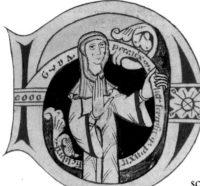

Another example, unusual in that the artist is a woman, is contained in an initial to a late twelfth-century German manuscript. It shows a nun holding a scroll on which are written the words: "Guda, the sinful woman, wrote and illuminated this book" (FIG. 16). This is one of the rare occasions in Romanesque art when it can be proved that the scribe who wrote the book, and the illuminator who decorated it were one and the same person. There is other evidence of women being active as artists, particularly in manuscript illumination and ecclesiastical embroidery. The sisters of her convent, for instance, are thought to have devised and painted the illustrations accompanying the written record of Hildegard of Bingen's visions (see pages 137-38). Christina of Markyate (see pages 135-37) is recorded as having embroidered gifts for the English pope, Adrian IV, in 1155 – when King Henry II of England sent ambassadors to the pope to request permission to invade Ireland, among the gifts sent with them were embroidered sandals, two shields and three beautiful mitres embroidered by Christina.

16. Initial with a portrait of Guda, c. 1180. Illumination on parchment, 3 x 2½" (7 x 6.5 cm). Stadt and Universitäts-bibliothek, Frankfurt.

The figure of Riquin, from the doors of the cathedral of St. Sophia, Novgorod.

The signatures discussed here do not appear to have functioned as indicators of authenticity. Indeed, it is inconceivable that certain of the larger projects discussed in this chapter, such as the tympanum at Autun, could have been the work of just one person. Instead, they appear to be have been produced by a team working under a master artist, who imposed his or her style on these assistants, and to whom the signature refers. Occasionally, artists like Nicholas of Verdun are referred to by the term Magister ("Master"), indicating their status. A Master is sometimes represented with an assistant or apprentice. On the giant bronze doors of the cathedral of St. Sophia at Novgorod, in northern Russia, the Saxon master bronze-founders, Riquin (see left) and Abraham, are represented with their youthful assistant, Waismuth, who holds a pair of tongs.

Two suggestions have been made concerning the function of artists' signatures in this period. First, it has been suggested that they were intended as requests for prayer from spectators on behalf of the artists, so as to assist them to gain eternal salvation. In this connection it has been noted that signatures frequently occur on images of the Last Judgement, as with Gislebertus at Autun. Second, it has been suggested that the signatures are indicators either of the social status of the artist or of the civic pride of the organisation that had obtained the artist's services. This appears to have been true of the sculptor Wiligelmo, who

is so highly praised at Modena. Modena was one of the northern Italian cities governed at the time by an embryonic form of the commune (that is, a group of citizens under the leadership of a consul), a precursor of the Italian city-state. The highest incidence of artists' signatures is found in the most urbanised and politically precocious regions of Europe, such as Tuscany, Emilia, and the Mosan region. This is not coincidental, but relates to the emergence of a sense of civic pride in the skills of "their" artists.

Along with inscriptions and signatures, documents of the period also record information about artists. An important historical development from the mid-eleventh century to the end of the thirteenth was that information increasingly came to be written down, rather than transmitted orally. Compared to previous centuries, there is a vast increase in the number of documents surviving from the Romanesque period, the most important of which, from the standpoint of art historians, are wills, the chronicles of monastic houses, and travel and pilgrim guides.

In manuscripts, the written evidence may be an integral component, consisting either of a dedication page or of what is known as a colophon, which provided information comparable to that found nowadays on the title page of a book. The Gospelbook (containing the texts of the four gospels of Matthew, Mark, Luke, and John) of Henry the Lion, named after its patron, the Duke of Saxony and Bavaria and dated c. 1188, is prefixed by a dedicatory poem written in gold, which records that the manuscript was the work of Herimann, one of the monks of the abbey of Helmarshausen. As the manuscript is written in one hand, it seems reasonable to infer that this was Herimann's, and that he was probably also responsible for the design, if not the actual execution, of the numerous sumptuous illustrations (FIG. 17).

Written documents are, however, usually found separately from the object or project to which they relate, and occasionally both document and commissioned work have survived. An interesting example, connected to the same abbey as the

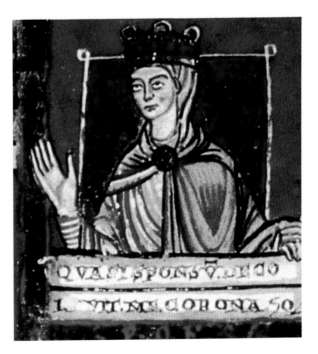

17. The Gospelbook of Henry the Lion, c. 1188. Detail of the Coronation portrait.

18. ROGER OF HELMARSHAUSEN
Portable altar of SS. Kilian and
Liborius, c. 1100. Detail of
top right-hand corner showing
the metalworking techniques.

Gospelbook of Henry the Lion, records the name of one of the most important German goldsmiths of the early twelfth century, Roger of Helmarshausen. The piece it refers to is a small raised, portable altar, made of gilded silver and copper plate and decorated with figures of Christ and various saints, including Kilian and Liborius, the patron saints of Paderborn Cathedral. It is a *tour de force* of metalworking techniques: engraving; repoussé work (produced by hammering from the back); and niello, an incised decoration filled with a black substance made of sulphides of silver, copper, or lead (FIG. 18).

Roger's career has been traced. He appears to have begun his artistic work as a member of the famous Benedictine abbey of Stavelot, in present-day Belgium, and later to have moved to the abbey of St. Pantaleon in Cologne. By the early years of the twelfth century he must have established himself as the head of the goldsmiths' workshop at the abbey of Helmarshausen in northeast Germany, where he is recorded as having died in 1125.

Roger of Helmarshausen was evidently a major figure in the artistic life of this region, and it has been suggested that he may have been the author of what is by far the most important artist's treatise of the period, as one of the earliest manuscripts of this text contains in a later hand the inscription *qui et Rugerus* ("he who is Roger"). This work, *Of the Various Arts (De Diversis Artibus)*, was written under the pseudonym, Theophilus, but in the absence of firm evidence, Theophilus's identification with Roger must remain conjectural. The treatise is thought to have been written in the 1120s in northern Germany, and consists of three sections covering the arts of painting, stained glass, and metalwork. The last of these is by far the most extensive and contains accurate descriptions of techniques used by Roger in his portable altar, such as niello and repoussé work.

The chronicle of the East Anglian monastery of Bury, one of the wealthiest monasteries in England in the twelfth century, contains an intriguing example of information about an artist's life. The chronicle mentions a Bible illuminated by a Master Hugo, and notes that it was necessary for him to go to Ireland to obtain parchment of suitably high quality on which to paint its illustrations. This Bible has been identified as the Bury Bible, where, as is recorded in the same passage, the illustrations are on separate pieces of parchment attached to the manuscript.

Master Hugo is also recorded as having been active as a metalworker and sculptor. The chronicle states that he cast a giant bell, executed the bronze entrance doors to the abbey church, and carved in wood a crucifix with accompanying figures of St. John the Evangelist and the Virgin Mary. This proficiency in more than one technique does not appear to have been exceptional, and Master Hugo's knowledge of metal-working techniques may be one factor in explaining the innovative style of his painting, as demonstrated in the Bury Bible illustrations.

Another twelfth-century English source provides information on an architectural project. Gervase of Canterbury, a monk of the abbey of Christ Church, which was attached to Canterbury cathedral, wrote an unusually full account of the rebuilding of the eastern end of Canterbury cathedral after a fire in 1174. He records that the monks of Christ Church first obtained the services of a French architect, William of Sens, and after his fall from scaffolding in 1178 (which for architects and stonemasons must have been an occupational hazard) employed a local architect, William the Englishman, to complete the project.

The information that can be culled from inscriptions and documents is, of course, fragmentary and limited. Even where we know the names of artists, we usually know nothing about their lives, their training, or, in much detail, their careers. In order to distinguish certain pre-eminent, but anonymous, artistic personalities, whose work is identifiable only by the distinctive characteristics of their artistic style, art historians have resorted to coining names for them. The main artist of the St. Albans Psalter, for example, is called the Alexis Master after a section of the work which contains the biography of a fifth-century Roman saint called Alexis (A psalter is a manuscript of the text of the book of psalms, together, sometimes, with other material). This process of naming betrays a gender bias as the artist is invariably referred to as "Master" when, of course, it cannot always be proved that the artist was male.

The Alexis Master has been credited with introducing a new figurative and narrative style into English art in the 1120s (FIG. 19). This new style was much indebted to eleventh-century German and early twelfth-century Italo-Byzantine art. However, it is much more likely that the Alexis Master was simply a major exponent of this new style, whose work has happened to survive, rather than its innovator. His most important surviving work is found in a manuscript that belonged to the head of a small priory for nuns, Christina of Markyate. As Christina was a recluse, the manuscript would have been practically inaccessible

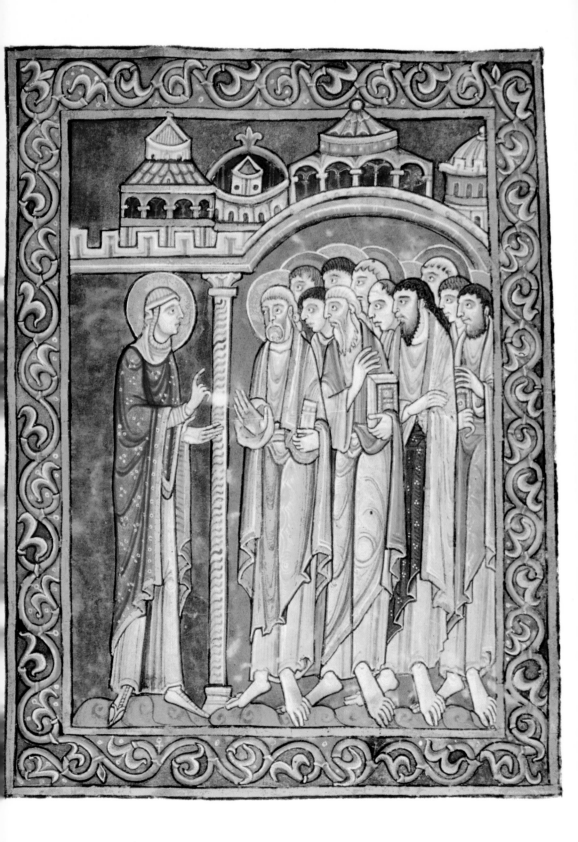

19. Mary Magdalene announcing the resurrection to the apostles from the St. Albans Psalter, 1120-30. Illumination on parchment, 7¼ x 5⅝" (18 x 14 cm). St. Godehard's church, Hildesheim.

20. MASTER OF THE MORGAN LEAF
The Book of Jeremiah, Winchester Bible, c. 1170. Detail of initial *R*.

to other artists until her death, some time after 1155, when it was returned to the priory's mother house, St. Albans abbey.

The Master of Cabestany is named after the village of Cabestany near Perpignan in southern France, where there is a relief carved in his distinctive style. This style has a number of characteristics: the figures have small, round heads with sharp edges to the jaw and cheekbones; eyes with an exaggerated slant and holes drilled deeply on either side of the pupil; and large hands with long slender fingers. The Master of Cabestany appears to have been active in the second half of the twelfth century on both sides of the eastern Pyrenees, in Catalonia and the Roussillon region of France, which then formed one vast territory under the rule of the House of Barcelona. His influence, if not his own hand, has been detected as far away as Tuscany, whence he may have originated. However, even in the case of the Master of Cabestany there are stylistic differences between the most important surviving work attributed to him – a fragment of the frieze from the facade of the abbey church of Sant Pere de Roda in Catalonia, representing Christ walking on the water (see FIG. 109) – and the relief at Cabestany which suggests the existence of a team of itinerant stonemasons working under him in his style.

One commonly held misconception is that artists of this period were all monks or nuns. Though there is evidence that monks and nuns were active as artists (Roger of Helmarshausen is a case in point), even within monastic communities lay people were employed. This is true, for example, of Master Hugo at Bury. During the course of the twelfth century there was an increasing tendency for artists to be lay people.

Nor was it exceptional for artists to travel extensively. Indeed, travel might have been necessary for an artist such as the Master of Cabestany in order to obtain sufficient work. Abbot Suger (1081-1151), abbot of the royal monastery of St. Denis, near Paris, records that in his embellishment of the abbey he obtained the services of the best artists from far and wide.

The Winchester Bible, one of the most important manuscripts of the Romanesque period, certainly employed itinerant artists. The hands of at least two of them – the so-called Masters of the Morgan Leaf (FIG. 20) and the Gothic Majesty – could also be seen in wall-paintings in the chapter house at Sigena in Catalonia. Unfortunately, these were destroyed during the Spanish Civil War, and they are now only known to us from fragments and photographs. It has also been convincingly

argued that the Master of the Morgan Leaf had seen the mosaics in the Palatine Chapel at Palermo and Cefalu Cathedral in Sicily, which were installed towards the middle of the twelfth century, and that he was influenced by their gentle, classicising, Byzantine style. This Sicilian influence should be seen against the background of the close dynastic ties binding the Norman court in England and that in Sicily: Joanna, one of the daughters of Henry II of England and Eleanor of Aquitaine, married William II of Sicily in 1177.

The itinerant nature of Romanesque artists helps to explain the international character of Romanesque art, and the apparently easy migration of ideas. This was facilitated by the artists' use of notebooks, in which they could record any images or schemes that took their eye while traveling. These notebooks, also called pattern books, appear to have been circulated among different artists' workshops. They are divided into those that are straightforward pattern books, which record single specific motifs, such as the distinctive posture of a figure, and those that function as iconographic guides, containing entire compositional schemes. Very few pattern books survive from the twelfth century, although it has been suggested that a set of separate leaves, made in the Mosan region in the 1160s and now dispersed between collections in London, Liège, and Berlin, may have functioned as an iconographic guide for goldsmiths and illuminators of the region (FIG. 21).

There is, then, considerable evidence providing knowledge of artists in the Romanesque period. And this evidence counters the commonly held view of the medieval artist as anonymous, effacing his or her personality to work selflessly in the service of God. Yet it remains true that the Romanesque artists occupied a very different position from that of the artists described in the sixteenth century by Giorgio Vasari, whose *Lives of the Artists* (1550 and 1568) assigned a pivotal role to the individual genius and personality of the artist.

By way of contrast, Abbot Suger, in his extensive account of the rebuilding of St. Denis, does not mention one artist by name. Even the new abbey's great architect, who may be credited with having introduced the Gothic style in architecture, is left unnamed. Moreover, on the rare occasions when artists are mentioned in documents, this is done in an apparently random manner, with no reference to their relative importance. As has been said, there is a comparatively high incidence of artists' signatures in sculpture from Tuscany and Emilia, and in metalwork from the Mosan region. But in other areas there are scarcely any

21. *Baptism of Christ*, 1160s.
Illumination on parchment,
10 x 6¹/₄" (24.9 x 15.6 cm).
Kupferstichkabinett
Staatliche Museen, Berlin.

artists' signatures from this period: the only piece of Romanesque English art to be signed is a small, late twelfth-century font at Bridekirk in Cumbria, which has on it the signature of the sculptor, Richard, who has also portrayed himself in the act of carving foliage.

Such biographies as there are from the Romanesque period (more eulogies than objective accounts) tend to be confined to the lives of the saints, such as St. Edmund, or rulers – for example, Countess Matilda of Canossa. Perhaps the best key to the status of Romanesque artists lies in the way they portrayed and thereby defined themselves, holding the tools of their trade in their hands. Art was perceived as a manual activity, which did not make use of the intellect, and was thus classified in the medieval conception of learning as a mechanical, rather than a liberal, art. This view was not seriously challenged until the publication of *De Pictura* by the architect Leon Battista Alberti in the early fifteenth century. As a manual activity, the practice of art was looked down upon both by the aristocracy and the monastic orders. However, if this attitude was not directly challenged during the Romanesque age, it was increasingly being questioned, as demonstrated by Theophilus's writing of his treatise, by the emphasis among the Cistercians on manual work as both a necessity and a spiritual exercise, and by the pride in civic art of the burgeoning towns.

The Role of the Patron

In general, works of art came into being in the Romanesque period because they were commissioned by a patron. It is only at the end of the period that there is any evidence for works of art being produced ready made in response to market demand.

Very little is known about the majority of Romanesque patrons, their intentions, and their methods of transaction, although information is occasionally provided by inscriptions. For instance, in the inscriptions on the Klosterneuburg altarfrontal, the name of the patron, Provost Wernher, is specified. The patron's name is also sometimes specified in documents. The dedicatory poem in the Gospelbook of Henry the Lion records that Henry and his English wife, Matilda (who probably paid for the work), commissioned the manuscript as a gift for the church of St. Blaise in Brunswick, central Germany. The document recording the payment to Roger of Helmarshausen for his portable altar contains the name of his patron, Henry de Werl, Bishop of Paderborn (1084–1127), who is also portrayed on the altar itself (see FIG. 13, page 24). In this instance, the method of payment is also recorded: a gift of property and tithes to the abbey of Helmarshausen.

Donor portraits are much more numerous than those of artists, and sometimes show the patron presenting the work of art to a sacred figure, such as Christ, the Virgin Mary, or one of the saints. An example of this is the Crucifixion window in Poitiers Cathedral, of c. 1165–75 where the kneeling figures of Henry II and Eleanor of Aquitaine are depicted at the base of the scene (FIG. 22). In an architectural project, the donor is usually shown offering up a model of the building. This can be seen in

22. Crucifixion window at Poitiers cathedral, c. 1165-70. Detail showing the kneeling figures of the donors, Henry II of England and Eleanor of Aquitaine.

The diagram of the window they hold is a nineteenth-century interpolation. Stained-glass windows were very expensive, and this example at Poitiers, which is one of the largest, required royal patronage to meet the costs of its manufacture.

one of the mosaics at Monreale in Sicily, where William II is shown presenting a model of the church to the Virgin Mary, to whom it is dedicated (FIG. 23). In presenting such gifts, the donors were no doubt acting in the hope that they would secure an easier passage to heaven and eternal salvation.

Powerful feudal families played a crucial role in church politics of this period, and lay patronage was obviously an important factor in the funding of church-building and religious art. The most important architectural project of the period, the great abbey church known as Cluny III, was largely made possible by the donations of King Alfonso VI of León and Castile, and later of King Henry I of England.

The best documented and, consequently, the most famous patron of the twelfth century was Abbot Suger. He was abbot of the ancient, royal monastic foundation of St. Denis and also one of the most important political figures of the period, becoming regent of France while King Louis VII was away on the Second Crusade. In the 1140s Suger set down for posterity a detailed account of his ambitious program for the rebuilding and embellishment of the abbey, and a number of the objects described therein can still be identified. This account may have been written as a justification of Suger's extravagance, in the face of criticism which came primarily from St. Bernard of Clairvaux. Suger's massive building program at St. Denis included the addition of a west front, complete with extensive sculptural decoration, and the rebuilding of the east end of the church, completed in 1144. Another motive may have been Suger's desire to inform future generations of his central role in the rebuilding of the abbey. The same motive probably accounts for the numerous donor portraits of Suger at St. Denis. In general, Suger's account contains a bias in favour of the patron to the detriment of the artist – a bias perpetuated in the subsequent historiography of Roman-esque and Gothic art.

One of Suger's motives for the rebuilding of the east end was the urgent need to provide greater space for the throngs of pilgrims who came to visit the abbey's holy relics, the most revered of which was that of St. Denis himself, considered to have been the first bishop of Paris. The donations of pilgrims to churches fortunate enough to house important relics was a vital source of income, although the practice was referred to disparagingly by St. Bernard in the famous critique of artistic excess and practices in traditional Benedictine monasteries contained in his *Apologia*: "their eyes are feasted with relics, and their purse strings are loosed." Funding for the rebuilding also came from better hus-

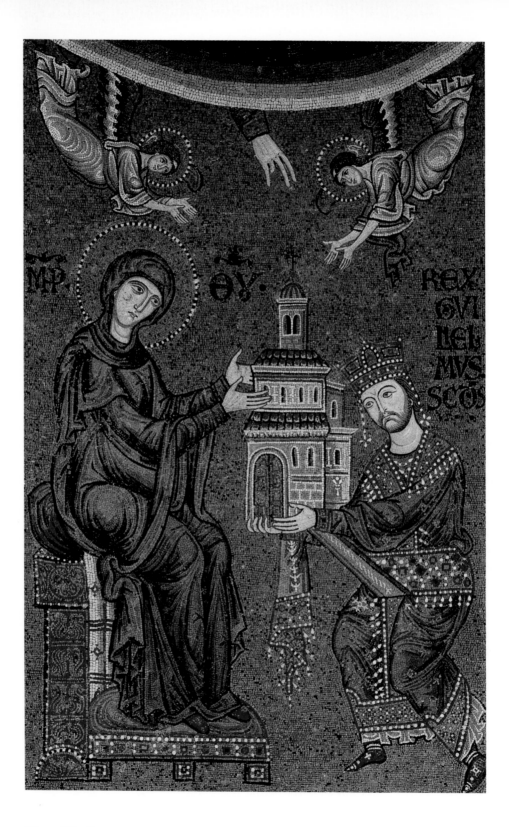

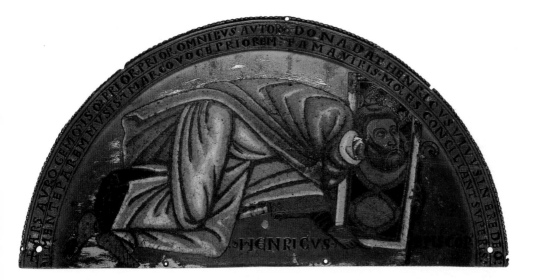

bandry of the abbey's estate, and, it has been plausibly argued, royal donations from Louis VII and his consort, Queen Eleanor.

Whatever the faults of Suger's account, it is invaluable to art historians, since Romanesque patrons did not, for the most part, set down in writing any record of their artistic patronage. A patron of probably equal importance to Abbot Suger was Henry of Blois (1129-1171), bishop of Winchester and brother of King Stephen of England. Henry of Blois was a great builder of churches and palaces, and as a patron of the arts he is associated with works of such major artistic importance as the Winchester Bible, yet it is possible to link his name securely with only one surviving object. This is a pair of enameled plaques, produced by a Mosan goldsmith working in England, on one of which Henry is portrayed (FIG. 24). Above him is an inscription containing the words *prior omnibus autor*, which in this context are generally interpreted as meaning that the patron ranks above all others.

Women patrons of the arts in the Romanesque period have until recently been given very little attention, despite the fact that they could be as influential as their male counterparts, and included some of the most prominent political figures of the age. One of these, Matilda of Canossa (d. 1115) ruled over the territories of Tuscany and Emilia in northern Italy, and was a keen supporter of the papal reform movement. She sided with Pope Gregory VII against the Holy Roman Emperor, Henry IV, as is recorded in her biography, written shortly after her death by a monk called Donizo. An illustration in that biography emphasises Matilda's role as a peacemaking mediator in the con-

24. Henry of Blois enamel (one of a pair), before 1171. Champlevé enamel, diameter 7¼" (18 cm). British Museum, London.

23. King William II presenting the Virgin Mary with a model of Monreale cathedral, mosaic in Monreale cathedral, c. 1185.

The hand of God emerges from the sky to bless William's good work. The cathedral of Monreale, with its monastic complex, was apparently begun by 1174 and substantially completed by 1183, when Pope Lucius III praised William for the speed with which it had been built, adding that its like had not been seen since antiquity. Monreale was intended to be the royal mausoleum of the Norman rulers of Sicily.

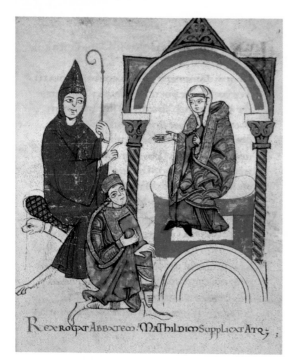

25. Henry IV's submission at Canossa, from the Life of the Countess Matilda of Canossa, 1115. Illumination on parchment, 6¹/₂ x 8¹/₂" (16 x 21 cm). Biblioteca Apostolica, Vatican.

flict. She is shown seated under a canopy at her fortress in Canossa on the occasion of Henry's submission to Gregory in 1077. Abbot Hugh of Cluny is to her right, and Henry himself is shown kneeling in front of her (FIG. 25)

Matilda is known to have commissioned a sumptuously illustrated Gospelbook made in the late eleventh century at the Cluniac monastery of San Benedetto di Polirone, near Mantua. One of its illustrations shows the highly unusual subject of Christ cleansing the temple (FIG. 26). This has been interpreted as a justification of papal military intervention, to which Matilda gave considerable material assistance. The Vatican's military actions, interpreted as cleansing Christendom of malign influences, would thus be seen as a parallel to Christ's actions. More generally, the buildings constructed in Matilda's domains during her reign, such as the church of San Miniato in Florence, have a classical appearance which reflects her pro-papal stance. At this time the papacy, in its building program for the city of Rome, sought to return to the glories of the late antique and early Christian period, as well as drawing on cultural influences from Byzantium, to express its spiritual revival. Wiligelmo's frieze at Modena cathedral, at the dedication of which Matilda was present (Modena came under her territories), reflects the influence both of Roman reliefs and a group of late eleventh-century ivories made at Salerno, which contain an extensive program of Old and New Testament subjects. Salerno was itself a papal stronghold in southwest Italy, and the site of Pope Gregory VII's burial in 1085. The use of architectural sculpture as pro-papal propaganda on such buildings as the cathedrals at Modena and Cremona was in keeping with the views of the Cluniac order, with its strong papal links, on the purposes of art. Matilda's artistic policies continued, even after her death, to dominate the art and architecture of Tuscany and Emilia in the first half of the twelfth century.

No legal contracts between artists and patrons survive from the Romanesque period, but it seems reasonable to assume that the patron specified the iconographic program – possibly, if he

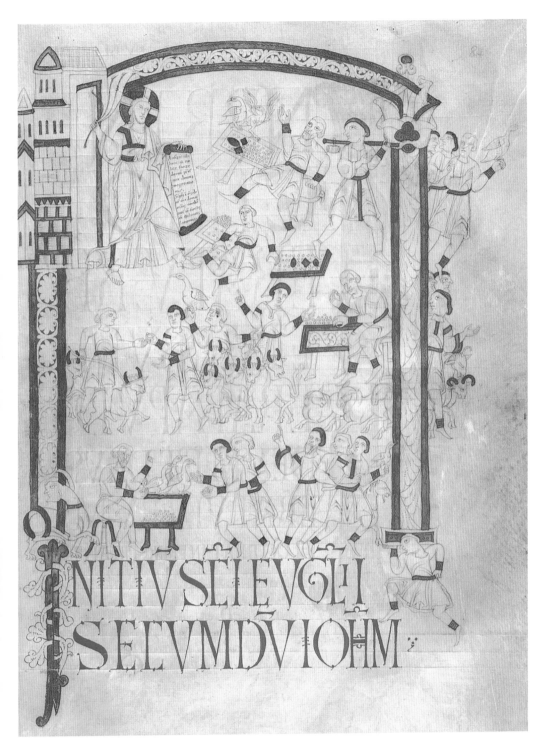

26. *The Cleansing of the Temple* from the Gospelbook of Matilda, late eleventh century.
Illumination on parchment, 13¹/₂ x 8⁷/₈″ (34.3 x 19.8 cm). Pierpont Morgan Library, New York.

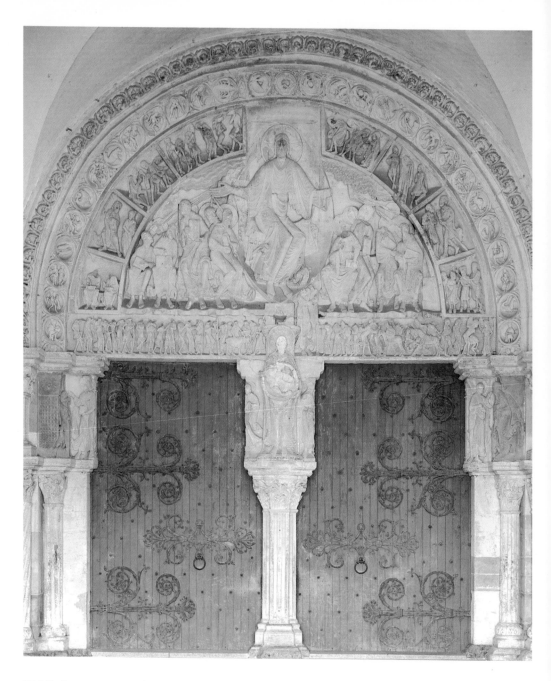

27. Vézelay, tympanum with Pentecost and Christ's mission to the apostles, c. 1130s.

or she were a lay person, or the imagery complex, in consultation with a theological adviser. The intricate iconography of the sculptured portals at Vézelay in Burgundy, which are generally dated to the 1130s, has been ascribed to Peter the Venerable, an influential theologian and abbot of Cluny, to which Vézelay was affiliated, from 1122 to 1156. It conflates three main themes:

Christ's ascension; the Pentecost, when the apostles were filled with the Holy Spirit in the form of tongues of fire; and Christ's mission of evangelism to the apostles (FIG. 27). The iconography is derived not only from the Bible, but also from a wide range of texts, including the writings of the Church Fathers, as well as those of classical and early Christian authors such as Pliny and Isidore of Seville. On the right side of the lintel are shown the monstrous races described by Isidore in the seventh century in his encyclopedia of late antique learning. These include, on the far right, the Panotii, a race with huge ears who were thought to live in India and who,

28. Capital in St. Gabriel's chapel, Canterbury cathedral, c. 1100.

though they can obviously hear, belong to the morally deaf, and pygmies, who are shown having to use a ladder to mount a horse. The works of all these authors would have been available to Peter the Venerable in the library at Cluny. The contribution of a theological adviser has also been confirmed in the case of the Winchester Bible, which has marginal instructions about the iconographic program to be followed.

If the selection of the theme was the patron's prerogative, it seems reasonable to assume that its presentation was left largely to the artist. In particular artists appear to have been allowed to give free expression to their imaginations in the use of small marginal motifs, within initials in manuscripts and on the capitals of columns (FIG. 28), and on the projecting ends of corbels beneath the eaves of a roof. They often have grotesque, erotic, or humorous themes, and must have been done, at the very least, with the acquiescence of the patron, but whether they were intended purely to amuse or had a more serious, symbolic significance is difficult to ascertain. Looking at them we can only ask the same question as St. Bernard: "To what purpose are those unclean apes, those fierce lions, those monstrous centaurs, those half-men, those striped tigers, those fighting knights, those hunters winding their horns?"

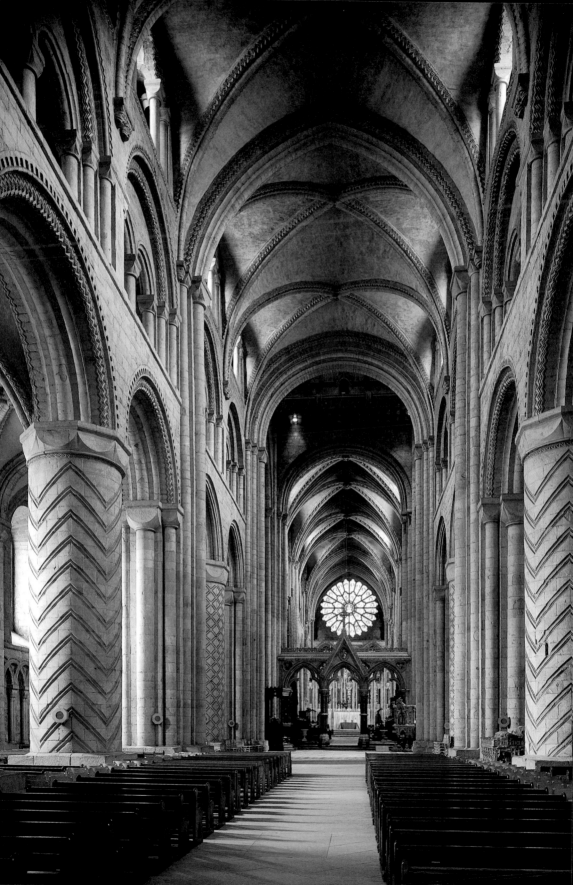

Stone, Mosaic, Enamel, and Glass: Developing Forms of Romanesque Art

29. Interior of the nave of Durham cathedral, first third of the twelfth century.

This view of the nave shows the three main storeys: the "arcade" (a series of arches resting on piers or columns); the middle storey (above the side aisles with openings looking on to the nave) is described as a gallery; and the upper storey as a clerestory (the upper part of the nave wall containing a range of windows). The nave is 73 feet high (22.2 m) and has a span of 39 feet (11.8 m), and has a similar grandeur to the cathedral at Speyer. Indeed specific details, such as the use of the stark cushion capitals which surmount the columns are derived from the architecture of the Rhineland.

The use of images by the church had been the subject of intense debate in the preceding centuries, both in the East and the West. It was argued that they contravened the Second Commandment, which states: "Thou shalt not make thee any graven image." Pope Gregory the Great (590-604) had justified the use of images on the grounds that they provided a book for the illiterate, and this justification was repeated frequently throughout the Middle Ages. It is found, for example, written first in Latin and then in Insular French, in the St. Albans Psalter, where it presumably provides a justification for the forty richly painted illustrations that preface the book. This debate about the use of images was to resurface in the Reformation, as can be seen at St. Gilles-du-Gard, where many of the sculptural figures were decapitated or defaced by Protestants during the religious wars of the sixteenth century.

In public art, images appear to have served a comparable function to advertising today. The greatest expense, artifice, and skill were expended to reinforce the Christian view of the world, and as a vehicle for propaganda and comment on contemporary issues. In the Romanesque period there was an enormous increase in both the quantity and range of artistic images, and the forms in which they were presented.

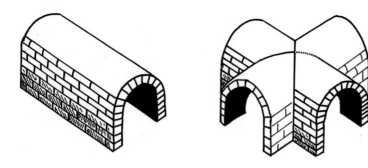

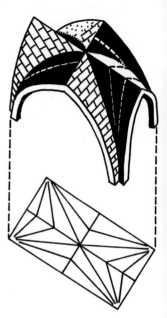

Architectural Sculpture

Very little architectural and monumental sculpture from the end of the fifth century to the eleventh century has survived. The main exceptions are the giant freestanding stone crosses found in northern England, Scotland, and Ireland, of which the late seventh-century Ruthwell Cross is the supreme example. Plainly, the skills of carving continued to be practised, but mostly on a smaller scale, in bone and ivory.

At the end of the eleventh century and the beginning of the twelfth, architectural sculpture came into its own for the first time since antiquity, whose works provided a ready, though not always obvious, source of inspiration. The scope for this revival was provided by the ambitious program of church-building in stone that was gathering pace at the beginning of the eleventh century.

The Romanesque building boom went hand in hand with a number of technological innovations. It is important to understand the form these took, as they are fundamental to developments throughout Romanesque architecture. Chief among them, and the supreme achievement of the Romanesque church builders, was the use of the stone vault (FIG. 30). This insulated against fire and improved the acoustics within churches, and it reached a level of such sophistication that Romanesque masons were ultimately able to vault the entire width of the church with stone. Initially, in order to do this, masons looked back to a vaulting solution used by the Romans – the barrel vault, in the shape of a half-cylinder. Early eleventh-century experiments in barrel vaulting can be seen in churches in Catalonia and the Pyrenees; the church of the monastery of St. Martin-du-Canigou in the Roussillon region of the Pyrenees is a good example. Barrel vaulting was particularly favoured in Burgundy: the nave of Autun cathedral (see FIG. 101, page 143), for example, is vaulted with a barrel vault with pointed transverse arches.

31. Interior of the nave of Speyer cathedral, c. 1030-61 and c. 1080-1106.

The elevation of the nave is probably based on that of the nearby Roman basilica at Trier. The choir terminates in an immense semi-circular apse with a blind arcade (a series of arches resting on piers or columns). Speyer has a stark monolithic quality to it.

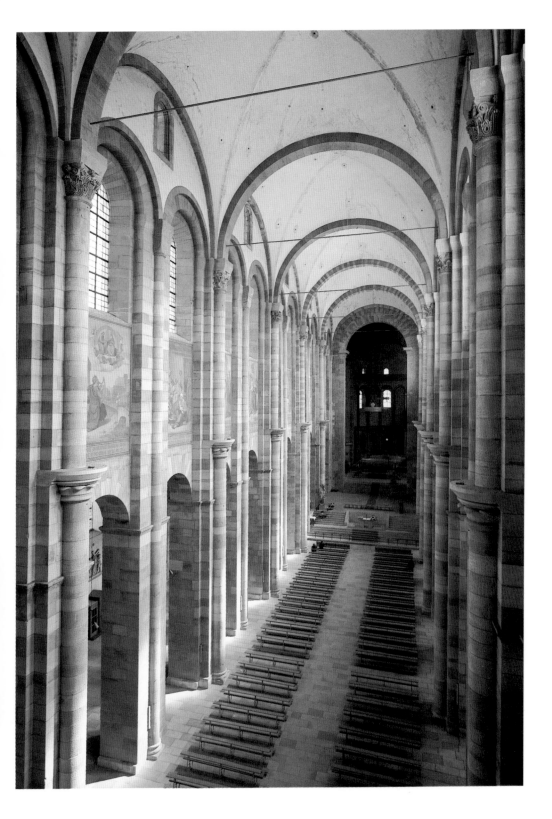

A more sophisticated solution was to use a groin vault. This consisted of two barrel vaults, intersecting at right angles. This was the solution adopted in the largest and most impressive church to have survived from the Romanesque period: Speyer cathedral in the Rhineland (FIG. 31). Speyer cathedral was the burial place of the Salian dynasty, who ruled the Holy Roman Empire from the early eleventh century to the beginning of the twelfth. It was built in two phases: the first between 1030 and 1061, and the second between 1080 and 1106, when the entire nave was vaulted. The nave is over 100 feet (30.5 m) high and its span is 45 feet (13.7 m), which is close to that of the widest Gothic cathedrals. Each double bay is spanned by an immense groin vault and separated by a transverse arch. Towards the end of the eleventh century the use of the groin vault increased throughout Europe and was particularly favoured in churches in the German Rhineland.

In northern England a new solution was devised at Durham cathedral: the rib vault. A rib vault is criss-crossed by diagonal load-bearing arches or ribs, and it was to become a central feature of Gothic architecture. Begun in 1093, with its nave vault completed by 1133, Durham cathedral was not only a symbol of the corporate identity of the church, but a proclamation in stone of the power of the new Norman rulers of England, following the Norman conquest of 1066. Its nave consists of three main double bays with compound piers, alternating with giant, cylin-

32. The dome of the Old Cathedral, Salamanca, c. 1200.

The design of the ribbed vault of the dome, with two tiers of windows, recalls Moorish architecture.

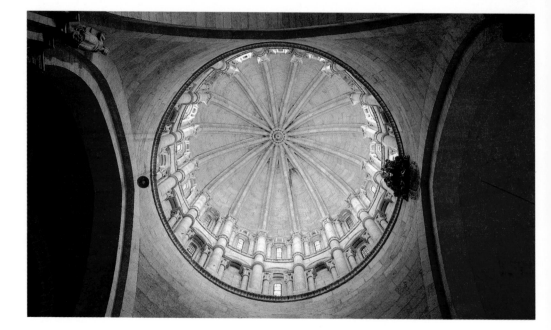

Stone, Mosaic, Enamel, and Glass: Developing Forms of Romanesque Art

drical columns (see FIG. 29, page 44). These have something of the appearance of huge tree trunks, and are incised with chevron ornament, diaper patterns, and spiral fluting. Under the roof of the gallery are concealed quadrant vaults in the form of half-arches, which support the thrust of the masonry of the main vault and in both function and appearance foreshadow the Gothic flying buttress.

An alternative solution was to cap the span of a church with one or more domes supported by pendentives (a concave, curved, three-sided section of stonework). There is an entire group of churches vaulted in this manner, under either Islamic or Byzantine inspiration, in south west France. The nave of the abbey at Fontevrault in the Loire region (see FIG. 100, page 133) is an example. There are also spectacular examples of churches with domes raised on circular drums in northern Spain at Zamora and Salamanca (FIG. 32)

But this building program does not in itself explain the re-emergence of architectural sculpture. One factor in understanding this is a change in attitude towards the stone sculpture of antiquity, which then survived in far greater quantities than it does today. In the early Middle Ages antique sculptures – particularly if they were freestanding and represented pagan gods – had been regarded suspiciously, as having mysterious and supernatural properties. They were even sometimes still worshiped as cult objects. But by the twelfth century, antique statuary began to be appreciated for its aesthetic qualities. Symptomatic of this change in attitude is Henry of Blois's acquisition in Rome of antique statues, which he brought back to England to grace his palace at Winchester.

Architectural sculpture was furthermore pressed into service by the church as a medium of mass-communication with which to address an ever increasing, but largely illiterate public. In the early and middle years of the eleventh century there were tentative but sustained experiments in the use of architectural sculpture in churches in Burgundy and the Loire valley, but these were confined to the capitals surmounting columns. It was in these unprepossessing and neglected areas of stone that Romanesque sculptors were to show some of their greatest inventiveness.

By the end of the eleventh century the use of architectural sculpture had become widespread, particularly in northern Spain, southwest France, and northern Italy. It was no longer confined to capitals, but extended to entire figurative groups, such as the ensemble of marble reliefs of Christ in Majesty,

33. BERNARDUS GELDUINUS
Christ in Majesty, marble
relief from the church of St.
Sernin, Toulouse, c. 1096.

The relief is probably by the
same sculptor as a table altar
in the sanctuary of the
church. This is signed
"Bernardus Gelduinus."

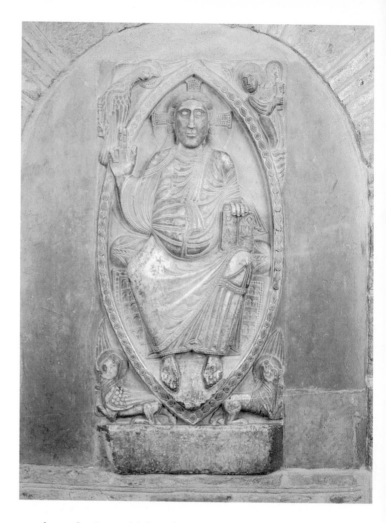

angels, and saints which today are set into the external wall of
the ambulatory of the important pilgrimage church of St. Sernin
at Toulouse (FIG. 33). It has been argued that these would origi-
nally have formed part of the decorative program of the shrine
dedicated to St. Sernin in the church crypt. Their style recalls
the late antique sculpture of Roman Gaul, but there is a greater
tendency towards abstraction and distortion, characteristic of the
Romanesque.

Romanesque sculptors frequently borrowed from the legacy
provided by antique sculpture. One of the most characteristic
antique devices they adopted was the horizontal frieze with nar-
rative scenes arranged from left to right. An important and early
example of its use is Wiligelmo's frieze on the facade of Modena
Cathedral (FIG. 34). This would originally have been much
lower than its present location, and arranged on either side of

the entrance portal. The frieze has as its main theme events from the Book of Genesis, including the creation of Adam and Eve, their expulsion from the Garden of Eden, their subsequent labor on earth, Cain and Abel's sacrifice, the murder of Abel, and, unusually, the death of Cain. The frieze culminates in Noah's salvation from the flood, with the last scene representing Noah and his three sons leaving the ark. The solid, squat figures exhibit human emotions and reactions – for instance, Adam's look of recognition when he bites the apple in the Expulsion scene, or the look of trepidation on the face of one of Noah's sons as he leaves the ark. This sense of the dramatic moment and the use of gesture strongly suggest the influence of the liturgical drama of the period. Indeed it has been argued that the frieze relates specifically to a contemporary liturgical drama known as *The Play of Adam*.

Another antique device adopted by Romanesque sculptors was the triumphal arch, already seen at St. Gilles-du-Gard. The associations of imperial power and victory attached to this architectural form are grafted on to a Christian theme. An important example of its use is the imposing entrance portal added in the

34. View of the west facade and Wiligelmo's frieze at Modena cathedral, early twelfth century.

The great rose window and the lateral doorways were added at the beginning of the thirteenth century.

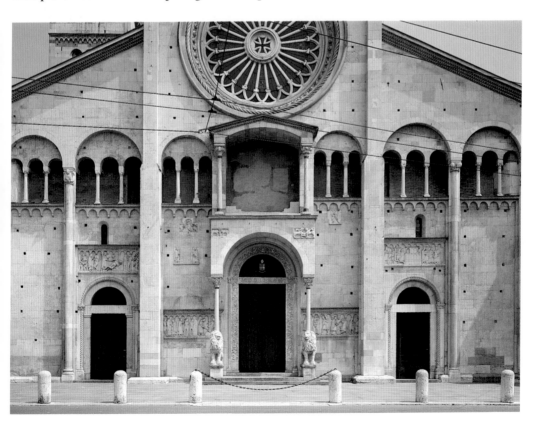

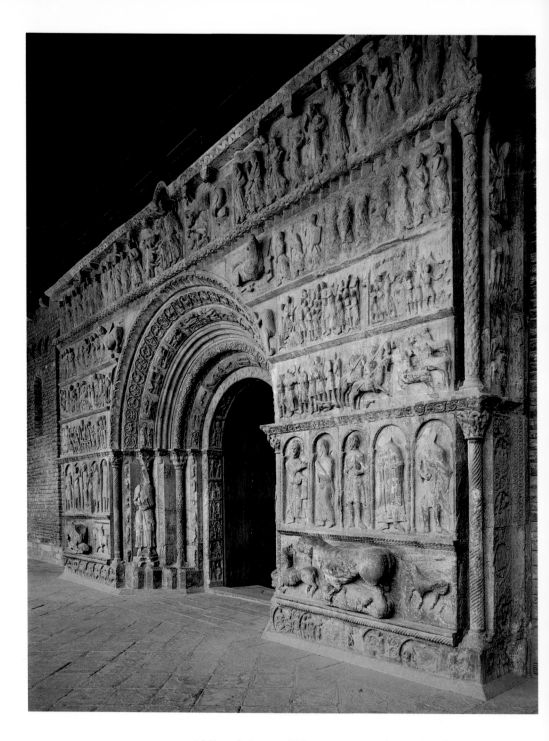

middle of the twelfth century to the early eleventh-century
church of the famous abbey of Santa Maria de Ripoll in the
foothills of the eastern Pyrenees (FIG. 35). The church became, at

about this time, the burial place of the Counts of Barcelona, rulers of Catalonia. A series of arch-shaped mouldings radiate out from the central portal in the splays of which the figures of St. Peter and St. Paul stand guard. The portal is surmounted by a long, narrow frieze, at the center of which Christ is seated, blessing and holding a book. He forms the apex of the composition and is surrounded by a heavenly entourage of angels, the evangelist symbols, and the twenty-four elders of the Apocalypse. Below this, on either side of the portal, are tier after tier of carvings, largely of Old Testament scenes. They include a number of episodes relating to kingship and war, such as David surrounded by his musicians and Joshua's battle against Amalek. These have been interpreted as referring to the *reconquista*, the military campaign waged against the Muslims in Spain.

In addition to modifying antique forms, Romanesque sculptors invented new forms of representation of their own. Their use of capitals as a field for decorative and figurative illustration is a prime example. Decorated capitals are most often found in the crypts of churches, high above the sanctuary, along the nave, and, most importantly, in the cloister.

There is an interesting series of decorated capitals in the extensive crypt built underneath Canterbury Cathedral at the end of the eleventh century. They are a variant of a type known as cubic, first developed in Germany at the beginning of the eleventh century and characteristic of German architecture, which provided four smooth surfaces to be used for relief carving. They were executed by a group of stonemasons, the most proficient of whom has been named the "Gabriel Chapel Master." His subjects include the amusing conceit of animals playing musical instruments (see FIG. 28).

A more ambitious type of capital, and another innovation of Romanesque sculpture, is known as historiated; that is, it contains one or more narrative illustrations. The subjects are usually Biblical, but episodes from the lives of saints also form an important theme. A consummate example of an historiated capital, from the former cloister of the cathedral of St. Etienne in Toulouse, has been ascribed to a sculptor called Gilabertus. It shows the previously rare subject of the beheading of St. John the Baptist. St. Etienne was served by a group of canons regular, an order created at the end of the eleventh century as a product of the papal reforms. They lived under a monastic discipline

35. West portal of Santa Maria, Ripoll, c. 1150-1160.

In the jambs of the doorway are panels with the occupations of the months.

36. Salome receiving the head of St. John the Baptist and presenting it to Herodias at a banquet. Capital from the former cloister of the cathedral of St. Etienne, c. 1125. Musée des Augustins, Toulouse.

Relief from the cloister of Gerona cathedral, last quarter of the twelfth century. Detail showing stages in the carving of a capital.

but were free to fulfil their obligations as priests in society. The capital contains four scenes in a narrative: on the left Salome dances before Herod, who caresses her chin – traditionally a lustful gesture; on the opposite face St. John the Baptist is beheaded; on the front face St. John's head is handed to Salome on a platter (FIG. 36). She in turn presents the head to Herodias, and also presents herself alluringly to Herod – her long hair being a traditional symbol of female seductiveness. The story clearly has a moral aspect and warns against the temptations of the flesh – temptations that might have afflicted the canons regular, catering to the needs of a lay community.

The sculpted tympanum is another important innovation of Romanesque sculpture. It began to be used extensively for figurative sculpture in the first quarter of the twelfth century, particularly in France and northern Spain. Important examples from this period survive at the Church of St. Sernin at Toulouse and the Church of San Isidoro in León in northern Spain.

By far the most frequent subject of the tympanum is that of the theophany – the vision of the Divine – usually in the form of Christ in Majesty enclosed in a mandorla, normally carried by two angels and encircled by symbols of the four evangelists. Gilbert Crispin, Abbot of Westminster from 1085 to 1117, in his *Dialogue between a Jew and a Christian* (which may have been based on an actual event), causes the Jew to comment that "sometimes, moreover, you depict God sitting on a lofty throne blessing with an outstretched hand, and around him, as it were a sign of great dignity, an eagle, a man, a bull-calf, and a lion." This had been the traditional decorative theme for the interior apse of a church, high above the sanctuary – the most sacred part of the building – but it also began to be used for the tympanum, above the main portal on the outside of a church. Its earliest use was in the tympanum of the church of Cluny III, only fragments of which survive. It also may be seen in countless smaller churches, such as that of Barfreston in Kent, England, or Besalu in Catalonia.

Another common theme was the Last Judgement, of which Gislebertus's tympanum at Autun Cathedral is an example (see FIG. 14). The scene has an immediacy to it and the figures a tactile quality – particularly that of one of the damned, in the lintel, whose head is being raised by a vice-like pair of hands. The vivid horror of the scene was originally accentuated by the

bright colours with which it was painted, as was customary for Romanesque architectural sculpture. Evidence of polychromy can still be seen in some surviving examples, such as the tympanum at Conques (see FIG. 51, page 74). The message of the scene at Autun is underlined by the caption above the lintel: "May this terror frighten those who are bound by worldly error. It will be true just as the horror of these images indicates." A fascination with the written word and script, whether Roman, Kufic, or Hebraic, is characteristic of Romanesque art and may be related to the logocentric nature of Christian religion and culture.

Imaginative variety is one of the key concepts in Romanesque aesthetics, but after the passing of almost a thousand years it can be difficult to gain an understanding of just how extraordinarily various the Romanesque imagination could be. Some idea of the power of this imagination can perhaps be gleaned from a monument that crosses the border of our normal expectations of medieval sculpture and comes closer to the performance and installation art of our own time: the monumental relief of Christ's descent from the cross carved into the rock face at the Externsteine near Horn in northern Germany (FIG. 37).

The Externsteine is a huge, rocky outdoor arena, thought originally to have been a pagan site, but later taken over by the Christian Church. At the beginning of the twelfth century Henry of Werl, Bishop of nearby Paderborn, decided to re-create there a number of the holy places in Jerusalem, which he had visited on a pilgrimage. Among these, hollowed out of rock, was a replica of the Holy Sepulchre, complete with altar and sarcophagus tomb, on the outside of which was carved the Deposition group. It would probably have formed the back-drop for an impressive Easter pageant.

The most unusual feature in the Externsteine Deposition is the bearded and haloed figure in profile to the upper left of the cross. He holds in his left hand a Resurrection banner and a small manikin – the traditional symbol of a risen soul – and with his right hand points to the scene below. This figure has been interpreted as the resurrected Christ, as inspired by the contemporary liturgical drama of the *Deposatio Crucis*. The theme of

37. *Descent from the Cross,* rock carving at Externsteine, Germany, c. 1115.

the Deposition is frequent in twelfth-century art, particularly in Germany, and is often found in isolation from the Crucifixion. Presented in this way it has been seen as the strongest possible refutation of one of the central heretical beliefs of the time – the denial of the reality of Christ's death.

Mosaic

After 250 years of virtual disuse, the technique of mosaic was revived in the West in the second half of the eleventh century at the great abbey of Monte Cassino in central Italy. Half a century later, it was also in use in Rome, in the churches of Santa Maria in Trastevere, and San Clemente. Mosaic is made up of tessarae, small cubes of coloured glass and stone, which in the Middle Ages were set irregularly in a prepared ground so as to catch and reflect the light. A theme common to mosaic, enamel, and glass of this period is a fascination with their interaction with light. Light had been invested with Christian symbolism since the writings of St. Augustine (AD 354-430), and was held to come from God.

This revival paralleled, and may perhaps be explained by, the papal reform movement associated with Pope Gregory VII. Mosaic was seen as a manifestation of what was regarded as the golden age of early Christianity, stretching from the age of Constantine in the early fourth century to the time of Gregory the Great at the end of the sixth. Major mosaic monuments in Rome and Ravenna survived from this early Christian period.

The late eleventh-century chronicler of the abbey of Monte Cassino, Leo of Ostia, records how Desiderius, abbot from 1058 to 1086, obtained Byzantine craftsmen from Constantinople to lay the mosaics in the abbey church. This had been newly rebuilt in the manner of an early Christian basilica, following the layout of Old St. Peter's in Rome. Leo notes that Desiderius instructed the Byzantine craftsmen to teach certain of the younger monks in the abbey their skills, so that the art of the mosaicist would not die out again in Italy. Nothing remains of the great mosaic scheme at Monte Cassino. However, fragments of mosaic at the nearby Cathedral of Salerno are thought to date from the same period, and to have been made by the apprentice monks referred to in Leo of Ostia's account. These apprentice monks, or their pupils, may also have been responsible for the mosaic schemes created in Rome in the first half of the twelfth century, the most important of which are in the churches of Santa Maria in Trastevere and San Clemente.

Santa Maria in Trastevere was completely rebuilt by Pope Innocent II between 1140 and 1143 in the style of an early Christian basilica. The compositional scheme of the mosaic program in the apse (FIG. 38) was based on that of the early Christian, sixth-century church of SS Cosma e Damiano in Rome. One novel feature is the presence in the scheme of the crowned Virgin Mary, who was traditionally identified with Ecclesia – the Church. She sits on the same throne as Christ, by whom she is embraced. This central group has been related to the Feast of the Assumption of the Virgin as it was celebrated in Rome during the Middle Ages. The liturgy for this service involved placing ancient and much-revered icons of the Virgin Mary and Christ side by side on a throne. It has also been suggested, convincingly, that the faces of the Virgin Mary and Christ in the mosaic are based on those of the actual icons used in the liturgical pageant. One of these, representing the Virgin Mary, still survives in the church of Santa Francesca Romana. It dates from the early seventh century, though in the twelfth century it was thought to have been painted by St. Luke.

The Venetian Doges and the Norman rulers of Sicily used mosaic with a very different ideological intent: they intended it to conjure up the sumptuousness of the imperial court at Con-

38. *The Triumph of the Virgin,* mosaic in the apse of Santa Maria in Trastevere, Rome, 1140-43.

39. Wall mosaic in the Chamber of King Roger at the royal palace, Palermo, 1154-66.

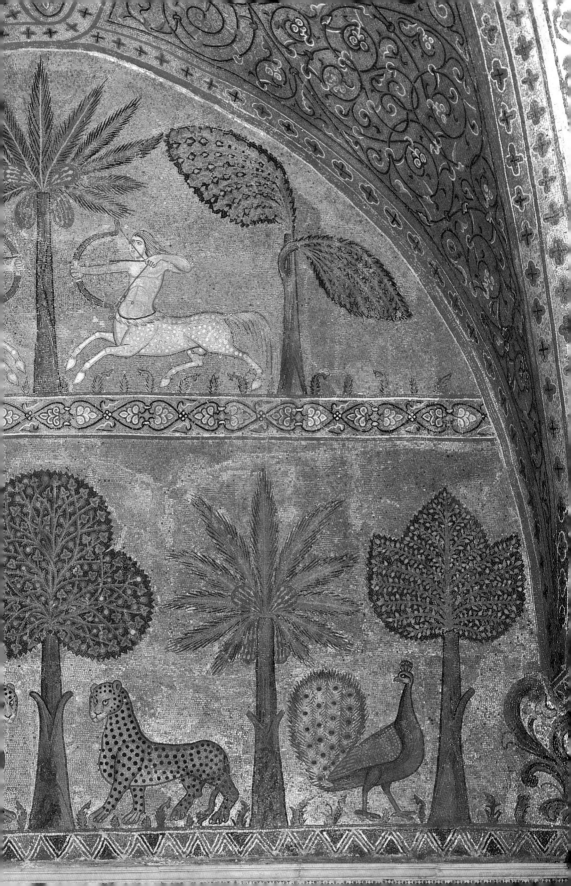

stantinople. The Basilica of San Marco in Venice, begun in 1063, was decorated between about 1070 and the late thirteenth century by Byzantine craftsmen, who gave it one of the most extensive mosaic programs still extant.

The twelfth-century Norman kings of Sicily – Roger II (1105-1154), William I (1154-1166), and William II (1166-1189) – also embarked on major architectural projects with mosaic as their chosen medium of decoration. Again they used Byzantine mosaicists, who largely followed an iconographic program of Western imagery. Among these projects the most important were the cathedral of Cefalù, the church of Santa Maria at Palermo (known as the Martorana), and, most ambitious of all, the huge cathedral complex at Monreale. The Norman kings also celebrated their wealth with the construction and decoration of palaces, such as that at Palermo. The palace at Palermo still contains part of its original mosaic scheme, in the so-called Chamber of King Roger (though in fact it is thought to date from the reign of William I). The scheme consists of hunting scenes and pairs of animals, set against a gold background interspersed with exotic trees (FIG. 39). It may have been inspired by the garden and hunting scenes of antique mosaics and paintings, but in design it reflects the influence of contemporary Islamic art. The mosaics of Norman Sicily had an enormous influence on northern European artists, particularly in Germany and England, as is shown by the illustrations to the Winchester Bible.

Romanesque wall mosaics survive only in regions of Italy. In the rest of Europe, wall-paintings provided a far cheaper form of interior decoration (FIG. 41). However, examples of figurative pavement mosaics do survive in other parts of Europe, notably in Spain, France, and Germany. In his *Apologia*, St. Bernard commented disapprovingly on their use. His primary objection was the sacrilege involved in walking on images of sacred figures: "People often spit on angels' faces, and their tramping feet pummel the features of the saints." The repertoire of images found in these pavement mosaics is restricted to saints and Old Testament figures; images of Christ and the Virgin Mary never occur.

One of the most extensive floor mosaics surviving from this period is in the cathedral

40. Floor mosaic of the occupations of the months from Otranto cathedral, 1163-65.

The inscription records the name of the designer, a priest called Pantaleon, and the name of the patron, Archbishop Gionato of Otranto.

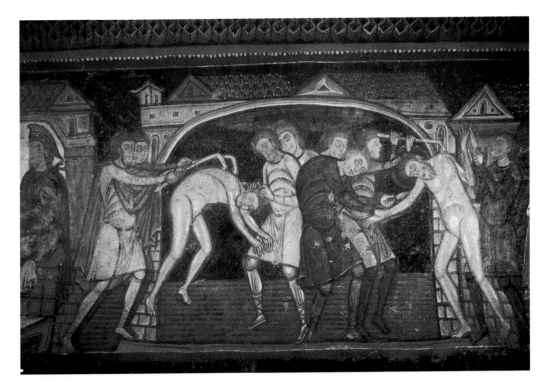

of Otranto in southern Italy, which in the twelfth century fell under the purview of the Norman rulers of Sicily (FIG. 40). This mosaic program includes scenes from the Old Testament, such as the Tower of Babel, the Tree of Life, and Noah's Ark. These are combined with secular themes, including scenes from the lives of Alexander the Great and King Arthur, and with one of the most common themes of floor mosaics, the calendar of the agrarian year. The complex narrative structure of the Otranto mosaic, together with its numerous inscriptions, has led to its being compared to one of the best-known artifacts of the Romanesque period, the Bayeux Tapestry.

Champlevé Enamel

The technique of champlevé enamel goes back to antiquity, but between about 1140 and the end of the twelfth century it was developed to a degree unprecedented in its history. As has been said, champlevé enamel is produced by setting powdered glass into grooves hollowed out of a thick metal plate, usually made of a copper alloy. This is then heated to a very high temperature, so that the powder fuses with the metal. In cloisonné enamel, the other principal enamel technique employed in the early

41. SS. Savinus and Cyprian are tortured, detail of the wall-paintings in the crypt of St. Savin-sur-Gartempe, c. 1100.

The church of St. Savin-sur-Gartempe, some thirty miles east of Poitiers, contains the most extensive cycle of Romanesque wall-paintings in France. Those in the crypt represent scenes from the lives of the two patron saints of the church, SS. Savinus and Cyprian. They were believed to be two fifth-century Christian converts who lived in northern Italy. Persecuted for their faith they fled to a location on the Gartempe river in France, where they were put to death. Their relics were discovered in the ninth century and are preserved in the crypt of the church.

Middle Ages, the design is formed by narrow gold strips, called *cloisons*, which are soldered together to form compartments into which the enamel is set. One reason for the widespread adoption of the champlevé technique in the twelfth century was the acute shortage of gold in the West.

There are differences between the champlevé enamel made in northern Europe, primarily in the Mosan region, Cologne, Lower Saxony, and England, and that made in northern Spain and southwest France. The latter is normally referred to by the generic term "Limoges enamel," after the town of Limoges in central France, where early documents refer to its having been made; modern scholarship, however, has demonstrated that Limoges was not the only center of production.

Northern enamels generally have a balanced and diagrammatic appearance; they draw upon the imperial tradition of late tenth- and eleventh-century German art linked with the court patronage of the Holy Roman Emperors. Typically, their imagery is recondite: for example, the representation of the virtues of faith or charity as female figures. Another important theme was the intellectual game of typology, in which events in the Old Testament were interpreted as prefiguring events in the New Testament: the sacrifice of Isaac by Abraham, for example, is an Old Testament type of the Crucifixion. Typology is designed to prove that the New Testament is a fulfilment of the Old.

42. Thomas à Becket *chasse*, c. 1190. Detail showing metalworking techniques.

By contrast, Limoges enamels have a very different aesthetic background: their design is bolder, reflecting the influence of Islamic art, frequently incorporating a pseudo-Kufic script as decoration. Backgrounds are usually decorated with a dense, intertwined pattern called *vermiculé* work, or with small geometric patterns. Heads or even entire figures are often raised above the surface of the enamel (FIG. 42). The colors of the enamels are anti-naturalistic, and are applied in flat areas (FIG. 43). The imagery is less abstract, but sacred subjects are characterised by an intense piety. Limoges enamels were produced in far greater quantities than northern enamels, in response to the market provided by the pilgrimage route through southwest France and northern Spain to Santiago de Compostela. This is a rare instance in the Romanesque period of art being produced not in response to a commission from a patron, but in answer to market demand.

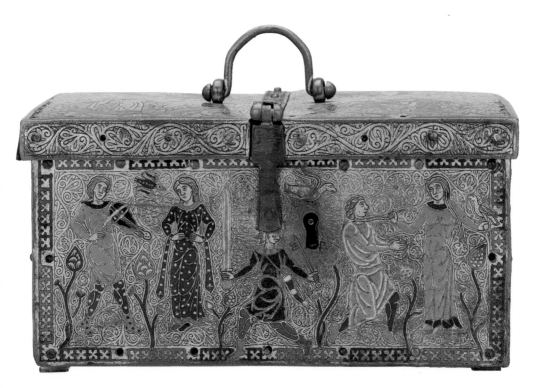

Almost all surviving northern enamels were produced for use in objects connected with church liturgy. Of all these objects, the most prized was the reliquary. Its ornamentation was the object of the greatest attention and often gave scope for stupendous exercises in the use of champlevé enamel. The Stavelot Triptych reliquary (FIG. 44), now in the Pierpont Morgan Library in New York, was probably commissioned by Abbot Wibald (1130-1158) of the Benedictine abbey of Stavelot. It is the earliest western reliquary to be designed in the form of a triptych (a central panel with side wings which close over it) and was assembled in the Mosan region, probably in the 1150s, to house fragments of the True Cross. (The True Cross was believed to be the actual cross on which Christ was crucified; supposedly genuine fragments of it were among the most precious of medieval relics.) These fragments may well have been aquired by Abbot Wibald on one of his trips to Constantinople.

The center of the Stavelot Triptych consists of two late eleventh-century Byzantine panels enameled in the cloisonné technique with Crucifixion scenes. These house the fragments of the True Cross. In 1973 these panels were opened up for technical examination; the smaller one was shown to have hidden cavities in it, containing a nail and a small fragment of wood. An accompanying parchment inscription identified the fragment.

43. Casket with scenes of courtly love, c. 1180. Limoges champlevé enamel, 3⅝ x 8½ x 6⅜" (9 x 21 x 16.2 cm). British Museum, London.

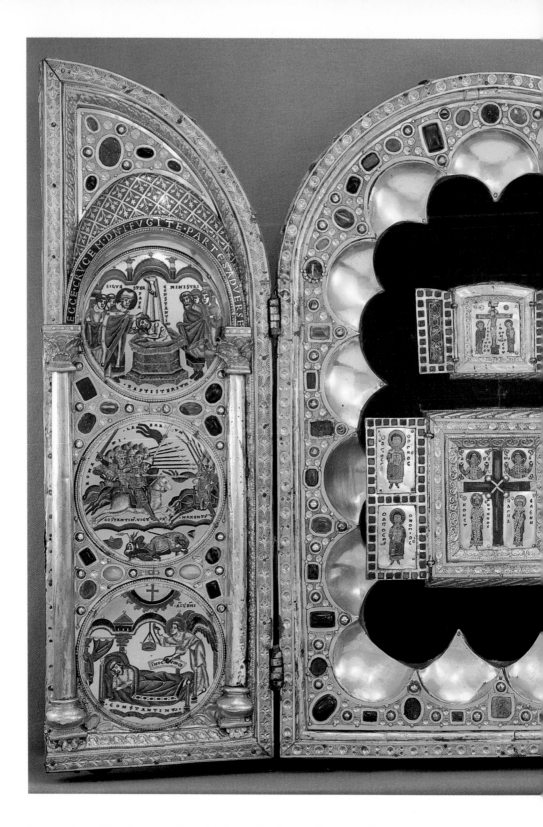

Stone, Mosaic, Enamel, and Glass: Developing Forms of Romanesque Art

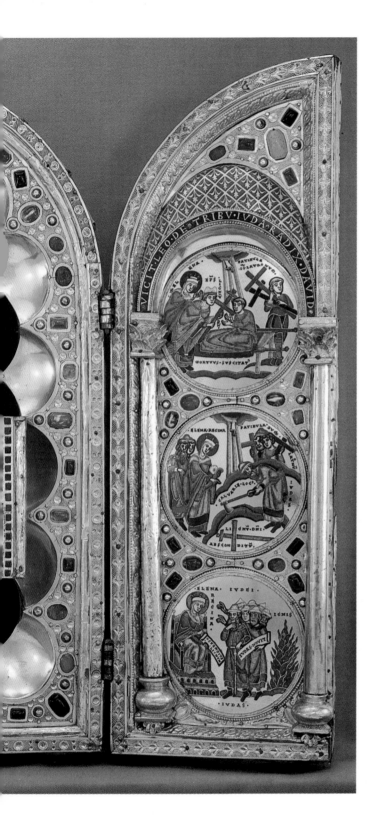

44. Stavelot Triptych, c. 1150. Mosan champlevé enamel with Byzantine cloisonné enameled Crucifixion panels at the center, height 19″ (48 cm). Pierpont Morgan Library, New York.

The left wing of the triptych shows scenes relating to Emperor Constantine's conversion to Christianity. It should be read from bottom to top: the vision of Constantine; the battle between Constantine and Maxentius; and the baptism of Constantine. The right wing contains scenes of the Empress Helena's search for the True Cross: Helena interrogates the Jews as to the whereabouts of the cross; Helena supervises the finding of the three crosses; the authenticity of the cross is tested and confirmed when a dead man is miraculously brought back to life.

45. *Hosea,* stained-glass window at Augsburg cathedral, c. 1100. 7'4" x 21" (2.2 x 0.5 m).

The champlevé enameled roundels on the wings of the triptych, representing scenes from the Legend of the True Cross, were the work of Mosan goldsmiths. Their technique is typical of Mosan champlevé enamels of the mid-twelfth century: the heads and hands are engraved, while the figures are picked out in colored enamels. These have delicate gradations or even contrasts in color, indicating areas of light and shade. The Mosan enamelist's consummate skill is evident in the way in which the flames of the fire in the bottom right-hand roundel appear to flicker – an effect achieved by the placing of a crumpled piece of foil behind the translucent enameling.

Stained glass

Very little stained glass survives from before the twelfth century. Its earlier use is recorded in documentary sources, and fragments of seventh-century colored, though not painted, glass have been excavated at Monkwearmouth in Northumbria in England. But on the basis of what survives, stained glass does not appear to have been extensively developed for illustrative and narrative purposes until the Romanesque period.

Theophilus devotes an entire book of his treatise to stained glass. He comments that "the human eye ... marvels at the inestimable beauty of the glass and the infinitely rich and various workmanship." The intense, jewel-like colors were obtained by adding metallic oxides, such as cobalt, copper, and manganese, to the molten glass. Though Theophilus describes how colored glass is manufactured, most glass would have been bought ready-made by the glass-painters. The pieces of colored glass were cut to the required shape, following a design prepared on a whitewashed board. (One such board, dating from the fourteenth century, was recently discovered complete with designs for a window in Gerona cathedral in Catalonia.) Once the glass had been cut, it was painted with a mixture usually consisting of iron or copper oxide and a binding agent. In order to fix the painted design onto the surface, the glass had then to be fired in a kiln. Finally, the fired pieces of glass were assembled on the board and joined together by strips of lead. Leading also helped to emphasise the structure of the design.

The earliest stained glass painted with entire figures, from the cathedral of Augsburg in southern Germany (FIG. 45), is usually dated to the turn of the twelfth century. Its three almost life-size figures of the prophets Hosea, Daniel, and Jonah – all that survive from an original set of twenty-two – have an hier-

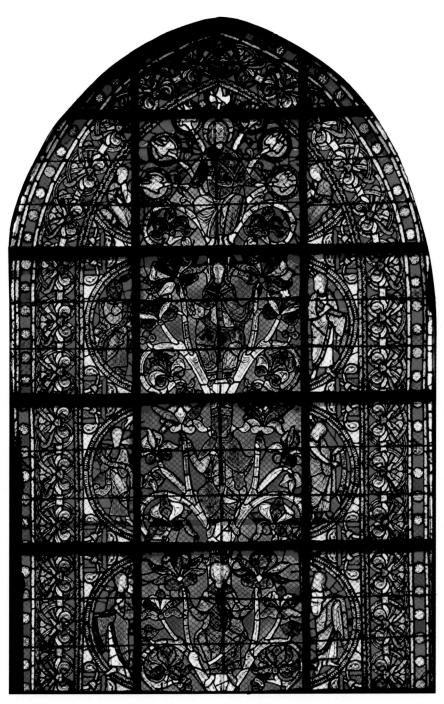

46. *Tree of Jesse,* stained-glass window at St. Denis, Paris, c. 1145.

The imagery of the Tree of Jesse was based on a prophecy of Isaiah: "And there shall come forth a rod out of the stem of Jesse." It used to be thought that it was first devised by Abbot Suger of St. Denis, but earlier examples have been found.

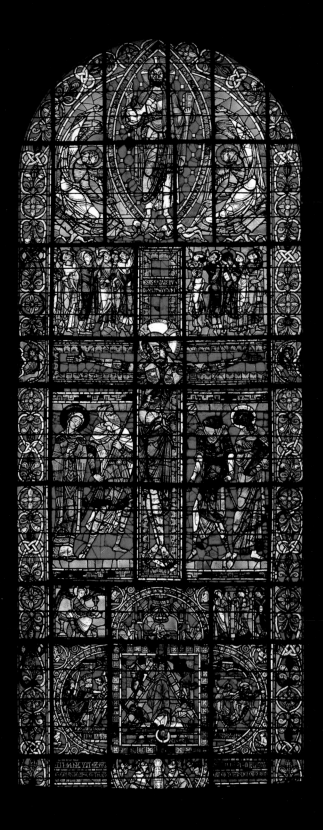

atic, geometric appearance, with a dominant green-red contrast, and they wear the distinctive pointed hats of medieval Jews.

Theophilus singles out France as pre-eminent in the technique of glass-painting. However, the earliest stained glass to survive from the Ile-de-France comes from Abbot Suger's redecoration of the east end of the Abbey of St. Denis. Its windows were constructed between 1140 and 1144, and thus postdate Theophilus's treatise by almost twenty years. Abbot Suger describes how the stained-glass windows caused the entire church to be bathed in a "wonderful and uninterrupted light." The windows consist of a series of medallions and half-medallions, with deep blue backgrounds (Suger refers to the sapphire glass); the foreground is occupied by crowded figurative scenes (FIG. 46). This format is similar to that of contemporary enamelwork from the Mosan region. The experiments of Abbot Suger's architect at St. Denis entailed opening up the wall surface with tall windows; in doing this the architect anticipated developments in Gothic architecture in which the wall surface was transformed by numerous large windows into a diaphanous membrane. This architectural development was to be crucial for the widespread adoption of stained glass in church interiors for illustrative purposes.

Western France was another important centre for the early use of stained glass. The supreme achievement of Romanesque stained glass in this region is the triumphant Crucifixion window at Poitiers Cathedral (FIG. 47). This huge window, over 31 feet (9 m) high, was commissioned between 1165 and 1170 by the Plantagenet King Henry II of England and his queen, Eleanor of Aquitaine. Above the Crucifixion group is the ascending figure of Christ, and below it the figure of St. Peter, the patron saint of the cathedral. Peter is shown, according to tradition, being crucified upside down. The dominant color contrast is between the red of the Crucifixion, recalling Christ's sacrifice, and the blue of the window's border. This contrast is taken up in the background to the scene and in the figure of Christ, who has blue hair and wears a purple tunic – the color traditionally reserved for emperors in antiquity. Though the figures, with their high waists, are distorted in appearance, they have a monumentality reflecting the influence of Byzantine art, and thus foreshadow the Transitional style.

47. *The Crucifixion,* stained-glass window at Poitiers cathedral, c. 1165-70. 31'4" x 11'6" (9.5 x 3.5 m).

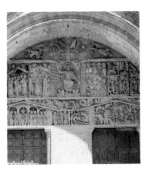

Romanesque Art and Society

48. *Tree of Jesse*, wooden ceiling of St. Michael's, Hildesheim, early thirteenth century. Length 91' (27.6 m), width 29' (8.8 m).

This is a rare survival of a Romanesque painted wooden ceiling, which we know from written sources were very common. The early twelfth-century choir at Canterbury cathedral, for example, destroyed in the fire of 1174, is recorded as having a wooden "ceiling decorated with outstanding painting." The wooden ceiling at St. Michael's was painted *in situ* after the roof had been constructed. The date of the ceiling used to be linked with the canonisation of the founder of the church, St. Bernard of Hildesheim, in 1192, but it is now thought to date from the early thirteenth century. The central panels depict Christ's earthly genealogy, from Adam and Eve, through Jesse and four kings, to Mary and Christ himself.

Around the year 1000, a new concept of the structure of society arose in Romanesque Europe. This distinguished three separate classes: priests, warriors, and peasants. This tripartite conception of society replaced an earlier view that had been based on a binary opposition between the clergy and the laity. The three classes were differentiated by their characteristic activities: prayer, fighting, and work, with each class being perceived as dependent on the other two.

A graphic illustration of the three fundamental classes of medieval society is found at the end of an early twelfth-century English chronicle written by two monks, Florence and John of Worcester. Its subject is a dream of King Henry I of England, in which he visualised separate groups of peasants, knights, and churchmen visiting him and complaining about excessive taxation (FIG. 49). The image is divided into three compartments, in each of which is the seated narrator Grimbald, King Henry I's physician, from whom John of Worcester learned about the dream. Each of the groups of figures is characterised by their dress and appearance and by the objects they carry: the peasants with their large heads and caricatured faces carry agricultural tools – a scythe, a hoe and a spade; the knights carry weapons, and their irascible appearance is accentuated by a bright red background; while the churchmen hold croziers.

This new view of society was formulated by the church, and reflected its interests. It represents a clear oversimplification, and excludes important sectors of the population, most notably women. That this model did not take into account the diversity

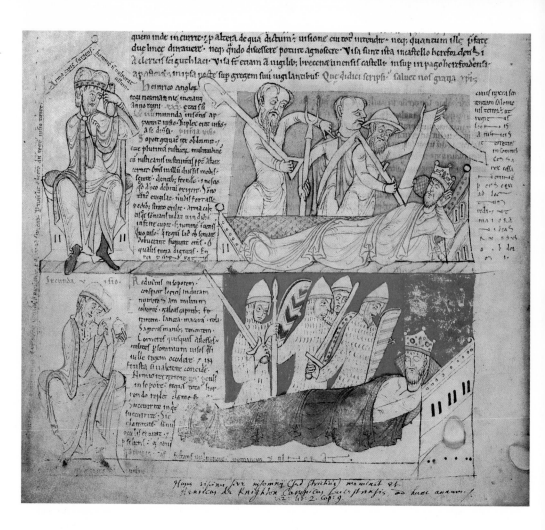

49. The dream of Henry I (peasants and knights complaining of excessive taxes) from the Chronicle of Florence and John of Worcester, c. 1130. Colored ink drawing with painted background, 13 x 9½" (32.5 x 23.7 cm). Corpus Christi College, Oxford.

of social and economic activity in medieval society was acknowledged by twelfth-century commentators. John of Salisbury, in his treatise on government, the *Policraticus*, observed that "all these different occupations are so numerous that the commonwealth in the number of its feet exceeds not only the eight-footed crab but even the centipede."

By the end of the twelfth century, with the growth of towns and their increasing importance as trade and economic centers, the tripartite division was beginning to break down. This development was most marked in Tuscany, Lombardy, and Flanders, and was regarded with a certain degree of apprehension by churchmen, who associated towns with the sins of greed and lust. These became a common theme of contemporary pictorial programs; for example, on the left wall of the porch of the abbey church at Moissac the sins of greed and lust are repre-

sented as human figures being punished (FIG. 50). Above, in a pointed comparison, is the parable of the rich man, Dives, gorging himself with food, and the poor man, Lazarus, whose sores are being licked by dogs. Dives and Lazarus are then shown in the afterlife, where Dives languishes in Hell, while Lazarus rests on Abraham's bosom.

The peasants formed the vast majority of the population. They were subject to the clerical and warrior classes, and bound to provide for them by their labor. In turn, the warrior class was theoretically subject to the church, and meant to function as its protector. However, the relationship between the church and

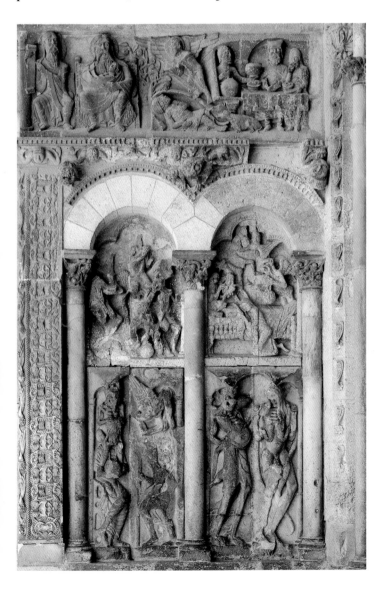

50. View of the left side of the porch at Moissac, c. 1130.

The realistic style of the sculpture on the side walls of the porch (note, for instance, the sores on Lazarus's body) is in contrast to the more hieratic, sublime style of the tympanum. This can be explained by the difference in subject. The relief shows (from right to left): Dives feasting, dogs licking Lazarus's sores while an angel receives his soul, and Lazarus in Abraham's bosom. The lower relief shows the death of Dives and a damnation scene. Below this there are personifications of lust and greed (these are badly eroded).

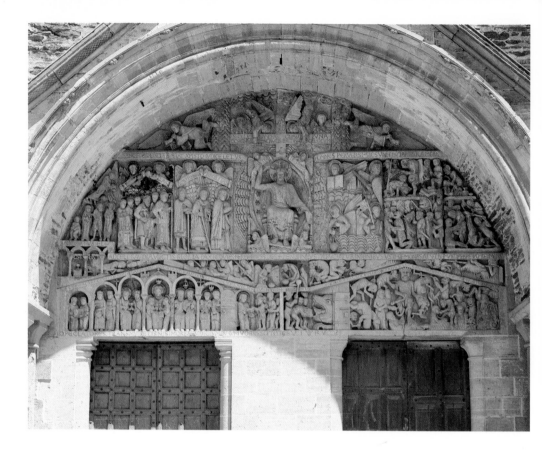

the military aristocracy was an uneasy one, and there are fre-
quent instances of monastic communities being attacked or
intimidated.

A mirror of the fears which the clergy had for lay society and
its temptations is often found in representations of Hell in Last
Judgement scenes of the period, in which miscreants are singled
out and linked to the seven deadly sins. This can be seen partic-
ularly clearly in the vision of Hell depicted in the tympanum at
Conques (FIG. 51). There, pride is represented as a knight
unseated from his mount by a demon with a fork. Lust is repre-

sented as an adulterous woman, with her breasts exposed, tied by a noose to her lover. Greed is shown being hung from on high with a purse around his neck. Among the damned are those who by their actions threatened the smooth running of feudal society, including the poacher and the forger. The poacher is depicted being roasted on a spit by two demons, one of whom, ironically, has the head of a hare. The forger is shown with the tools of his trade, including an anvil and a currency hallmark; as his punishment, a demon is forcing him to swallow molten metal.

The center of feudal organisation was the castle. Castles transformed the landscape of Europe between the tenth century and the thirteenth. In England, this development was particularly marked after the Norman Conquest, when the Normans initiated an extensive program of castle building; the pre-eminent surviving example is William the Conqueror's own principal castle in London, the Tower of London, part of which (the White Tower) was under construction in 1077 and provided the model for a whole series of castles built in England (FIG. 52).

From the eighth century onwards, the practice of warfare was transformed by the increasing deployment of mounted knights. Phalanxes of them are represented in the Bayeux Tapestry, and they were the decisive factor in the Norman victory at Hastings in 1066.

The clerical and the warrior classes were often closely connected through family ties. This was true of Henry of Blois, while another example is Bishop Odo, the half-brother of William the Conqueror and the probable patron of the Bayeux Tapestry. (It was William who appointed Odo Bishop of Bayeux.) In one scene in the tapestry Odo is shown dressed as a soldier (contrary to any of the written sources and probably, therefore, an example of artistic licence), rallying the troops at

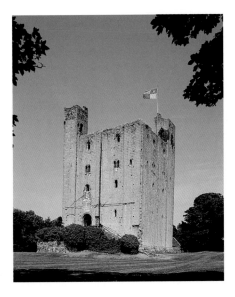

52. Hedingham castle in Essex, c. 1140.

The building is in the form of a great tower or *donjon* ("place of lordship"), characteristic of castle architecture in the late eleventh and twelfth centuries. It was built for Aubrey de Vere, who came from one of the most powerful Norman families.

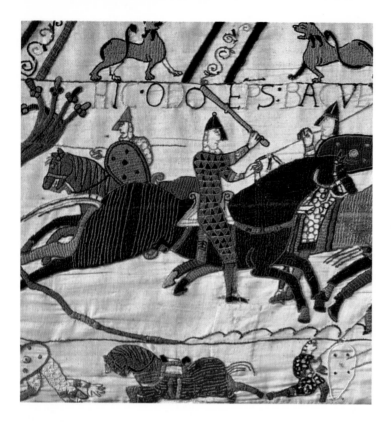

the Battle of Hastings (FIG. 53). After the Conquest, Odo was made Earl of Kent and thus became one of the most powerful landholders in England. He is also recorded as having had an illegitimate son. Odo was precisely the type of churchman that the papal reforms associated with Pope Gregory VII aimed to root out. Abbots of the traditional monasteries often functioned as feudal lords, with control over extensive lands and many people. In certain of the more lax monastic houses the monks even indulged in hunting, the principal recreation of the warrior classes and the aristocracy; the unreformed monks of Mont-Saint-Michel, for example, were accused of spending all their time in this activity.

The Role of the Church

Despite the closed nature of most monastic communities, they were intimately connected to, and influential upon, the other strata of Romanesque society. Monks were usually drawn from the aristocracy, and it was customary for them to enter one of the traditional Benedictine monasteries as children. The Cister-

Above left 53. Bishop Odo, from the Bayeux Tapestry, c. 1080. Wool embroidered on a linen background, 21″ x 226′ (53 cm x 69 m). Musée de la Tapisserie de la Reine Mathilde, Bayeux.

Bishop Odo rides a black charger and is identified by the inscription above him: *Hic Odo Eps.*

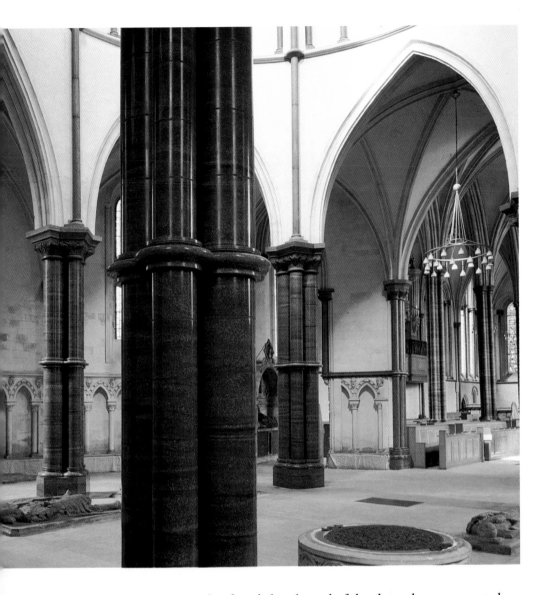

54. Interior of Temple Church, London, c. 1160.

The building is in the form of a rotunda, characteristic of Templar churches.

cian order, founded at the end of the eleventh century, rested on a wider social base, although its monks were still primarily from noble families. St. Bernard, for instance, the most prominent Cistercian of the twelfth century, came from a minor noble family who were vassals of the Duke of Burgundy. At the age of twenty-two (Cistercian monks usually entered the order as adults) he joined the monastery of Cîteaux, along with many other members of his family.

A curious hybrid of the warrior class and the church was the knight-priest. Of all the various religious-military orders that originated in the twelfth century, the most famous are the

Knights Templar. Their foundation in 1118 by Hugues de Payns was a direct consequence of the First Crusade and the capture of Jerusalem in 1099, and their original function was to protect pilgrims traveling to the Holy Land. In Jerusalem their headquarters was part of the palace of one of the Christian kings of Jerusalem, Baldwin II (d. 1131). The building adjoined the Dome of the Rock, then believed to be the Old Temple of Solomon, and from this the Knights Templar derived their name. They developed a distinctive church architecture with a centralised plan and a circular aisle, intended to imitate models found in Jerusalem – the Dome of the Rock and the Church of the Holy Sepulchre. Important surviving examples of twelfth-century churches of the Knights Templar include London's Temple Church (FIG. 54).

55. Tomb plaque of Geoffrey of Anjou, c. 1158. Limoges champlevé enamel, 25 x 13" (63 x 33 cm). Musée de Tessé, Le Mans.

The Warrior Class

The concept of the feudal knight had been given literary expression in the earliest epic poem to be written in the Anglo-Norman vernacular, *The Song of Roland (Le Chanson de Roland)*. Although it is thought to have been written down at the end of the eleventh century, it must have existed in an earlier oral form since a version of it is recorded as having been sung at the Battle of Hastings. The poem has as its setting Charlemagne's retreat from Spain in AD 778, when the rearguard of his army was ambushed and decimated by a Muslim force. The hero of the poem, a knight called Roland, is represented as a paradigm of feudal, knightly virtues: he shows complete allegiance to his lord, Charlemagne, and demonstrates great courage in the face of insurmountable odds. The poem's epic nature and narrative structure provide a literary analogy to the Bayeux Tapestry, with which it has frequently been compared.

The Emperor Charlemagne depicted in a twelfth-century stained-glass panel.

Geoffrey of Anjou (1114-1151) was Count of Maine and Anjou and father of the future King Henry II of England. His image on an enameled plaque shows him not as an individual, but in an emblematic and generalised way, as a representative of his class (FIG. 55). The plaque is over 2 feet (63 cm) high – unusually large for an enamel – and appears to have functioned as a funerary effigy for Geoffrey's tomb. Geoffrey has a sword in his right hand and holds a tall shield with his left. The shield extends to the height of his shoulders, and is emblazoned with one of the earliest representations of a coat of arms, consisting of four gilded lions standing on their hind legs against a blue background. The art of heraldry originated in the twelfth century as

a means of identifying combatants either in battle or in a tournament. It evolved into an elaborate form in which the genealogy and alliances by marriage of great families could be memorialised; and it was to become a conspicuous feature of Gothic art.

The most important example of propaganda art and political iconography to survive from this period is the Bayeux Tapestry. This exceptional visual representation of contemporary history depicts the warrior class engaged in the military activity that defined it. The tapestry consists of a thin strip of white linen, 226 feet (69 m) in length, embroidered in eight different colored wools. In its present state, it is incomplete. Stylistic characteristics and the English spelling and lettering of the Latin captions indicate that the tapestry was made in England, probably at Canterbury. (At the time England had a tradition of embroidery work, for which it was renowned.) The clarity of conception and the narrative flow of the tapestry indicate that it was designed by one person; its execution must, however, have been achieved by a team, most likely one made up of female embroiderers.

The Bayeux Tapestry is generally assumed to have been commissioned by Bishop Odo of Bayeux, as the prominent role and flattering portrayal it accords him are at variance with the historical chronicles. Its precise date is a matter of dispute; it must have been executed after 1066 and before 1097, when Odo died, but in general commentators favour a date before 1082, when the disgraced Odo was imprisoned by William the Conqueror.

It is first recorded as being in Bayeux Cathedral in 1476, where it was exhibited in the nave on certain feast days. This need not, however, have been the location for which it was made, and several scholars have argued that it originally adorned a secular setting, such as a banqueting hall. This would imply that it was intended for a courtly audience.

The tapestry represents the events leading up to the Norman invasion of England and culminates in the Battle of Hastings. In order to understand its contents it is necessary to know something of the historical situation. From 1042 to 1066 England had been ruled by the Anglo-Saxon king, Edward the Confessor, who died childless. There were three main claimants to the throne: Harold, Earl of Wessex; William, Duke of Normandy; and Harold Hardrada, King of Norway, whose ancestor, King Cnut, had ruled England from 1016 to 1035 as part of the then extensive Scandinavian empire. On his deathbed Edward the Confessor had designated Harold as his heir, and this decision was ratified by the ruling council of Anglo-Saxon nobles.

William maintained, however, that Edward had earlier promised him the throne and, according to Norman sources, Harold had been sent to Normandy by Edward in 1064 to reaffirm this promise. English sources confirm Harold's presence in Normandy at this date, but according to them, his motive was to recover members of his family who were being held hostage by William. Another explanation is that he arrived there

by pure accident: his ship, driven by unfavourable winds, was forced to land in northern France. Both English and Norman sources also record that Harold swore an oath of allegiance to William, but this may well have been under duress, in which case it would not have been binding.

At Edward the Confessor's death Harold became king. He soon faced invasions from both Harold Hardrada in the north and William in the south. He defeated Harold Hardrada in a decisive victory at Stamford Bridge near York on 25 September 1066, only to learn that William had landed unimpeded at Pevensey in Sussex three days later. Harold marched south with his army and was defeated by the Norman forces at Hastings.

The Bayeux Tapestry arranges these scenes in a continuous narrative, usually from left to right, though the order is reversed on two occasions, one of which is the death and funeral procession of Edward the Confessor. The scenes are punctuated by captions, which act as pointers to the action and usually begin with *hic*, meaning "this." The tapestry can thus be compared to a silent film with subtitles. Over half of it deals with events preceding the Battle of Hastings. It begins with Harold apparently being sent by Edward the Confessor on a sea journey, presumably to Normandy, though the destination is not specified (FIG. 56); unfavourable winds force him to land in the territory of the Count of Ponthieu, by whom he is taken prisoner. William then intervenes on his behalf and Harold becomes his guest, assists him in his campaign against Brittany, and swears an oath of allegiance to him on holy relics (FIG. 57). On his return to England after the death of Edward the Confessor, Harold is crowned

56. Initial scene with Edward the Confessor under a canopy as Duke Harold sets off for Bosham, from the Bayeux Tapestry, c. 1080. Wool embroidered on a linen background, 21" x 226' (53 cm x 69 m). Musée de la Tapisserie de la Reine Mathilde, Bayeux.

Overleaf 57. Harold swearing an oath to William on holy relics at Bayeux, from the Bayeux Tapestry, c. 1080. Wool embroidered on a linen background, 21" x 226' (53 cm x 69 m). Musée de la Tapisserie de la Reine Mathilde, Bayeux.

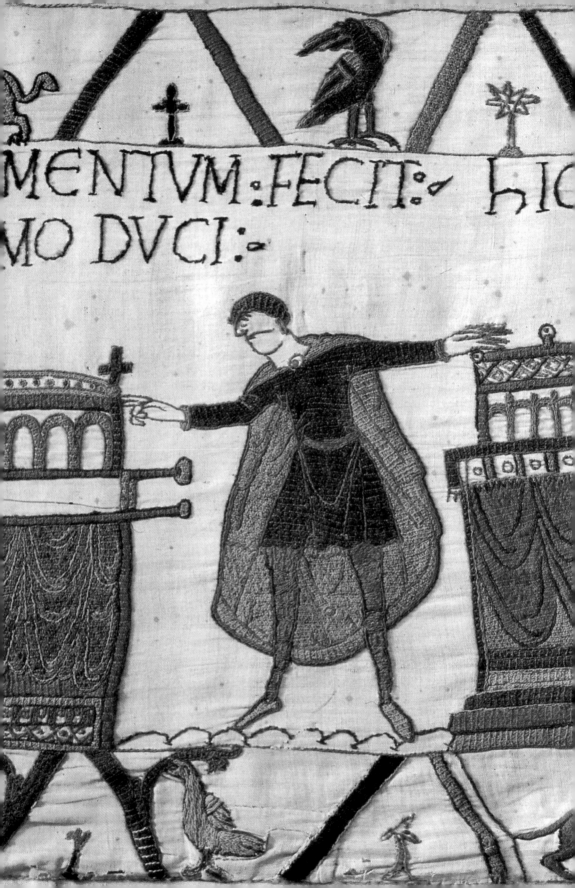

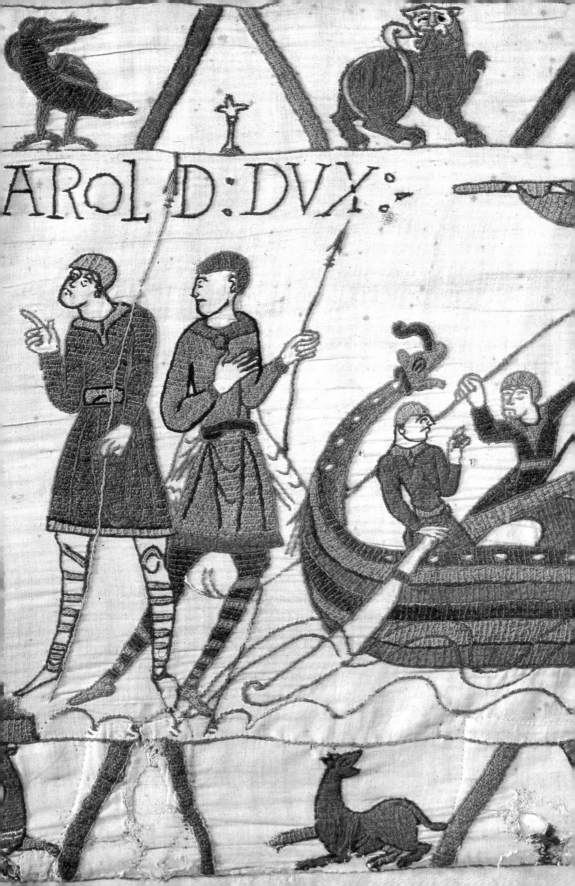

AROLD:DVX:

King of England. The second half of the tapestry depicts the preparations for the invasion and culminates in the battle itself.

Among the most engaging features of the tapestry are the genre scenes with their realistic details. These include the preparing and eating of meals; the felling of trees; the building of ships; the loading of ships with armour and casks of wine; the construction of a fortified camp; and the burning down of a house, with a woman and child left destitute. They belong to the tradition of English naturalistic painting of the first half of the eleventh century, other examples of which are found in a manuscript known as Aelfric's Pentateuch, made at the abbey of St. Augustine in Canterbury.

The events represented in the tapestry have an obvious Norman bias, and provide a vindication for the Norman invasion. They must be interpreted within the values of feudal society. Harold is represented not only as William's friend and ally, but also as his vassal. Harold, however, betrays his oath by usurping the English throne. Omens of the disastrous consequences to follow are provided by a comet (in fact, Halley's comet) in the border above Harold's throne and the shadowy outlines of ships beneath his feet.

There is a persuasive argument that the tapestry also contains subversive elements sympathetic to the English cause. For example, the first scene may represent Harold being despatched to Normandy by Edward the Confessor to confirm that William is Edward's favoured choice as heir, in accordance with Norman sources. However, it might equally represent the alternative English version of events, according to which Harold went to Normandy, against Edward's advice, in order to recover his relatives.

Narrow borders run above and below the main narrative. These borders do not function as an enclosing frame, as in Renaissance and later painting, but are frequently cut into by the main narrative. They contain figurative elements, some of which comment upon the main narrative. These figurative elements include animals, zodiacal signs, scenes from country life, animal fables (a very popular genre in the early Middle Ages), and erotic figures.

Some of these features are open to an ambiguous and subversive interpretation. For example, one of Aesop's animal fables, of the fox and the crow, occurs no fewer than three times in the border to the tapestry. It depicts a crow, perched on a high tree, with a piece of cheese in its beak. The fox, who wants the cheese, appeals to the crow's vanity by asking whether its voice

compares to its physical beauty; when the crow opens its beak to caw, the cheese falls to the ground and is promptly eaten by the fox. One interpretation identifies the fox with Harold, who obtained his goal – the throne of England – by deceit and guile. However, a pro-English interpretation would identify the crow with Harold, who was the obvious heir to the throne, and who, by going to Normandy in 1064, allowed himself to be ensnared by William's subterfuge. If this seems like overinterpretation, it should be remembered that such fables were originally devised by slaves as a means of criticising their masters, and that there was considerable resentment felt by the native population in England against the victorious Normans.

Another curious feature of the borders is the presence of various erotic figures. One example is found underneath the enigmatic scene of a woman whose name is given as Aelfgyva (FIG. 58). She is shown accompanied by an unknown cleric under a doorway with phallic-shaped columns. No convincing explanation has been provided for this scene. The pose and the gesture of the cleric, who caresses Aelfgyva's chin, are mimicked by a naked figure in the border, whose genitals are conspicuous. The scene may allude to a sexual scandal with which some of the earliest viewers of the tapestry would be acquainted. Women rarely occur in the tapestry, and when they do, are represented as passive victims. The picture presented in the Bayeux Tapestry is one of a predominantly masculine society.

58. Unidentified cleric and Aelfgyva, from the Bayeux Tapestry, c. 1080. Wool embroidered on a linen background, 21″ x 226′ (53 cm x 69 m). Musée de la Tapisserie de la Reine Mathilde, Bayeux.

The Imagery of Power: Roger II and Henry the Lion

Almost all rulers of this period used art to enhance their prestige and to make political statements: in this connection two of the most notable were King Roger II of Sicily and Henry the Lion, Duke of Saxony and Bavaria.

Roger II ruled over Sicily from 1112, when he came of age, to 1156. Calabria and Apulia in southern Italy also came under his control, and he reached the apogee of his power in 1130, when

The Palatine chapel was in the royal palace at Palermo. It served both as a private chapel for the Norman rulers of Sicily and as a public audience hall.

he became the first Norman king of Sicily. Roger was usually in dispute with the papacy, and was excommunicated by Innocent II in 1139. His political ambitions extended towards the Byzantine empire in the East, and in 1147 he seized Corfu.

Roger II presided over a cosmopolitan court, uniting influences from Byzantium, Islam, and the West. This cultural mix is embodied in the Palatine chapel (FIG. 59), his personal chapel in the palace at Palermo: its mosaics were made by Byzantine craftsmen; its elaborate wooden and painted stalactite ceiling by Muslims; and its imagery reflected the liturgical and political interests of the West. The chapel was built between 1132 and 1140, and its mosaic program was mostly designed, if not completed, during Roger's lifetime. The use of mosaic, a medium closely associated with the Byzantine empire, may in itself be a political gesture, in view of Roger's open rivalry with the Byzantine emperors. The Western imagery in the chapel is evident in the presence of St. Martin and St. Dionysius (in the twelfth century St. Dionysius was wrongly identified with St. Denis, the patron saint of the royal abbey of St. Denis, near Paris): both these saints were associated with the kingdom of France, with which Roger was closely allied.

Roger's political aspirations are nowhere more explicit than in his mosaic portrait in the church of the Martorana in Palermo (FIG. 60). It shows him dressed in the manner of a Byzantine emperor, being crowned by Christ himself, rather than by Christ's earthly representative, the pope. This was a traditional arrangement of Byzantine imagery. The mosaic not only indicates Roger's relationship with the papacy, as the Church is made subordinate to the state, but also underlines the Norman ruler's aspiration to conquer the Byzantine empire.

Henry the Lion (1129-1195), Duke of Saxony and Bavaria was, at the height of his achievements, the most powerful subject of the Holy Roman Emperor. He was described by the twelfth-century chronicler Helmold of Bosau in 1164 as "a prince of the princes of the earth." His success was largely dependent on his being the close ally of the Holy Roman Emperor, Frederick Barbarossa (d. 1190). He took part in Frederick's military campaigns in Italy and when, in 1174, Frederick again requested his assistance, Henry asked in return for the city of Goslar in Lower Saxony, with its rich mineral resources. The request was declined and Henry refused his support. In 1180 Frederick took his revenge by confiscating Henry's land and forcing him into exile in England, where he lived from 1182 to 1185 (Henry had close dynastic ties with the Plantagenet kings of England

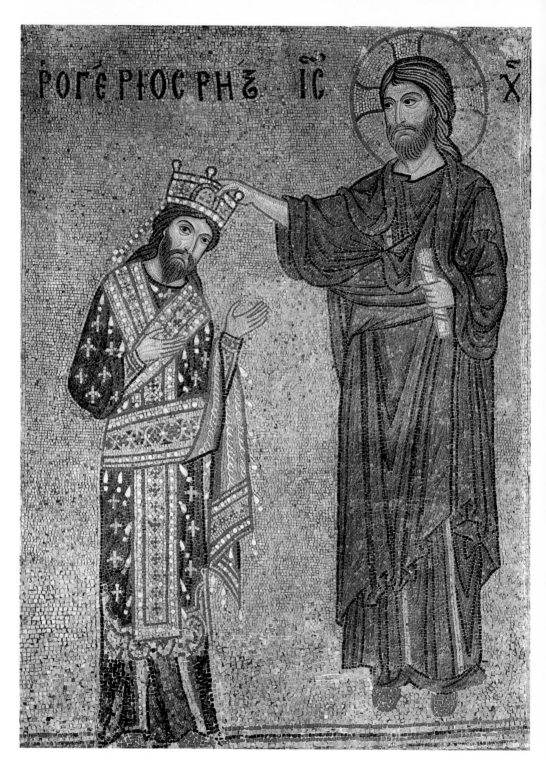

60. Christ crowning Roger II, mosaic, church of La Martorana, Palermo, 1143-48.

through his wife, Matilda, a daughter of Henry II). He returned to Saxony in 1185, when most of his lands were returned to him, and he died there ten years later.

Henry used art to underline his political aspirations to rule territories that would rival those of the Holy Roman Emperor. In his capital city of Brunswick in northern Germany he built an impressive castle called the Dankwarderode, and next to it a church dedicated to St. Blaise (later to be Brunswick cathedral). This housed the precious relics which he had brought back from Constantinople in 1173 on his return from a pilgrimage to the Holy Land. In front of these buildings Henry had erected in 1166 a monument larger than life-size of a lion – the heraldic symbol of his family (FIG.61). Cast in bronze, it is the earliest freestanding public monument to survive from the early Middle Ages. It has been suggested that it was inspired by the famous Etruscan bronze of a she-wolf which in the twelfth century was one of the monuments placed outside the papal residence of the Lateran Palace in Rome. The fame of that bronze can be judged by the fact that it was singled out by the English writer Master Gregory in his mid-twelfth-century travel guide entitled *Marvels of Rome*, where it was interpreted as the "Mother of the Romans," in accordance with the legend that a she-wolf had suckled Romulus and Remus, the founders of the city.

Henry also endowed churches and monasteries with lands and other gifts. Numerous pieces of goldsmiths' work are linked with his patronage. One of the finest of these is a reliquary made in Cologne, where the goldsmiths specialised in making reliquaries in the shape of miniature buildings (FIG. 62). It was designed in the form of a church surmounted by a drum-shaped dome, and may have been intended to recall the Dome of the Rock in Jerusalem. It is known to have once housed the skull of St. Gregory of Nazianzus, which was probably one of the relics Henry brought back from Constantinople.

61. Bronze lion monument to Henry the Lion, 1166.

The lion stands foursquare, with his mouth open in a roar. His eyes would originally have been inset with glass, thus accentuating his threatening appearance. For the period, this sculpture is a fairly convincing, naturalistic representation of a lion, and may be compared to that of the Arlanza wall-painting, which has a more stylised, anthropomorphic appearance (see FIG. 77, page 108).

Henry established the monastery of Helmarshausen as one
of the most important centers of book illumination in the sec-
ond half of the twelfth century. Its most important commission
was a sumptuously illuminated Gospelbook, containing texts of
the four gospels, which today bears his name. Its extensive use of
gold letters and purple-stained parchment – unusual for the
twelfth century – as well as specific aspects of its imagery hark
back to the great imperial Gospelbooks of the eleventh century,
such as the Gospels of Otto III.

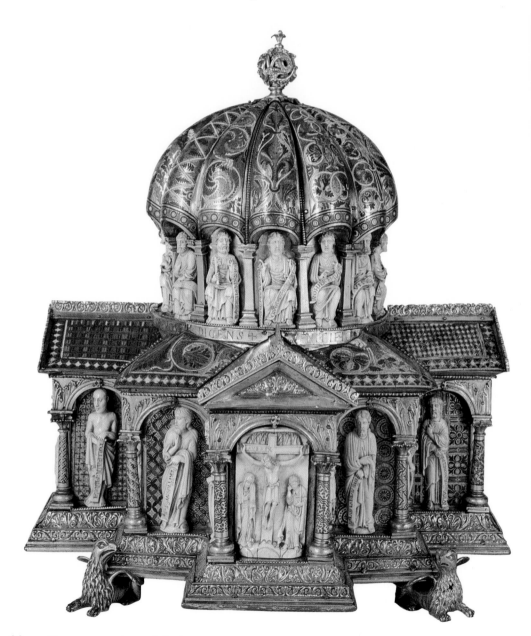

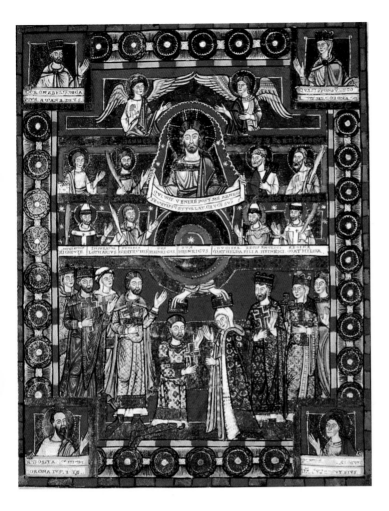

63. Coronation portrait from the Gospelbook of Henry the Lion, c. 1188. Illumination on parchment, 9 x 6" (23 x 15.5 cm). Herzog August Library, Wolfenbüttel, Germany.

It was once thought that the Gospelbook was produced before Henry's disgrace and exile, but recent research has demonstrated that it must have been completed no earlier than 1188, and that it was intended for public display on an altar dedicated to the Virgin Mary in the church of St. Blaise in Brunswick.

One of the images in the Gospelbook of Henry the Lion is a coronation portrait (FIG. 63). It shows Henry and Matilda being crowned by two hands emerging from the heavens, with the figure of Christ above. The ducal pair hold gold crosses, a symbol of their faith, and possibly a reference to a fragment of the True Cross also brought back from Constantinople by Henry. To either side of them are some of their most illustrious ancestors: these include Henry's parents, Henry the Proud and Gertrude, who was the daughter of Emperor Lothar III, who is also represented; along with Matilda's father, Henry II, and grandmother,

the Empress Matilda, who had been married to the Holy Roman Emperor Henry V. Above Henry and Matilda are the saints personally associated with them; for Matilda these include Thomas à Becket, who holds a palm, the symbol of his martyrdom. Becket, the Archbishop of Canterbury, had been canonised in 1173, only three years after his assassination (possibly committed on the orders of Matilda's father).

The image conflates the supernatural or divine, the here-and-now, and the past to make an ideological statement concerning Henry and Matilda's credentials to rule. The increased interest in genealogy evident in this image may be related to the development of heraldry. In art, this development may have given rise in the late eleventh and early twelfth centuries to a new religious image, known as the Tree of Jesse. As described in the Book of Isaiah, this used the image of a tree, springing from the old Testament figure of Jesse's loins, to trace Christ's lineage back to Jesse himself. The most impressive and monumental Tree of Jesse to survive from the Romanesque period is that on the wooden ceiling of the former abbey church of St. Michael in Hildesheim, Lower Saxony (FIG. 64).

64. *Tree of Jesse*, early thirteenth century. Detail of the figure of a king from the painted wooden ceiling of St. Michael's, Hildesheim.

Both Roger II and Henry the Lion are representatives of the new breed of parvenu ruler which emerged in the eleventh and twelfth centuries. Roger II was the grandson of Roger de Hauteville, a minor noble from the region of Coutances, and Henry the Lion's great-grandfather was a minor Italian noble-man, Azzo of Este, who had married into the ancient Welf dynasty. Roger and Henry both claimed to trace their ancestry back to Charlemagne through dynastic marriages, though these claims were tenuous at best.

It is a measure of the increasing status of warriors such as Roger II and Henry the Lion in Romanesque society that in 1166 Charlemagne was canonised at the instigation of Emperor Frederick Barbarossa. The figure of Charlemagne, mythologised in such secular epics as *The Song of Roland*, provided an important role model for such rulers. In this context it is particularly significant that in the Last Judgement scene at Conques (of which institution he was believed to have been a benefactor), the figure of Charlemagne is conspicuously present among the blessed.

The Peasant in Romanesque Art and Society

Attitudes among the dominant classes of society towards the peasants were ambivalent. On the one hand, it was recognised that they formed an essential component of society: in his late twelfth-century analogy between the human body and society, John of Salisbury likened them to the feet. On the other hand, they were regarded with fear and subjected to ridicule and denigration. How were they viewed in the art of the time?

Images of peasants are almost exclusively confined to depictions of the occupations of the months, calendar illustrations for each of the twelve months of the year. This genre originated in pagan antiquity, when each month was represented by a passive figure, accompanied by an identifying attribute. In a fourth-century Roman calendar, known to us only through later copies, the month of September, for instance, is represented as a heroic nude figure holding a bunch of grapes.

Depictions of the occupations of the months were transformed in the early Middle Ages in two important ways: first, they were transposed to a Christian context; and, second, the figures were shown in action, often with a degree of control over their environment. The latter development was anticipated

65. Tympanum from the former church of St. Ursin, Bourges, first half of the twelfth century.

Note the prominent signature of the sculptor at the mid-point of the tympanum. The tympanum itself is divided into three levels: the bottom level shows the occupations of the months; the middle level a hunting scene based on a Roman sarcophagus; and the upper level scenes from Aesop's *Fables* (the donkey-schoolmaster, the wolf and the stork, and the burial of Renard).

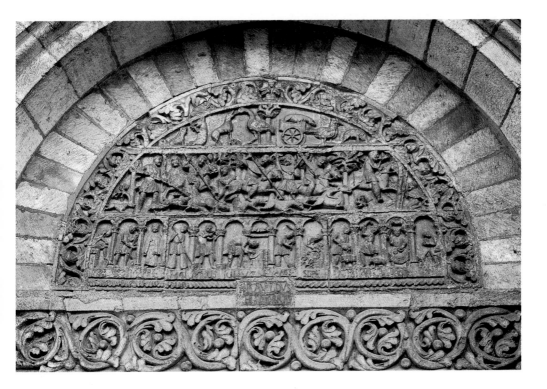

Previous pages 66.
Creation Tapestry, c. 1100.
Embroidered in wool and
linen on a wool background,
12′ x 15′ 8″ (3.6 x 4.7 m).
Gerona cathedral Treasury,
Spain.

This is one of the most
comprehensive images of the
medieval cosmos.

in the cultural efflorescence (often referred to as the Carolingian Renaissance) associated with Charlemagne and his immediate successors, as may be seen in certain of the illustrations to two ninth-century astronomical manuscripts made at Salzburg. In these the illustration for the month of June consists of a peasant guiding a plough drawn by two oxen.

In the twelfth century, illustrations of the occupations of the months become far more widespread and are found in new contexts, both public and private. They began to appear on the exterior of churches, usually as a subordinate element to a sculptural program. They are, for example, present in the radiating archivolts (mouldings that follow the shape of the arch) above the tympanum, as at Autun or Vezelay, and on the door jambs of the entrance portal, as at Ripoll. Exceptionally, they occupy the entire lower zone of the tympanum of the church of St. Ursin in Bourges in central France (FIG. 65). In England they were often a feature on lead and stone fonts. And they occasionally appeared on mosaic pavements, as at Otranto cathedral, where they are arranged in a series of roundels (see FIG. 40).

A spectacular example of their use is in the lateral borders of the giant Creation Tapestry at Gerona cathedral in Catalonia, where they are shown as an essential component of medieval cosmology (FIG. 66). The tapestry's focal point is the figure of the Pantocrator, the blessing and omnipotent Christ, who, in the tradition of Carolingian art, is beardless. Around Christ radiates a Wheel of Creation, with compartmentalised images of five of the seven days of Creation. In the spandrels between the wheel and the borders of the tapestry there are images of the four winds, represented as human figures blowing horns and seated on giant windbags. The borders themselves include figures personifying the year, the four seasons, and the four rivers of Paradise, of which only that of the reclining figure of Geon in the left-hand corner survives, as well as the occupations of the months. They begin at the bottom left with February and proceed upwards: February is represented as a hunter; March as a man holding a snake in one hand and frog in the other – a scene for which the only precedent is in Carolingian art; April as a man ploughing; May as a shepherd tending flocks; and June as a man fishing. The right border has been badly damaged, but the subjects for July – cutting corn – and October – the wine harvest – can still be discerned.

The occupations of the months also began to appear in the eleventh century in liturgical calendars, which list saints' days and the most important events of the church year. The liturgical

calendar was an essential component of a new type of book to emerge in this period, the deluxe illustrated psalter, made for personal and private use. It contained a liturgical calendar and prayers personally tailored to the devotional requirements of its owner, an extensive series of illustrations - generally of scenes from the life of Christ − as well as the text of the psalms.

In the layout of psalters the calendar illustrations were usually relegated to the space above the text at the top of the page. However, in a late twelfth-century psalter, probably made at the Norman abbey at Fécamp in Normandy for a woman patron, the entire left-hand page facing the calendar text is given up to a calendar illustration. This arrangement is unique for its time, and, together with the juxtaposing of scenes of noblemen with those of peasants, looks forward to the famous calendar illustrations of the fifteenth-century Books of Hours (books for private devotional use) such as the *Très Riches Heures* of Jean de Berry. The illustration for the month of October, for example, represents in the upper zone a peasant man sowing and a peasant woman spinning with a distaff and spindle (FIG. 67). In the lower zone a peasant guides a horse-drawn harrow, with sharp spikes to break up the soil. A horse was an important status symbol throughout peasant society.

67. *October* from the Fécamp Psalter, c. 1180.
Illumination on parchment, 7 x 4¹/₂″ (17 x 11 cm). Royal Library, The Hague.

Certain general observations may be made concerning Romanesque illustrations of the occupations of the months. First, the subjects of the illustrations are not constant. They vary from region to region, depending on such factors as the climate and the local agricultural economy: the illustration for January, for instance, in the Otranto floor mosaic is of a man warming himself, while further north this scene is traditionally reserved for February, as can be seen at Bourges. Second, the lives of the

peasants are represented as ordained by God, and as unchanging as the passing of the seasons themselves. Peasants are represented as docile: they do not pose a social or political threat. Finally, the society depicted is, as in the Bayeux Tapestry, a predominantly masculine one. Women are almost entirely absent; the Fécamp Psalter is exceptional in containing two female figures (the second being a gleaner gathering wheat in the illustration for August, representing the grain harvest).

68. The expulsion from Paradise, with Eve spinning and Adam digging, from the York Psalter, c. 1170. Illumination on parchment, 11⅝ x 7⅜″ (29 x 18.5 cm). Glasgow University Library.

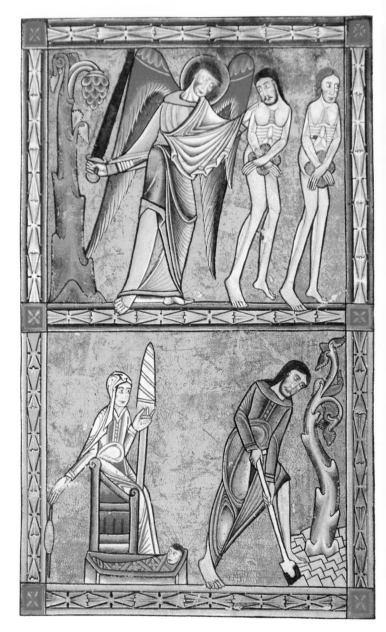

Biblical exemplars for the medieval peasant were provided in the Book of Genesis by Adam and Eve, who were expelled from Paradise, and had the curse of work imposed on them. The expulsion scene is usually followed by one in which Adam is shown cultivating the land, while Eve stays at home weaving cloth and caring for their children. This division of labor is shown in an illustration to a late twelfth-century psalter made in the north of England (FIG. 68).

69. WILIGELMO
Adam and Eve laboring, from the Modena cathedral frieze, early twelfth century.

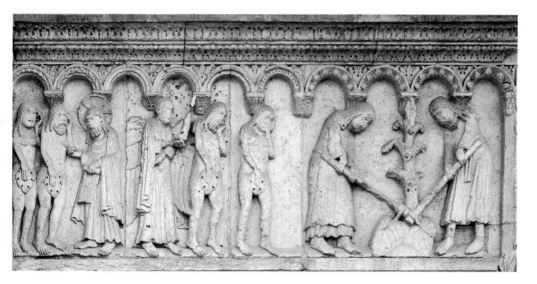

The curse of manual labor fell chiefly on the peasants. It was looked down upon both by the traditional monastic orders, whose only manual activity was the copying and transcribing of manuscripts, and by the knightly classes. However, there are signs that in the twelfth century this attitude was being questioned, with a greater emphasis being placed on the redemptive potential of work. It has been suggested that this change of emphasis is reflected in the unusual laboring scene in the sculptural frieze at Modena cathedral, in which both Adam and Eve, dressed as peasants, till the soil with hoes (FIG. 69). In an accompanying scene, Cain and Abel offer up sacrifices to Christ in Majesty – Abel a lamb and Cain a bushel of wheat. A possible interpretation of this scene would be that just as Cain and Abel gave to God some of the fruits of their labor, so the peasants should give part of the fruits of their labor to the Church in the form of tithes.

FOUR

Romanesque Art and the Church

The most elevated category in the tripartite view of society was "those who pray." Within this category, the preeminent position was given to monks. It is difficult for us to comprehend the status of monasticism in the eleventh and twelfth centuries. The monks' defining activity of prayer was thought to place them in a privileged relationship with God, forming a bridge between the temporal and the divine world.

Monasticism and Cluny

Monasteries had three main functions. They were centers for prayer; they were repositories for sacred relics (the cult of relics was to become increasingly important in the twelfth century); and they were also centers of learning.

The eleventh and twelfth centuries were the golden age of monasticism. There was a dramatic increase both in the number of monks in existing houses and in the foundation of new monastic orders, of which the Cistercians were to become the most famous. In England alone between 1066 and 1150 the number of monasteries increased tenfold.

As discussed in the Introduction the foundation of the abbey of Cluny in southern Burgundy in AD 910 was an event of paramount importance in the history of monasticism. As Cluny was answerable only to the pope, it was increasingly drawn into the papal orbit, both politically and artistically; it also shared with Rome its patron saints, Peter and Paul.

70. Wall-painting in the apse of Berzé-la-Ville priory, beginning of the twelfth century.

The wall-painting is dominated by the figure of Christ in Majesty in a mandorla. He hands St. Peter a scroll granting him authority to govern the church, and is surrounded by the Twelve Apostles. The style of the wall-painting is characteristic of that in Rome and southern Italy at the beginning of the twelfth century, and exhibits the strong influence of Byzantine painting.

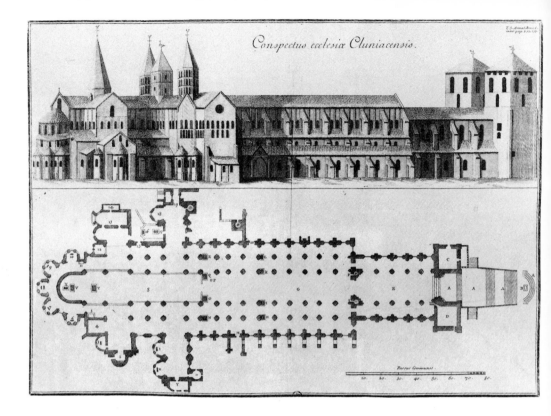

Conspectus ecclesiæ Cluniacensis.

71. Exterior view and ground plan of Cluny III (1088-1130) from an eighteenth-century print.

This connection with Rome is reflected in Cluniac artistic imagery. For instance, the early twelfth-century wall-painting in the apse of the chapel of the summer retreat of the abbots of Cluny at Berzé-la-Ville – probably a replica of one originally found in the apse of the now-destroyed abbey church of Cluny III – has as its unusual theme the Twelve Apostles combined with the *Traditio Legis* (FIG. 70). In this Christ grants to St. Peter the authority to govern the Church, symbolised by the handing over of a scroll; thus Peter is identified as the precursor of the popes.

The monks of Cluny followed in general the rule of St. Benedict, but placed a far greater emphasis on an expanded liturgy. Their elaborate masses for the dead were renowned. One commentator observed that "it is customary for masses to be said without an instant break from dawn until the hour of sleep." Another important aspect of Cluniac liturgy was the role given to plainsong, the unison chanting that was one of the key art forms of monasticism. The desire for good acoustical effects was one motive behind the building of high churches with barrel vaults throughout.

72. Interior of the nave of Autun cathedral, second quarter of the twelfth century.

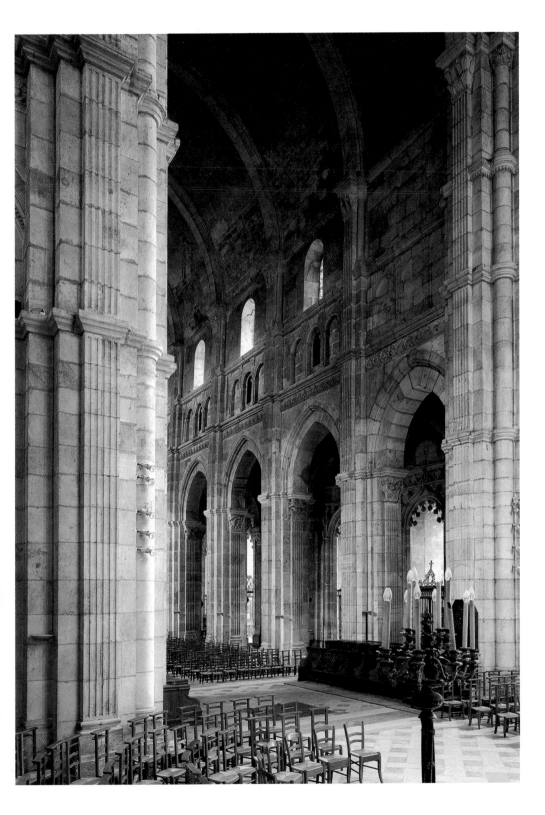

73. The cloister and fountain at Monreale cathedral, 1175-85.

The Cluniacs championed the visual arts, particularly architectural sculpture. The crowning achievement of their artistic ambitions was the building of one of the most magnificent churches in Christendom, known to art historians as Cluny III (FIG. 71). Its architect was a monk of Cluny named Gunzo, and his assistant, a man called Hezelon. Begun in 1088, Cluny III was consecrated by Pope Innocent II in 1130. Only one transept of it survives, but the original design and layout have been reconstructed.

A spectator approaching Cluny in 1130, with its massive scale, numerous towers, bold massing and the stepped, pyramidical arrangement of its east end, might have believed it was a vision of the heavenly Jerusalem. On entering the long nave of eleven bays, the visitor would have been struck by its height, overarched by a broad, tunnel-shaped stone vault over 100 feet (30.5 m) high. The ground plan had three main characteristics: the five-aisled nave, which recalls Old St. Peter's at Rome; the double transepts, very unusual for the time; and the so-called ambulatory with radiating chapels of the east end. This consisted of a semicircular corridor, surrounding the sanctuary, with a ring of side chapels projecting from its outer wall. The ambulatory with radiating chapels was one of the most important architectural innovations of the tenth and eleventh centuries.

The internal elevation of the nave of Cluny III was similar to that at Autun cathedral. This has a high arcade with pointed arches, a narrow false triforium (a wall passage below the clerestory) of three arches to each bay, separated by fluted pilasters (an arrangement also found on several of the ancient city gates in the region), and a clerestory close in height to the triforium, with a single central window to each bay (FIG. 72).

Very few of the subsidiary buildings that clustered around the great abbey church of Cluny III have survived. Of these the most important artistically were the cloister and the chapter-house. In theory the cloister was intended to provide a foretaste of Paradise; and cloisters still exude a sense of tranquility and contemplation today. Its practical function was to provide the monks with a place for exercise, reading, meditation, and washing. A fountain or water basin was usually placed at its center or off to one side. An exceptionally ornate example survives in the cloister at Monreale in Sicily (FIG. 73), built in the 1180s. The fountain here is in the form of a palm tree, surrounded by an arcade of pointed arches supported by columns of white marble. These are encrusted with colored and gilded intarsia – a decoration made of different colored marbles.

74. View of the cloister at Moissac, c. 1100.

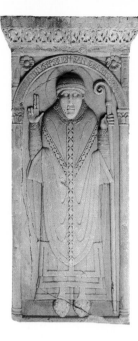

75. Abbot Durand depicted on the central pier of the cloister at Moissac, c. 1100.

Only fragments of the original cloister at Cluny survive. The cloister at Moissac, erected at the end of the eleventh century, when Moissac was under Cluniac control, is thought to be the earliest surviving example of a cloister adorned with extensive figurative sculpture (FIG. 74). It contains an array of historiated capitals as well as corner or central pier reliefs (piers are solid masonry supports as distinct from horizontal slabs). These depict the Twelve Apostles and, on one of the central piers, the first Cluniac abbot of the monastery, Abbot Durand (1047-1072). The apostles are carved in shallow relief and are in profile, while Abbot Durand is shown frontally (FIG. 75).

The capitals at Moissac are shaped like inverted truncated pyramids, capped by rectangular blocks. There are seventy-six in total, supported by alternating twin and single columns. Forty-one are historiated: subjects include scenes from the life of Christ, the Book of Revelation, the Old Testament, and the lives of the saints, including some of direct significance to Moissac or to the monastic life, such as St. Martin and St. Benedict. It has not been possible to decipher a coherent iconographic program in the choice and placement of the capitals, though certain themes have obvious relevance to the communal life, such as the Last Supper or Christ washing the feet of the apostles – an act of humility regularly re-enacted by the monks.

Cloister decoration was sharply criticised by St. Bernard. Not surprisingly, cloisters in early Cistercian monasteries have a Spartan appearance, devoid of superfluous decoration.

Another important monastic building was the chapterhouse, where the daily business of the community was discussed. Chapterhouses occasionally had elaborate programs of decoration, as can be seen in the chapterhouse of the abbey of St. Martin-de-Boscherville in Normandy, which appropriately includes in its sculptural program the figure of St. Benedict (FIG. 76). A chapter of the Rule of St. Benedict was read daily in the chapterhouse. Displaced fragments also survive from the decoration of chapterhouses, as in the late twelfth-century wall-paintings from the chapterhouse of the monastery of San Pedro de Arlanza, near Burgos in northern Spain. This chapterhouse may also have functioned as a funerary chapel; its wall-paintings have fantastic animals for their enigmatic theme, probably inspired by English bestiary illustrations. They include the famous stylised lion with an anthropomorphic head, now in the Cloisters, New York (FIG. 77).

An achievement equal to the building of these magnificent abbeys was the making and illuminating of manuscripts for their vast libraries. The writing and reading of manuscripts formed an

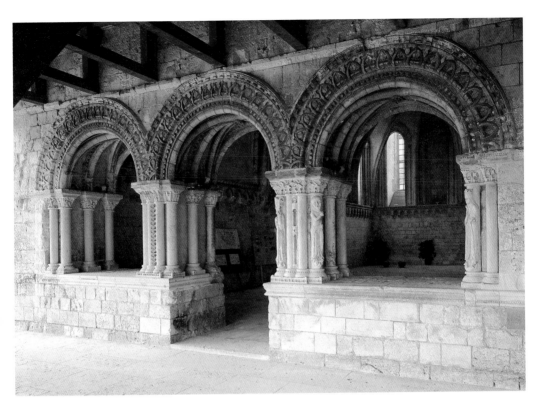

76. View of the chapter-house of St. Martin-de-Boscherville, near Rouen, c. 1175.

important part of monks' lives. The abbey of Cluny had, as might be expected, one of the largest libraries. The mid-twelfth-century catalogue records 570 volumes, including not only such obvious works as the Bible, both in its entirety and in parts, theological commentaries on the Bible, and the liturgical books used in church services, but also historical works and, perhaps more surprisingly, classical texts. Monastic libraries played an important role in preserving classical learning.

Pride of place was given to the Bible, and of all surviving Romanesque Bibles perhaps the finest is the Winchester Bible, made in about 1160 for the community of St. Swithun's, who served Winchester Cathedral. Its entire text was written by one scribe; this would have been a formidable task, taking at least four years and requiring for parchment the skins of over 250 calves.

Illustrating the Winchester Bible appears to have been a complicated affair. The intention was to prefix each book of the Bible, from Genesis to the Book of Revelation, with an historiated initial, usually related to the text. As an afterthought, full-page frontispieces to three books of the Bible were added (one of which, for the Book of Samuel, has been separated from the

77. Lion wall-painting from the monastery of San Pedro de Arlanza, near Burgos, c. 1200. Fresco, transferred to canvas, 7'5" x 11' (2.2 x 3.3 m). Metropolitan Musuem of Art, New York.

The margin shows a seascape with fish.

rest of the work, and is now in the Pierpoint Morgan Library, New York). The illustrations were drawn and painted by at least six different artists, yet in spite of this the program of illustration was left incomplete, with many illustrations half-painted or only underdrawn.

The six artists were anonymous, but names have been invented to distinguish their different styles: the Master of the Leaping Figures, the Master of the Apocrypha Drawings, the Master of the Morgan Leaf, the Amalekite Master, the Genesis Initial Master, and the Gothic Majesty Master. Of these the Master of the Leaping Figures appears to have been the first to work on the Bible and to have had overall control of its design. He

worked in a style current in England in the mid-twelfth century. Painted in jewel-like colors, his figures move like acrobats, gesticulate with emphatic gestures, and wear sinuous garments that cling in patterned folds to their bodies (FIG. 78).

In the 1170s a second team of artists arrived at Winchester. They painted in a more subdued naturalistic manner, anticipating the Transitional style and reflecting the influence of Byzantine art. The Master of the Morgan Leaf, in particular, shows the influence of the Byzantine mosaics of Sicily. This influence is most evident in the initial *R* that opens the prayer of Jeremiah (FIG. 79). In the bowl of the letter is a majestic figure of God, resembling that of Christ Pantocrator (Christ as the ruler of all), an image found in the mosaics at Cefalù. Below, Jeremiah appeals to God, holding a scroll in his hand. As with the Sicilian mosaics, the figures are set against a highly burnished gold background, and have heavy facial modeling with the features clearly delineated. Jeremiah has a haunting, fixed, melancholic expression, a device no doubt borrowed from Byzantine art, but nevertheless reflecting a new emphasis on human values in Western society.

Cistercian Art and Architecture

The Cistercian order was founded in France at the end of the eleventh century as part of the reaction against traditional monasticism as exemplified by the Cluniacs. It began as a break-away movement in 1098, when a group of monks from the Cluniac abbey of Molesme settled in a desolate region south of Dijon, called Cîteaux. They called their community simply the New Monastery.

The aims of the Cistercians differed from those of the Cluniacs in several important respects. They advocated a more stringent application of the Rule of St. Benedict, with a more even balance among the three activities of prayer, meditation, and manual work. The only manual labor done by the Cluniac monks had been the transcribing and illustrating of manuscripts. The Cistercians wished to be self-sufficient, depending for their livelihood purely on their own cultivation of the land. However,

78. MASTER OF THE LEAPING FIGURES
Initial *V* prefixing the Book of Jeremiah, Winchester Bible, c. 1160. Illumination on parchment, 4¾ x 5¼" (12 x 13 cm). Winchester Cathedral.

God is shown appearing to Jeremiah, who reels back in astonishment in the upper right-hand corner of the initial. The use of scrolls of speech is similar to modern cartoons, while the use of the interlace pattern at the top of the vertical bar of the letter, and the human head at the top of the curve both recall Insular book illumination and can be seen in the Book of Kells. The style of the initial represents a development from that of Master Hugo.

noster · complet sunt dies nri qa uenit finis nr.
Velociores fuerunt psecutores nri COPH.
aquilis celi · sup montes psecuti sunt nos · in
deserto insidiati sunt nobis. 5 tubuf REX.
Spus oris nri xps dns captus est in peccatis
nris cui diximus · in umbra tua uiuem ingen
Gaude & letare filia edom quia SEN
bitas in terra bus · ad te quoq; puenet calix
inebriaberis atq; nudaberis. TAV
Completa est iniquitas tua filia syon · non
addet ultra ut transmigret te · Visitauit ini
quitate tua filia edom · discoopit peccata tua
FINIT LAMENTATIO IEREMIE Phe

INCIPIT ORATIO EIVSDEM :

ECORDARE
dne quid acciderit nob.
intuere & respice op
probrium nostrum.
Hereditas nra uersa
est ad alienos · domus
nre ad extraneos.
Pupilli facti sumus
absq; patre · matres
nre quasi uidue ·
Aquam nostram pecunia bibimus & lig
na nostra precio comparauimus ·
Ceruicibus minabamur lassis
non dabatur requies ·
Egypto dedimus manum & assyris ·
ut saturaremur pane ·
Patres nostri peccauerunt & non sunt ·
& nos iniquitates eorum portauimus ·
Serui dominati sunt nri · & non sunt
qui nos redimeret de manu eorum ·
in animabus nris afferebamus panem
nob a facie gladii in deserto ·
Pellis nra quasi clibanus exusta est
a facie tempestatum famis ·
Mulieres in syon humiliauerunt
uirgines in ciuitatibus iuda ·
Principes manu suspensi sunt · facies
senum non erubuerunt ·
Adolescentibus impudice abusi sunt ·
& pueri in ligno corruerunt ·
Senes de portis defecerunt · iuuenes
de choro psallentium ·
Defecit gaudium cordis nri · uersus est in luc
tum chorus nr · cecidit corona capitis nri ·
ue nobis quia peccauimus ·
Propterea mestum factum est cor nrm · ideo
contenebrati sunt oculi nostri ·
Propter montem syon quia disperit :

uulpes ambulauerunt in eo ·
Tu autem dne in eternum permanebis · solium tuu
in generatione & generationem ·
Quare impetuum obliuisceris nri · & dere
linques nos in longitudinem dierum?
Conuerte nos dne ad te & conuertemur · in
noua dies nros sicut a principio ·
Sed piciens reppulisti nos · iratus es contra
nos uehementer FINIT ORATIO IEREMIE :

INCIPIT PROLOGVS IN LIBRV
BARVCH NOTARII IEREMIE Phe

Liber iste qui baruch nomine pnotatur in hebreo
canone non habetur · sed tantum in uulgata editione. Si
militer & epla ieremie ppheta · Propter notitiam autem
legentium hic scripta sunt · quia multa de xpo nouissimisq;
temporibus indicat :

FINIT PROLOGVS

De oratione & sacrificio pro uita Nabuchodonosor :

INCP LIB BARVCH NOTARII IEREMIE
PROPHE :

EC
VERBA
LIBRI
QVE SCRI
PSIT

baruch filius neeri · filii amasie · filii sedechie
filii sedei · filii belchie in babylonia · in anno
quinto · in septima die mensis · in tempore quo
cepunt chaldei ierlm & succenderunt eam igni ·
Et legit baruch uerba libri huius ad aures ie
chonie filii ioachim regis iuda · & ad aures uni
uersi populi uenientis ad librum · & ad aures
potentium filiorum regum · & ad aures presbi
terorum · & ad aures populi a minimo usq;
ad maximum eorum omnium habitantium in
babylonia · ad flumen sudi · Qui audientes
plorabant & ieiunabant · & orabant in con
spectu dni · Et collegerunt pecuniam secdm
quod potuit uniuscuiusq; manus · & miseru
ierlm ad ioachim filium belchie · filii salon
sacerdotem · & ad reliquos sacerdotes · & ad
omnem populum qui inuentus est cum eo ierlm :

this proved impossible, and it was soon necessary to take on lay brothers who were bound by vows and undertook a greater share of the manual work. They were not serfs, but worked side by side with the monks, as can be seen in an early twelfth-century initial from Gregory the Great's *Moralia in Job* (FIG. 80). These lay Cistercians were usually accommodated in the western part of the cloister, or "westrange." The ruins of one such westrange can still be seen at Fountains Abbey in Yorkshire in England (see FIG. 83). Finally, the Cistercians aspired to a simple life of poverty and asceticism in remote places. This aspiration was symbolised by wearing habits of white or undyed wool, in contrast to the black robes worn by the Cluniacs.

By 1151 there were 353 Cistercian monasteries in Europe, and one factor behind this expansion was the highly centralised nature of Cistercian organisation. With success, however, came drawbacks: it was necessary for the Cistercians to compromise their ideals and to become increasingly embroiled in the economic and social mechanisms of feudal society.

The Cistercians developed their own attitude to both art and architecture. St. Bernard's strong views were codified in his *Apologia* and with the expansion of the Cistercian movement came a growth in their legislation on art. To cite only a few examples: abbeys were not allowed to have crossing towers (the tower above the intersection of the nave and choir); initials in manuscripts were to be non-figurative and of one color; stained-glass windows were to be plain. The obvious question is, how faithfully were these regulations obeyed in the art the Cistercians produced?

The earliest Cistercian art to survive is a series of remarkable illustrated manuscripts made at Cîteaux between 1109 and 1133, when the abbot was an Englishman named Stephen Harding. Some of the earliest of these are painted with an immediacy,

freshness, humor, and realism in the rendering of detail unparalleled in Romanesque art. They look back to the genre scenes of the Bayeux Tapestry and to an earlier naturalistic vein in English art; indeed it has been suggested that the artist came from England. The *Moralia in Job*, completed in 1111, contains a series of initials showing monks engaged in everyday tasks, the design of which imaginatively follows the shape of the letter: an initial I, for example, becomes the trunk of a tree, with a lay brother cutting off its upper branches with a hand axe, while below him a monk – note the tattered hems of his habit – cuts away at the base of the tree with an axe, seemingly oblivious to the consequences of his action for his colleague.

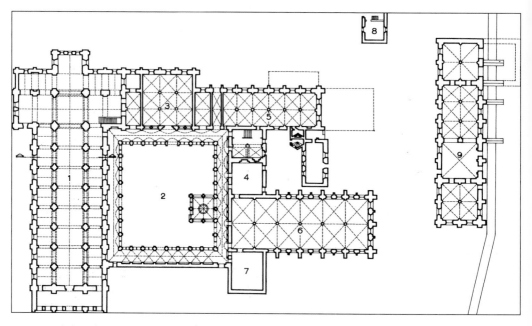

81. Ground plan of Fontenay abbey, 1139-47.

1. Church
2. Cloister
3. Chapterhouse
4. Warming room
5. Great Hall
6. Refectory
7. Kitchen
8. Infirmary
9. Forge

The Cistercians are best remembered for their architecture. Of the Cistercian monasteries built in the first half of the twelfth century the best-preserved is that of Fontenay in Burgundy, which is complete with its original outbuildings. One of these is a large iron foundry – the Cistercians were at the forefront of technological innovation in the twelfth century. Fontenay was founded by St. Bernard in 1119 and the abbey church was built between 1139 and 1147. Its ground plan, in the form of a simple Latin cross, is characteristic of Cistercian abbeys and follows what is known as the Bernardine plan (FIG. 81). It contrasts most markedly with that of Cluny in the design of the east end, which has a flat-ended apse and side chapels clustered around both sides of the single transept. The interior has a stark appear-

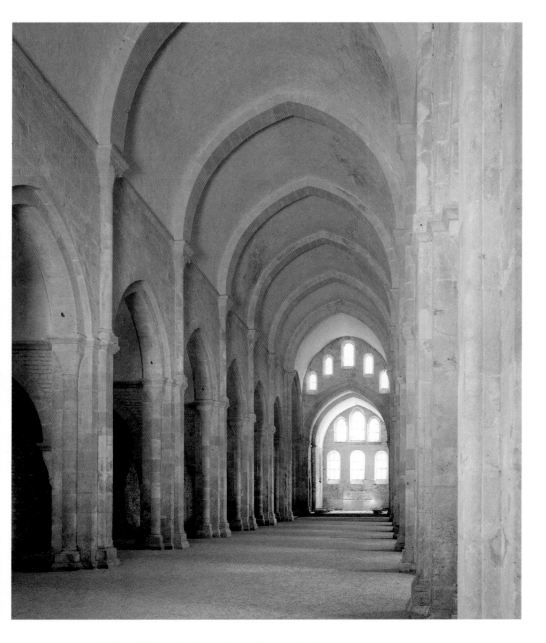

ance, redolent of the self-deprivation of the Cistercians' muscular Christianity (FIG. 82). The elevation of the nave consists of eight one-storeyed bays, lit by plain windows in the side aisles and at either end of the church. The greatest intensity of light is concentrated symbolically around the east end. The entire church is covered with a tunnel vault with pointed arches. From the exterior the church has low, squat proportions, resembling a barn, and it blends effortlessly into the landscape.

82. Interior of the nave of Fontenay abbey, 1139-47.

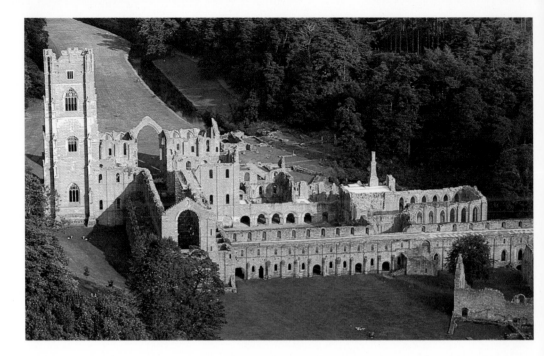

83. Fountains abbey from the west, mid- and late-twelfth century.

Important Cistercian monastic complexes from the twelfth century survive in other parts of Europe, notably in northern England and Catalonia. Fountains abbey in Yorkshire is one of the most impressive in England and one of the earliest to survive, albeit as a ruin. It was founded in 1132 by a group of monks who left the Benedictine monastery of St. Mary's in York to set up a new community on land that had been given to them by Thurstan, Archbishop of York, "More fit for wild beasts than men to inhabit."

The view of Fountains abbey from the west is dominated by the long, low proportions of the westrange, punctuated by the even, regimented rhythm of its window openings, the entire composition being counterbalanced by the simple vertical of the west facade (FIG. 83). The westrange was built in two phases in the late twelfth century, and originally housed over two hundred lay brothers. The austere design of the abbey church itself, built between 1148 and 1160, follows Cistercian practice both in spirit, with ornament kept to a minimum, and in specific details, such as the use of the Bernardine plan, with pointed arches in the arcade and barrel vaults in the aisles. However, it also incorporates specifically Anglo-Norman features, such as the bulky columnar pier supports, and it originally had an impressive tower at its crossing – contravening one of the regulations of the Cistercian order.

The Pilgrimage Route and the Cult of Relics

One of the pier reliefs in the cloister of the abbey of Santo Domingo at Silos in northern Spain shows Christ on the road to Emmaus (FIG. 84). Christ is barefoot and dressed as a pilgrim, wearing the characteristic bonnet and satchel and holding a long staff. He is specifically identified by the scallop shell sewn on to his satchel as a pilgrim en route to the shrine of St. James at Compostela in northwest Spain. The pilgrimage route to this shrine passed some sixty miles north of Silos.

The Romanesque period saw a rise in popularity of pilgrimages, which were often undertaken as acts of penance: two pilgrims to Jerusalem and Compostela are represented among the blessed in the lintel of the Last Judgement tympanum at Autun (FIG. 85). The three most revered pilgrimage sites were Jerusalem, regained for Christendom in 1099 by the First Crusade, Rome, which possessed the relics of St. Peter and St. Paul, and Santiago de Compostela, which contained the body of St. James the Greater, one of the twelve apostles.

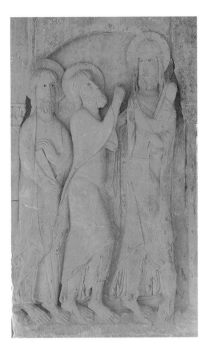

84. *Christ on the way to Emmaus,* first half of the twelfth century. Cloister pier relief at the abbey of Santo Domingo, Silos.

85. Detail of the pilgrims in the Last Judgement tympanum at Autun.

Of these three sites, Compostela gave rise to specific routes. Even today thousands of pilgrims set out every year to Compostela, following in the footsteps of their medieval predecessors. In about 1140 a guide to the pilgrimage route was written, describing the four routes that crossed France and converged in northeast Spain, taking in on their way other churches and monasteries containing major relics.

It is difficult for us to understand the importance attached to relics in the Middle Ages. They were a visible point of contact between the believer and the holy person of whose body they were once a part, or with whom they were once associated. The spirit and authority of the deceased were thought to continue to reside in their relics, which were often held to possess miraculous properties. One practical function that relics served was as objects on which solemn oaths might be taken, as depicted in the Bayeux Tapestry.

Magnificent churches were built to provide appropriate settings for relics, and to receive large numbers of pilgrims. Among these rank some of the greatest surviving achievements of Romanesque architecture, including the church at Vézelay, dedicated to Mary

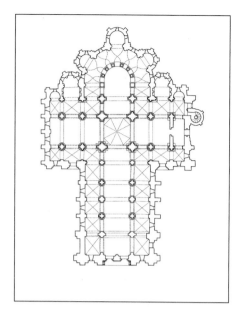

86. Ground plan of St. Foy, Conques.

Relics were kept in the sanctuary, at the center of the east end (surrounded by the ambulatory and the radiating chapels of the east end itself), or in the crypt beneath the church. The wide nave and the ambulatory were designed to accomodate the large numbers of pilgrims visiting the church. The radiating chapels were used by the pilgrims to pray, or to hold masses for dead donors to the church.

Magdalen, and St. Gilles-du-Gard in Provence, which was dedicated to St. Giles. The pilgrimage route was an important channel of communication for artistic exchange. For instance, the same workshop of sculptors who were active at St. Sernin at Toulouse also worked at Santiago de Compostela in Spain.

The pilgrimage route gave birth to a specific type of church design, which was determined by the requirements of the pilgrims. The main features of its ground plan were wide transepts, an ambulatory with radiating chapels at the east end (with the inner wall of the ambulatory open to enable the pilgrims to see into the sanctuary), and a broad nave with side aisles (FIG. 86). The elevation was two-storeyed, with a broad gallery. This could be used on special occasions when large numbers of pilgrims entered the church, but it also had a structural function, as its own internal vaulting took the thrust of the main vault.

The three surviving examples of this design are the church of St. Sernin at Toulouse, the cathedral of Santiago de Compostela and the church of St. Foy at Conques. The best preserved is St. Foy, and there the spirit of the pilgrims can still be felt (FIG. 87). It is also the smallest, its size being partly determined by its location on the side of a steep hill. The date of its construction is the subject of controversy. Building began in the mid-eleventh century, but the major part of the church was not built until the first decades of the twelfth century.

The object of the pilgrims' quest was the golden effigy of St. Foy, which contained the most precious relic of her skull (FIG. 88). This was originally kept in the sanctuary. The pilgrims had access to the effigy (protected by an iron grille) through the ambulatory passage encircling the sanctuary. (St. Foy was a young girl who lived in the 3rd century; she converted to Christianity and was put to death for refusing to make sacrifices to the pagan gods. Her relics were brought to Conques in the ninth century.)

The golden effigy shows St. Foy in majesty, seated on a throne and wearing the heavenly crown of a martyr. It was largely assembled in the late tenth and early eleventh centuries, with later additions and restorations. Its wooden core is completely covered with gold leaf in which are embedded precious stones and classical cameos donated by pilgrims. The parallel

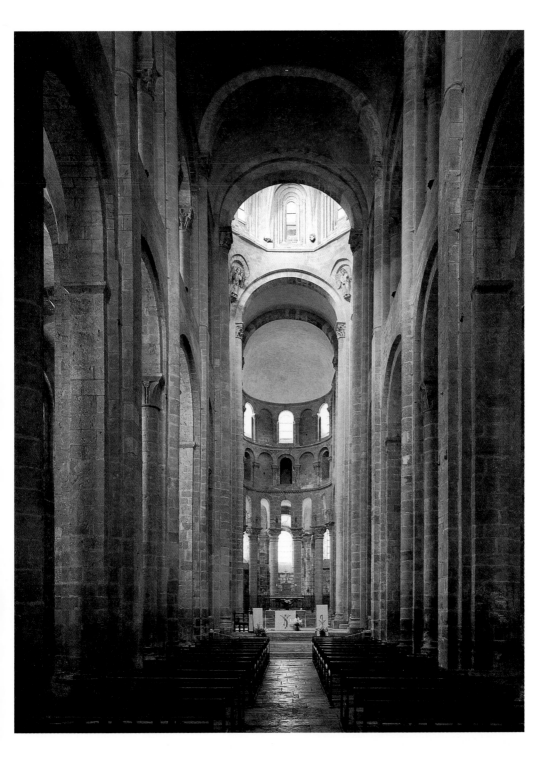

87. Interior of the nave of St. Foy,
Conques, early twelfth century.

between St. Foy's martyrdom and Christ's Passion is made explicit by the image of the Crucifixion engraved in rock crystal and set into the back of her throne. A disconcerting feature of the effigy is the head, which is oversized in relation to the rest of the body and tilted backwards. It is, in fact, a re-used late antique golden mask.

The effigy of St. Foy is the sole surviving example of a type of cult image very common in the region around Conques. The type was commented on in the early eleventh century by Bernard, Master of the episcopal school at Angers. "A venerable and antique custom exists both in the lands of Auvergne, Rouergue and Toulouse, and in the neighbouring regions. Each district erects a statue to its saint of gold, silver, or another metal, depending on its means, inside which either the saint's head or some other venerable part of his or her body is enclosed." Bernard of Angers also provides a fascinating insight into the reception which an image of this type was given when, commenting on a similar effigy of St. Gerald at Aurillac, he wrote that it "reproduced with such art the features of a human face that the peasants who looked on it felt themselves pierced by a penetrating gaze and sometimes thought that they glimpsed in the rays from his eyes the indication of a favour more indulgent to their wishes."

88. Reliquary effigy of St. Foy, mostly 983-1013 with later additions (head: late antique). Gold and silver gilt over a wooden core, studded with precious stones and cameos, height 34″ (85 cm). Church Treasury, Conques.

St. Foy holds in her hands two phials. The supposed relic of her skull was housed in a cavity carved in the back of the reliquary.

The Cult of the Saints

Saints occupied a central position in the religious, social, and political life of the period. Ordinary mortals could identify with them and they were venerated rather than worshiped. Saints received the prayers of the faithful and interceded for them with God; they served as role models; and they functioned as protectors of churches or even of entire kingdoms, as in the case of St. Denis of France.

In most art of the Romanesque period saints were represented either in static arrangements around Christ or the Virgin Mary or in narrative illustrations of their lives. A good example of the latter is the illustrated life of St. Edmund, made at the abbey of Bury St. Edmunds in East Anglia, in about 1130. St. Edmund, the King of East Anglia, was murdered by the Danes in 869 and within forty years of his death had come to be venerated as the subject of a local cult. In 1020 the abbey of St. Edmunds was founded in his honor, and by the early twelfth century it had become one of the wealthiest landowners in England.

The text of the life of St. Edmund is preceded by a set of thirty-two illustrations designed, if not painted, by the Alexis Master of the St. Albans Psalter. They are without captions, and provide a visual narrative, not only of events in the saint's life, culminating in his martyrdom, but also of miracles that took place after his death and with which he was credited.

As in the case of St. Foy, the parallel between St. Edmund's martyrdom and Christ's Passion is made explicit in the illustrations. In one St. Edmund is dragged along, struck with long sticks, and mocked by men spitting in his face (FIG. 89). The scene recalls Christ's flagellation and mocking, and its compositional scheme is based on that of Christ carrying the cross.

St Edmund is also portrayed as the protector and guardian of the interests of the abbey. Another illustration shows a group of thieves raiding the saint's shrine. His intervention freezes them motionless, and the next morning they are arrested and tried by the local bishop: their subsequent fate (hanging) is graphically represented. Abbots at Bury St. Edmunds at this time had the power to try miscreants and sentence them to death.

Certain of the scenes refer to affairs at Bury St. Edmunds at the beginning of the twelfth century. One illustration shows King Sweyn (d. 1014), a Danish king, ordering the monks of Bury St. Edmunds to pay tribute money. In the next scene he comes to a violent end as a consequence, at the hands of the

spirit of the saint. King Henry I was at this time exacting taxation from the abbey, thus contravening an ancient privilege dating back to the reign of Edward the Confessor. The series of illustrations culminates in the apotheosis of St. Edmund: the saint is in heaven, enthroned and crowned, and surrounded by angels. At his feet are two kneeling monks.

The eleventh and twelfth centuries also saw the creation of new saints. One of the most famous was Thomas à Becket, Archbishop of Canterbury. In 1170 four knights, acting on behalf of King Henry II, assassinated Becket in Canterbury cathedral. In this event the struggle between the church and monarchy in

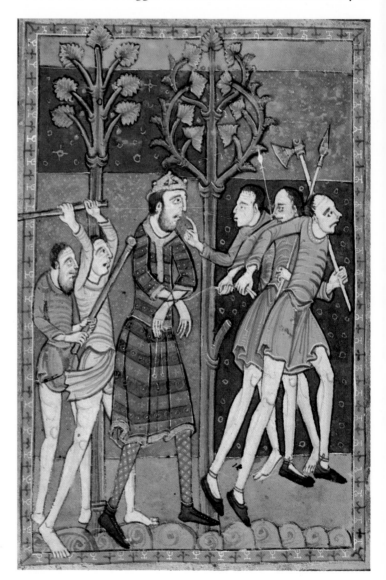

89. St. Edmund being led to his death, from the illustrated Life of St. Edmund, c. 1130. Illumination on parchment, 8¹/₈ x 5³/₈" (20.4 x 13.4 cm). Pierpont Morgan Library, New York.

St. Edmund is crowned, and wears a garment made of Byzantine silk.

England came to a head. The action was universally condemned and Henry was forced to do penance. Within a short period miraculous events had come to be associated with Becket's grave; he became the object of a popular cult and in 1173 he was canonised by Pope Alexander III (1159-1181). His cult was encouraged by the Church as a ploy to further its interests, one that was to be of great financial benefit to the monks of the abbey of Christ Church, Canterbury.

Thomas à Becket's martyrdom is represented on a series of enameled caskets intended for his relics. They are of Limoges workmanship (Limoges then being part of Henry II's Angevin domain). One of the earliest caskets depicts Thomas's murder while celebrating mass (it is inaccurate in showing three instead of four knights), his burial, and the ascent of his soul into heaven (FIG. 90).

90. Thomas à Becket *chasse*, c. 1190. Limoges champlevé enamel, 11¼ x 15½ x 4⅝" (28 x 38.5 x 11.5 cm). British Museum, London.

Women and Romanesque Art

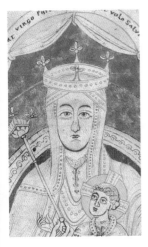

91. Siegburg Madonna, c. 1160. 16½ x 16½" (41 x 41 cm). Schnutgen Museum, Cologne.

The apple the Virgin Mary holds in her right hand identifies her as the new Eve. Stylistically, the relief may be related to the sculpture on the west portal at Chartres (c. 1145-55). It is an early example of the influence of the Gothic sculpture of the Ile-de-France on the art of Cologne. Discovered in 1919 at the abbey of St. Michael at Siegburg near Cologne, the fragment probably originally formed part of a gable for a stone sarcophagus or the canopy of a tomb.

The church of Neuilly-en-Donjon in Burgundy, which is dedicated to Mary Magdalen, has a tympanum on which are juxtaposed three interrelated scenes from the Bible (FIG. 92). Each shows Biblical archetypes of women: the Fall, in which Eve tempts Adam by offering him the apple from the Tree of Knowledge; Christ in the house of Simon the Pharisee, where Mary Magdalen anoints his feet and wipes them with her hair; and the Adoration of the Magi, in which the three kings pay homage to the infant Christ, who is seated on the lap of the Virgin Mary. In each of these scenes the woman is defined in relation to a man: Eve as Adam's sexual partner and temptress; Mary Magdalen by her self-abasement and selfless love of Christ; and the Virgin Mary as the mother of Christ – the vessel through which God assumed human form.

Biblical Archetypes

In Romanesque art Eve, Mary Magdalen, and the Virgin Mary are presented as the three main archetypes of woman, each with distinctive characteristics. They are given a far more prominent

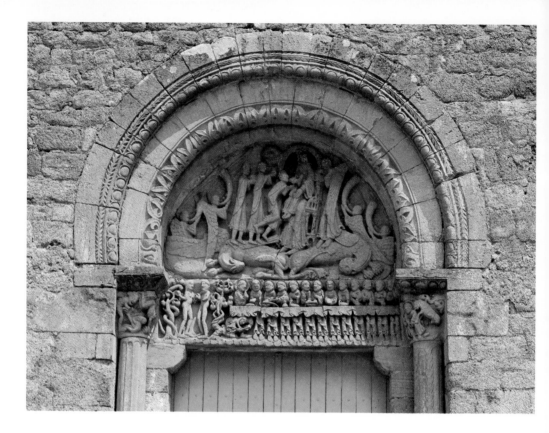

92. Tympanum and lintel at the church of La Madelaine, Neuilly-en-Donjon, second quarter of the twelfth century.

role in Romanesque artistic imagery than in the art of earlier periods; arguably these archetypes of the Romanesque period have continued to be used in the depiction of women in Western art ever since.

Their creation and presentation in Romanesque art was determined by the requirements of the literate and male-dominated culture of the church. The cults of Mary Magdalen and the Virgin Mary were promoted by the Church partly in response to popular piety. This had its own oral traditions which are difficult to trace, and consequently the precise development of the Magdalen and the Virgin as Biblical archetypes of women is to some extent unknown.

Throughout medieval theology, Eve was seen as responsible for man's original sin. Images of her in art frequently stress her role as a sexual temptress. One of the most sensuous representations of Eve is in a fragment by Gislebertus from Autun cathedral (FIG. 93). This originally formed part of a more extensive ensemble on the lintel of the north portal, and would have been completed with a pendant image of Adam to the left and the serpent behind her.

Eve is shown nude and, unusually, lying down. Her knees are half-bent and she supports herself on her right elbow. A tree is deployed to conceal her pubic area. Her left arm is stretched back to pick the apple off another tree, while her right hand is placed to one side of her mouth, as if she is about to whisper the idea of tasting this forbidden fruit into Adam's ear. This could also be an allusion to the misdemeanor of talking in church – a fault women were often accused of by the clergy.

Eve's unusual posture has been interpreted as an allusion to God's punishment of her, which compelled her to crawl on her

93. GISLEBERTUS
Eve, c. 1130, width 4' (1.3 m).
Musée Rolin, Autun.

belly like the serpent by whom she was tempted. It has also been related to the liturgical practice of Ash Wednesday as it was followed at Autun in the twelfth century, in which penitents approached the north portal crawling "on their knees and elbows," and were not allowed to stand until they had been pardoned by a penitential sacrament.

The sinuous figure of Eve, with her rounded breasts, is one of the most erotically charged images of Romanesque art. Like Salome in the capital from St. Etienne (FIG. 36), the Autun Eve has a naive quality: both Salome and Eve are portrayed not so much as sinners but as temptresses who invite Herod and Adam respectively, and by implication men in general, to commit sin. These images should be seen in the context of the papal reforms of the eleventh and twelfth centuries, which were attempting to enforce celibacy on the clergy.

The figure of Mary Magdalen in Romanesque art is a creation of medieval mythology. She is a composite character, a conflation of four women, three of whom are mentioned in the Gospels and one of whom was an early Christian penitent: first, Mary of Bethany, who wiped Christ's feet; second, Mary of

Following pages 94. Interior of the nave at Vézelay, 1120-1140.

The composition of the nave is characterised by a gentle rhythm, balance, and lightness, accentuated and enlivened by bands of repeated but restrained ornament, and by the alternating colors of the masonry on the transverse arches which separate each bay. Each bay is spanned by a groin vault.

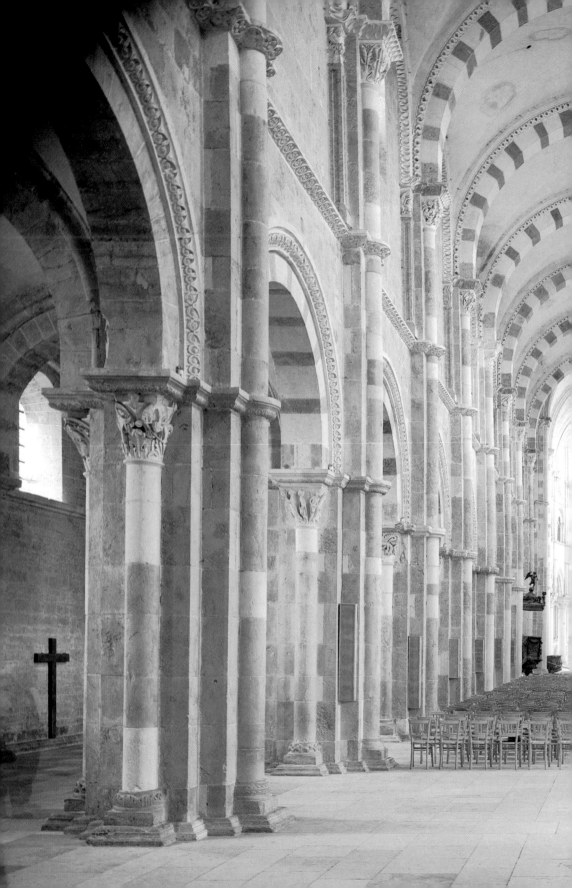

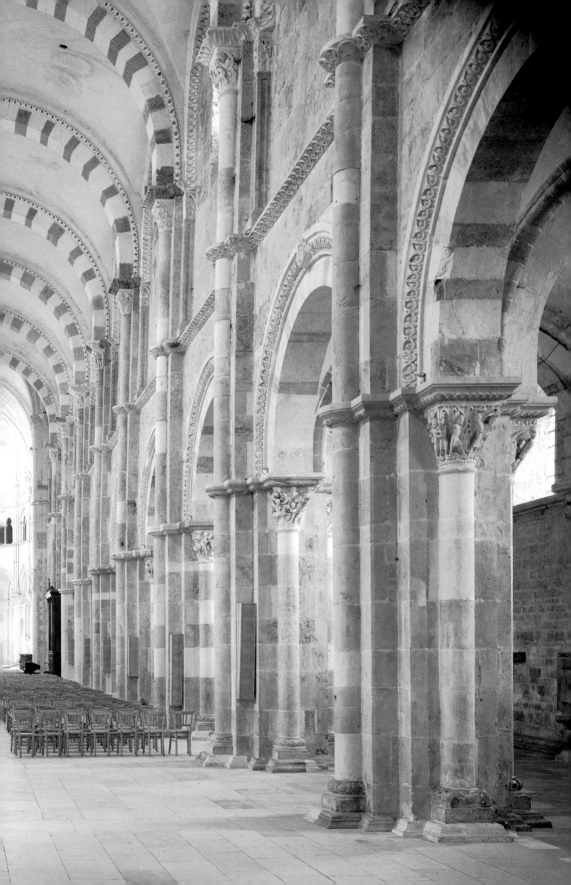

Magdala, the adulteress; third, Mary Magdalen, who was privileged to be the first person to meet Christ after the Resurrection; and finally, Mary the Egyptian, a prostitute who became a penitent and expiated her sins in the desert for forty-seven years. The church promoted this character as a role model for ordinary women: she combined selfless love, faith, and a repentant nature which enabled her to obtain salvation. An indication of the scale of Mary Magdalen's cult can be gained from "the large and most beautiful basilica" built to house her relics at Vézelay (FIG. 94). The quote comes from a book entitled *The Pilgrim's Guide*, written in about 1140, which further comments: "Thanks to her love, the faults of the sinners are here remitted by God, vision is restored to the blind, the tongue of the mute is untied, the lame stand erect, the possessed are delivered, and unspeakable benefits are accorded to many."

The Virgin Mary was presented by medieval theology as the second Eve, who redeems the first by her obedience to God and thus also provides the means of redemption for humanity. This parallel with Eve is often made explicit in Romanesque artistic imagery by the presence of an apple in one of the Virgin's hands. An example of this can be seen in the Siegburg Madonna, discovered at the abbey of Siegburg near Cologne in 1919 (see FIG. 91, page 122).

It is often thought that the cult of the Virgin was essentially a phenomenon of the Gothic period. In fact, there was a dramatic increase in popular interest in the Virgin Mary from the

95. Legend of Theophilus relief at Souillac, c. 1150.

Originally this relief was probably the side panel of a sculptural ensemble such as that found in the porch of the church at Beaulieu-sur-Dordogne. The figures of St. Peter and St. Benedict are to right and left of the relief.

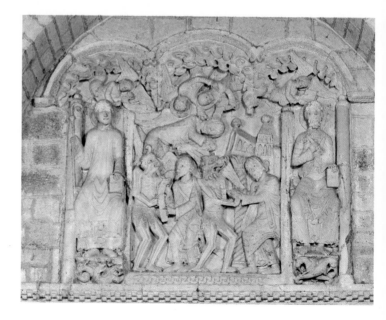

second half of the eleventh century onwards. This is reflected in the art of the period. The Virgin presented an image that was at once accessible and close to the realities of life (she is, after all, most often shown as a mother with a small child), but which was also miraculous – a virgin mother, born without original sin, and very far from the sexuality and sin symbolised by Eve. Most popularly, the Virgin Mary could function as an intercessor on behalf of the ordinary mortal with the distant and remote figure of Christ. Her role as an intercessor is explicit in a relief at Souillac (FIG. 95). The relief depicts the legend of a priest called Theophilus, who was a medieval version of Faust. According to the legend, Theophilus was a priest living in sixth-century Asia Minor, who was dismissed from his position of treasurer by an incoming abbot. Disgruntled, he signed a pact with the devil in exchange for reinstatement in his old job. Then, filled with remorse for what he had done, he prayed for forty days to the Virgin Mary to intercede on his behalf and deliver him from the devil. Eventually she answered his prayers and canceled the bond he had made with the devil. At Souillac, Theophilus is represented in two scenes, both making an oath with the devil and signing a pact with him. In a third scene above, he lies prostrate in front of a church and the Virgin descends from heaven, holding the pact which she has forced the devil to relinquish.

In works from the beginning of the Romanesque period the Virgin Mary is found in a subsidiary role in narrative illustrations, either in scenes to do with Christ's incarnation (the events by which God assumed human form, such as the Annunciation), or in scenes to do with Christ's life and Passion, such as the Crucifixion. In these contexts greater emphasis is increasingly placed on her presentation. This can be seen in the whalebone panel of the Adoration of the Magi (FIG. 5) where she towers above the rest of the figures, even though she is seated. Her head, which appears to be dislocated from her body, combined with her melancholic expression – in premonition of the fate awaiting her infant son, who nestles in the womb-like contours formed by the edge of her garment – provides a central focus to the image with which the spectator can empathise.

Another context in which the Virgin Mary occurs, characteristic of Romanesque art, is in the hieratic, iconic image of a seated, enthroned, static figure, with the infant Christ on her lap. This image expresses the theological mystery and duality of the incarnation: she is a human mother, but also the Mother of God, seated on the Throne of Wisdom, which symbolises Divine Wisdom. An example of this type is found in an illustra-

96. *Virgin and Child* from the Passionary of Hirsau, c. 1125. Colored drawing, 13⅝ x 8⅛″ (34 x 20.8 cm). Württembergische Landesbibliothek, Stuttgart.

This manuscript was probably made at the double monastery (containing both men and women) of Zwiefalten on the river Danube.

tion to an early twelfth-century German manuscript of the lives of various saints (FIG. 96). The Virgin is represented in majesty, enthroned and crowned, with a sceptre in her right hand. She holds the infant Christ in her lap and looks straight ahead impassively; there is no emotional interchange between mother and child.

In the twelfth century new images of the Virgin Mary in European art were either adapted from Byzantine or Near Eastern art, where she had traditionally been given a more prominent role, or were newly created types. In these images greater emphasis is placed on a more human representation of the Virgin, in which she displays compassion, tenderness and sorrow.

97. *Tree of Jesse*, c. 1130. Colored ink drawing on parchment, 5 x 3″ (12.5 x 7.5 cm), Bibliothèque Municipale, Dijon.

This drawing, from a manuscript made at the Cistercian abbey of Cîteaux, is done in a style that reflects Byzantine influences. It is an early and rudimentary example of the Tree of Jesse, with the Virgin Mary holding the infant Christ at her breast (the Virgo Lactans). It is also an example of the theological system of typology, as the Tree of Jesse is surrounded by Old Testament "types" of the Virgin Birth as cited by the theologian Honorius of Autun (died c. 1130). These include Moses and the burning bush, Gideon watching the dew falling on his fleece, Daniel in the lions' den, and the Hebrews in the fiery furnace. It illustrates the recondite sophistication of twelfth-century theology.

One of the most characteristic images of the Virgin Mary in Byzantine art is the Hodegetria, named after the Hodegos church in Istanbul. In it, the Virgin Mary is usually shown standing, holding the infant Christ, who is in the act of blessing, on her left arm. An early example of its adaptation in Western art is the Siegburg Madonna. Though the Virgin Mary still has a serene appearance in this sculptural fragment, she also has a more relaxed air, while her plaited hair and modest head-covering give her the appearance of an ordinary woman.

Another, more earthly image of the Virgin Mary, first evolved in the Coptic art of Christian Egypt, is the Virgo Lactans, in which the Virgin Mary is shown with the infant Christ at her breast. An isolated example of its use in Western art occurs in a Cistercian manuscript made at Cîteaux in about 1130 (FIG. 97), where the Virgin is labeled by her Greek title as Theotokos ("Mother of God"). Early Cistercian monks held the Virgin Mary in particular esteem, dedicating all their churches to her. St. Bernard was especially devoted to her.

The death and Assumption of the Virgin were common themes in Byzantine art, and infiltrated German art in the early eleventh century. In the twelfth century in Europe there was an intense debate, particularly in England, as to whether the Virgin's soul or her entire body ascended to heaven at her death. This debate is reflected in an illustration to a late twelfth-century English psalter in which the Virgin Mary's shrouded corpse is escorted to heaven by an entourage of angels (FIG. 98).

One of the most important innovations of Western art in the twelfth century was the image of the Triumph of the Virgin. This later developed into one of the most enduring themes of Christian art: the Coronation of the Virgin. In the Triumph of the Virgin, Mary is shown seated on a throne as the companion of Christ. The imagery was developed from the *Song of Songs*, one of the most discussed books of the Bible in the twelfth century, where the Virgin was interpreted as the bride of Christ and as a symbol of the church. In the Coronation of the Virgin the image was further developed; Christ physically places a crown on the Virgin's head and she becomes not only his bride, but also his queen (FIG. 99). Thus she became Christ's equal, and no longer played a purely subsidiary role as his mother.

98. *Assumption and Burial of the Virgin Mary* from the York Psalter, c. 1170. Illumination on parchment, 11½ x 7½" (29 x 18.5 cm). Glasgow University Library.

This extraordinary image has been linked to a vision experienced by a twelfth-century German Benedictine nun, Elizabeth of Schonau (d. 1164), in which Mary was carried to heaven in body and spirit by a multitude of angels. In its highly patterned appearance and use of non-naturalistic colors the image typifies the late Romanesque book-illumination of northern England.

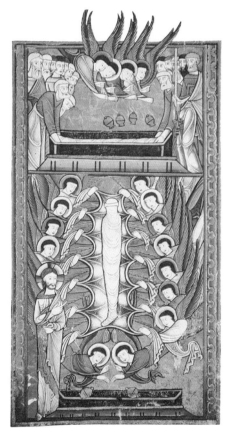

99. *Coronation of the Virgin,* side panel from the wooden altar of the church of Santa Maria de Lluca, Catalonia, c. 1200. Pigments on wood, 3'4" x 3'6" (1 x 1.1 m). Museu Episcopal, Vic, Spain.

A large number of Romanesque paintings on wood have survived in Catalonia. They were chiefly used to cover the sides and frontals of altars, because they were cheaper than textiles.

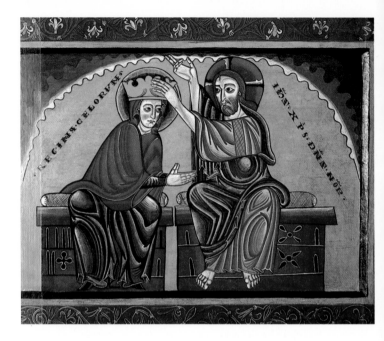

A phenomenon parallel to the cult of the Virgin Mary, with its emphasis on divine love, was the cult of courtly love. This was eulogised by the twelfth-century troubadour poets of Provence and emphasised a more earthly form of love. It is the theme of the enamels on a late twelfth-century casket of Limoges workmanship, which depict a pair of dancers and a pair of lovers (FIG. 43). Here, the lover kneels before his lady with his hands joined together in the shape of a heart; his fealty to her is symbolised by the rope tied around his neck, the end of which she holds. The total adoration which the lover displays for his lady replicates the relationship between the faithful and the Queen of Heaven.

Tomb of Eleanor of Aquitaine at Fontevrault abbey, first quarter of the thirteenth century.

Women as Creators and Consumers of Art

As has been said, during the twelfth century, women's opportunities to lead a religious life multiplied dramatically. In England alone, 120 new religious communities for women were established, so that by the end of the century the religious institutions of England could accommodate more than three thousand women. In France, the famous abbey of Fontevrault was founded in 1101. This was a "double monastery" with both male and female communities under the direction of an abbess. It was later patronised by Eleanor of Aquitaine and became the burial place of the Plantagenets. The twelfth-century abbey church survives (FIG. 100): it has a nave consisting of four domed compartments – an arrangement characteristic of the architecture of southwest France – which culminates in a more traditional design for the east end. This is composed of a choir surrounded by an ambulatory passage from which side chapels radiate. Contemporary evidence suggests that there was a division of use of the church, with the nave being occupied by the nuns, while the choir was reserved for the monks. In Germany a similar tradition developed of convents presided over by abbesses from noble families (FIG. 101).

100. Interior of the nave of Fontevrault abbey, first half of the twelfth century.

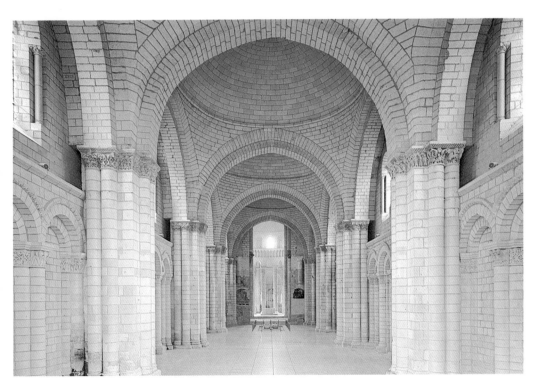

101. *Virgin and Child with Saints* from a psalter of c. 1200. Illumination on parchment, 6³/₄ x 4¹/₂" (17 x 11 cm). Biblioteca Apostolica, Vatican.

This is the sole illustration to a psalter made for the use of a nun in a Middle Rhenish convent. It contains instructions written in Old German on how to use images for private devotion. One instruction states: "stand in front of the cross and gaze at it ... now look at the visage of our Lord."

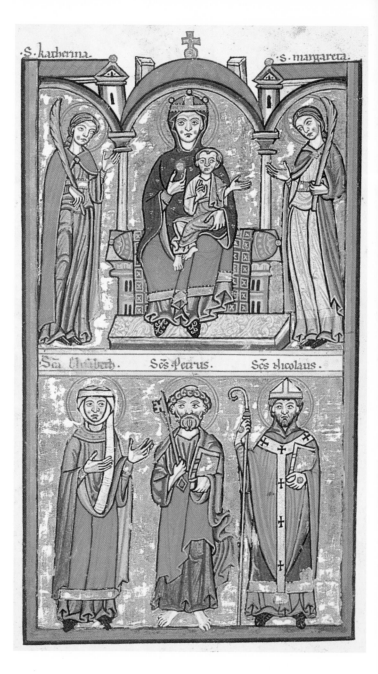

The monastic environment of the twelfth century provided an opportunity for women to gain an education, to pursue artistic and cultural activities, and to exercise a degree of autonomy independent of the influence of men. The lives of three remarkable holy women demonstrate these developments to an exemplary degree; and while they may not have executed the artifacts

discussed here directly, they were responsible for creating a cultural and spiritual ambience without which these works of art would never have come into being.

Christina of Markyate

Christina of Markyate was the prioress of a small community of nuns in the vicinity of St. Albans near London, and died after 1155. Shortly after her death her biography was written by a monk of St. Albans. It records that she made a private vow of virginity in her youth, but was eventually forced by her parents to consent to an arranged marriage. In order to escape from this she went to live in secrecy, first with a woman recluse and later with a hermit named Roger. After Roger's death she was befriended by Abbot Geoffrey (d. 1146) of the local abbey of St. Albans.

The St. Albans Psalter, one of the most sumptuous and extensively illustrated manuscripts of the twelfth century, is thought to have been commissioned by Geoffrey as a gift for Christina. It might perhaps be more appropriate to refer to it as the Christina of Markyate Psalter, as it contains so much material of personal significance to her. The psalter, written in French, includes the life of St. Alexis (a fifth-century saint whose life paralleled that of Christina, as he too was forced into marriage against his will, but escaped on his marriage night). It also contains a copy in Latin and a copy in French of Pope Gregory the Great's famous letter on the function of images as a means of teaching the illiterate (probably a justification for the set of forty richly painted illustrations prefacing the text); and three colored drawings of the story of Christ at Emmaus, with Christ dressed as a pilgrim. These drawings parallel events recorded in Christina's biography, in which an unknown pilgrim visits and eats with her at her priory, and is only subsequently recognised by her as Christ. The date of the psalter is the subject of some controversy, but it is tempting to link it with Christina's monastic profession at St. Albans in about 1131.

There is considerable evidence of psalters of this type being made for high-ranking women who belonged either to the church, as in the case of the St. Albans Psalter, or to lay society, as with the Melisende Psalter discussed in chapter one and the late twelfth-century Ingeborg Psalter belonging to the Danish princess Ingeborg, wife of the French king Philip Augustus, or the Fécamp Psalter, discussed in chapter three. It seems likely that the rich illustrations in these psalters were used as devo-

102. *The Annunciation* from the St. Albans Psalter, 1120-30. Illumination on parchment, 7¼ x 5½" (18 x 14 cm). St Godehard's church, Hildesheim.

The extensive use of purple and the paneled background reflect the influence of German art. The white, comb-like patterns of the highlights are derived from southern Italian painting. The illustration's elaborate frame should also be noted.

tional aids for private meditation – Christina evidently had an intense interior religious life and her biography records that she experienced visions.

One of the illustrations in the St. Albans Psalter is of the Annunciation. It contains an iconographic innovation, depicting the Virgin Mary with an open book on her lap (FIG. 102). She looks as if she has just been interrupted in her reading by the miraculous entrance of the Archangel Gabriel. Ailred, abbot of the Cistercian abbey of Rievaulx in Yorkshire from 1147 to 1167, described how, at the moment of the Annunciation, the Virgin Mary held the Book of Isaiah in her hands and read the words, "Behold a Virgin shall conceive." Showing the Virgin Mary in the act of reading provided an intellectual role model for Christina and for women in general, and the use of this motif

indicates a greater literacy at this time among both noble and religious women. Another illustration in the St. Albans Psalter contains the extremely rare subject of Mary Magdalen announcing Christ's resurrection to the apostles (FIG. 19).

Hildegard of Bingen

The best-known religious woman of the twelfth century was Hildegard of Bingen (1098-1179). Hildegard joined the double monastery of Disibodenberg in the Rhineland as a child and became the abbess of its community of nuns (FIG. 103). In 1147 she experienced a vision that caused her to leave Disibodenberg and set up her own community, solely of nuns, at Rupertsberg near Bingen in the Rhineland. Hildegard was a cultured woman of wide learning: she composed music, was a prodigious letter-writer and wrote texts on medicine and herbalism.

However, she was best known in her time for her visions, which were set down in writing and illustrated by the nuns of her new community. The two books of Hildegard's visions are entitled *Know the Ways of God (Scivias)* and *The Book of Divine Works (Liber Divinorum operum)*. The earliest illustrated manuscript of the former, executed in Hildegard's own lifetime, has been lost since 1945 and it is now only known to us through previous reproductions. The illustrations appear to have been designed under her close supervision, though they cannot have been painted by her in their entirety as they are the work of several hands. An illustrated copy of *The Book of Divine Works*, does, however, survive from the early thirteenth century. In it are recorded ten visions of the cosmos. The illustrations have a poetic, surreal, and ethereal quality.

Below the first illustration in this book is a small vignette of Hildegard writing down her visions on wax tablets with the assistance of the nun Ricardis; to the left her confessor and lifelong friend, the monk Volmar, copies the text into a book (FIG. 104). The subject of the main illustration is divine love as a "supreme and fiery force." This abstract concept is embodied in the traditional form of a young woman. What is unusual in the illustration is the scale and rendering of the figure: her face is bright red, a color associated in the twelfth century both with

103. *The Feeding of the Five Thousand* from the Prayer Book of Hildegard of Bingen, c. 1180. Colored ink drawing, 6½ x 4″ (15.9 x 10.3 cm). Bayerisches Staatsbibliothek, Munich.

A later inscription in the book identifies it as having belonged to Hildegard of Bingen, but her ownership has been questioned. The manuscript is thought to have been made in the Middle Rhine region, where Hildegard was abbess of the convent at Bingen. Like the luxury psalters of the twelfth and thirteenth centuries, and the Books of Hours of the later Middle Ages, this richly decorated manuscript was intended to serve the private devotions of a woman of high rank.

104. The *Vision of Divine Love, who holds the Lamb of God, and tramples upon Discord and the Devil* from *The Book of Divine Works,* c. 1200. Illumination on parchment, 13¾ x 6½" (34.5 x 16 cm). Biblioteca Statale, Lucca.

divine love and the element of fire, and from the top of her head emerges the face of an old man – "fatherly tenderness." She also holds the Lamb of God in her hands and tramples on Satan and Discord under her feet.

Herrad of Hohenberg

Herrad of Hohenberg (d. 1195) was one of the most learned women of the twelfth century, and abbess of Hohenberg in Alsace. She is chiefly remembered for her encyclopedia, compiled between 1170 and 1196, and entitled the *The Garden of Delights (Hortus Deliciarum)*. It was intended for the personal education of the nuns under her care, and was conceived as a history of the world, told against a Biblical background. The information it contains was culled from a wide range of sources, including Eastern and classical literature. Herrad described her efforts as being "like a bee ... I drew from many flowers ... and I have put it together ... as though into a sweet honeycomb." Unfortunately the original manuscript of the *The Garden of Delights* was completely destroyed in the Franco-Prussian War of 1870-71, but again it is known to us through earlier reproductions. Some of its illustrations were almost the size of small panel paintings, and fittingly they have a monumental appearance, betraying the influence of Byzantine art. Some of them show great originality (see FIG. 105).

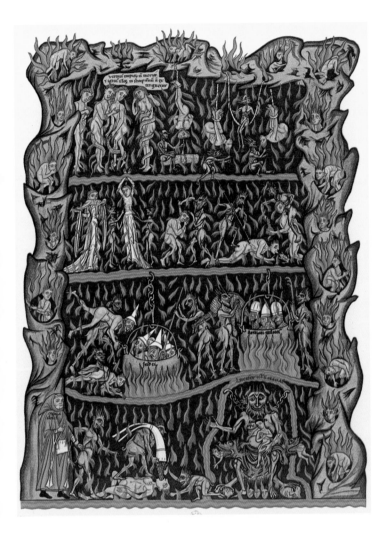

105. Illustration of the Last Judgement from *The Garden of Delights*, c. 1180. (Facsimile), Bibliothèque Nationale, Paris.

In the bottom level of the illustration a monk clutching a money bag is condemned to Hell, while to his right Satan is enthroned with the Anti-Christ on his lap. Above this, groups of Jews and knights are thrown into burning cauldrons. At the top of the illustration various other punishments are depicted. This vivid image anticipates the Last Judgement scenes of Hieronymus Bosch. The illustrations to *The Garden of Delights* have many idiosyncratic elements. Here tormented figures emerge from holes in the unusual framing device, and the black background is laced with red flames.

The achievements of Christina, Hildegard, and Herrad must be seen as part of the short-lived period in the history of monasticism when the male-dominated church was sympathetic to women's cultural and intellectual aspirations. The universities of Paris, Poitiers, and Oxford, then coming into being as part of the reaction in the new urban centers against monasticism, might have provided women with alternative places of learning, but by the thirteenth century the misogynist fears characteristic of male monasticism had begun to reassert themselves.

SIX

Romanesque Art and Alien Cultures

106. Herimann Cross, c.
1050 (head: 1st century AD;
filigree background: early
thirteenth century). Cast
bronze, engraved and gilded,
with lapis lazuli head, 16½ x
11¼" (41 x 28 cm).
Erzbischofliches
Diozesanmuseum, Cologne.

A bronze crucifix made in the middle of the eleventh century for Herimann, Archbishop of Cologne, has on its front face the effigy of Christ. Affixed to this effigy is a head made of an intensely blue stone (FIG. 106). On closer examination the head, with its idealised features and soft modeling, obviously comes from a culture very different from that which produced the torso. The diagrammatic appearance of this part of the effigy is characterised by the sharp edges of the drapery folds of the tunic, bound at its center by an intertwined knot in the form of a figure 8. The head is, in fact, Roman and was made in the 1st century ad; it has been identified as a portrait of the Empress Livia, and was presumably incorporated into the crucifix at the request of Herimann, who is portrayed on its reverse side.

What were the motives of the artist in incorporating an object from a pagan culture into this central symbol of the Christian faith? It might have been prompted by the preciousness and color of the head, which is carved from lapis lazuli, the only source of which in the Middle Ages was a mine in Badakshan in present-day Afghanistan. The same intense blue is found in the "sapphire" glass in the windows at St. Denis and forms the background to the vision of Ezekiel in the Bury Bible. According to the twelfth-century monk Adam of Scotland, this color was redolent of heaven and spirituality. Another possible motive was the imperial aspiration of Archbishop Herimann, who was a grandson of the Holy Roman Emperor Otto II. The classical association is made even more explicit in the so-called Lothar Cross (FIG. 107) which contains at the center of one of its sides an antique cameo of the Roman emperor Augustus. Presumably, a

107. Lothar Cross, detail of the antique cameo of the Emperor Augustus, c. 1000. Height 20″ (49.8 cm). Aachen Minister Treasury.

On the reverse of the cross is engraved an image of the Crucifixion.

third motive was an aesthetic appreciation of the object itself which in the process of appreciation had been divested of its associations with a pagan culture.

The Heritage of Antiquity

The legacy of antique art and architecture has been interpreted in different ways by successive generations of artists, and continues to inspire artists in the twentieth century. In the twelfth century there was so marked a renewal of interest in texts by classical authors such as Cicero and Pliny, that historians speak of a twelfth-century "renaissance." Was there a parallel phenomenon in the visual arts? For the eleventh and twelfth centuries, "antique" art meant primarily the art and architecture of the Roman empire. Nevertheless, it should be remembered that Roman art in turn had copied many of the most significant pieces of Greek sculpture (indeed, many Greek objects are known to us only through Roman copies).

During the Romanesque period, Roman ruins survived to a far greater extent than they do today, especially in Rome itself. The throngs who descended on Rome, either on papal business,

or as pilgrims come to venerate the relics of St. Peter and St. Paul, toured the ancient sites of the city. Two guidebooks were written for these visitors in the middle of the twelfth century. One of them, by an Englishman called Master Gregory, describes various pagan antiquities. It includes a description of a nude statue of Venus, which is praised for its material, the consummate skill of its carving and, following a commonplace of aesthetic appreciation, its lifelike appearance: "This image is made from Parian marble with such wonderful and intricate skill that she seems more like a living creature than a statue."

Antique art was primarily used by Romanesque artists as a quarry for materials. The ruins of Roman civilisation were found throughout Europe. To cite a few examples: the abbey at St. Albans was rebuilt shortly after the Norman Conquest with materials from the nearby Roman city of Verulamium (St. Albans); the powdered glass used for champlevé enamel came from the glass tesserae of Roman floor mosaics; and the relief attributed to the Master of Cabestany, from the abbey of Sant Pere de Rodes in Catalonia, re-used white marble from a Roman or early Christian sarcophagus.

Elements were also borrowed from the vocabulary of Roman art and architecture, as can be seen in the nave elevation of Autun cathedral (FIG. 108). The triple-arch arrangement of its triforium was based on the Roman city gates at Autun, which are still standing. The frieze of rosettes underneath the triforium is also Roman in style, but in Roman architecture it would have been found on a coffered or vaulted ceiling. This antique vocabulary is combined with distinctly post-antique features, such as pointed arches and historiated capitals, and is introduced into contexts in which it would never originally have occurred. Motifs are lifted from Roman art with a complete disregard for the aesthetic principles that originally regulated their use.

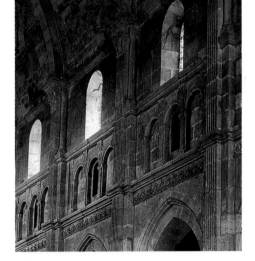

108. Autun cathedral, detail of the nave elevation.

Did Romanesque artists consciously look at antique art and set out to imitate its style and model their forms on it? Some of the sculpture discussed earlier – such as the Modena frieze, the St. Sernin reliefs, the hunting scene in the tympanum at Bourges, the Brunswick lion, and the Autun Eve – reflect an interest in Roman precedents. But the degree of Roman influence is difficult to gauge. The appearance of these sculptures is

certainly very different from anything found in Roman art. The fragment of the frieze attributed to the Master of Cabestany representing Christ walking on the water bears the clear imprint of late antique and early Christian art: the carving is deeply undercut, an effect achieved by the use of the Roman device of the drill; the heads have a classical appearance; it has also been suggested that the inscription has been carved in a consciously archaic style. Yet the piece could not be mistaken for antique work: the artist exhibits a distinctly expressionistic streak, evident in the elongated fingers and the slanting eyes of his figures. The characteristic Romanesque love of pattern also asserts itself, in the treatment of the waves of the water and the uniform, serried row of fish (FIG. 109).

109. ATTRIBUTED TO THE MASTER OF CABESTANY *Christ Walking on the Water,* c. 1150. Marble relief, 33 x 24½″ (82 x 61 cm). Museu Frederic Marès, Barcelona.

The scene is thought to represent Christ walking on water (as described in Matthew 14: 24-32) both because Christ appears to be standing on water and because of the inscription, which can be translated as "wherein Christ appears to the disciples on the sea." St. Peter is stepping out of the boat to go toward Christ. The high quality of the marble may have prompted its re-use from the earlier piece.

After the fall of the Roman empire the classical tradition survived in Byzantine art, with its sense of the human form beneath the concealing garment. It was also revived in the earlier Middle Ages, most notably in certain aspects of Carolingian and early eleventh-century German art. Romanesque artists seem to have assimilated classical influences more readily through these intermediaries than from antique survivals themselves.

The difficulties concerning the question of classical influence are demonstrated by the bronze font made between 1107 and 1118 probably by Rainer of Huy for the church of St. Barthélémy in Liège (FIG. 110). The font is the finest example of a series of objects made at or near Liège. Their antique appearance and recondite imagery typify the intellectual refinement of Liège in the twelfth century; the city was described by contemporary monks as "the Athens of the North" and its school was compared to the Academy of Plato. Cast on the font are five scenes, separated by trees, on the theme of baptism. The figures balance gracefully on a projecting platform and stand out from the background, creating an illusion of space. Some are naked, while

even those that are clothed retain a sense of the form of the body and of its free movement beneath the garment. The half-length, naked figures of the centurion Cornelius and the philosopher Crato, who are shown immersed in small cylindrical fonts, have been compared to a surviving Roman bronze statuette in Cologne. And yet the general consensus is that the sources of Rainer of Huy's style are to be found not in any actual works of classical art, but in Liège ivories of the eleventh century (themselves strongly influenced by classical examples) and in contemporary Byzantine art.

110. RAINER OF HUY
Baptismal font (1107-1118).
Bronze, height 24″ (60 cm).
St. Barthélémy Church, Liège.

The five scenes on the font show St. John the Baptist preaching in the wilderness; the baptism of the publicans by St. John the Baptist; Christ's baptism, the focal point of the design; the baptism of the centurion Cornelius by St. Peter; and the baptism of the philosopher Crato by St. John the Evangelist.

Romanesque Art in Relation to Islam

Carved in shallow relief on one of the wooden doors to the cathedral of Le Puy in central France are episodes from the childhood of Christ (FIG. 111). The door, which can be dated to the middle of the twelfth century, bears the signature "Gauzfredus," and around its borders is an inscription in stylised Kufic script which has been translated as "all power to Allah."

The presence of such an inscription at the entrance of a Christian church is, to say the least, surprising. In 1095 Pope Urban II, preaching only some fifty miles north of Le Puy at Clermont, called for a Crusade against the Muslims, whom he described as an "infidel race, so justly scorned, which has sunk from the dignity of man and is a vile slave of the devil." Le Puy stood at the beginning of one of the four pilgrimage routes through France to Santiago, the Spanish section of which bordered Islamic territories and had become reasonably safe for pilgrims to travel only in the second half of the eleventh century. It can only be assumed that the meaning of the script was understood neither by Gauzfredus nor by his public. However, the use of Kufic and pseudo-Kufic script within Christian contexts was not exceptional; rather it was symptomatic of the West's assimilation of the visual culture of Islam. It indicates the lack of Western understanding of Islamic religion and culture and its view of Islam as a vague, foreign, external "other" (as opposed to the Jews who functioned as an internal cultural "other," against which Romanesque society defined itself). The ignorance of Islam among European Christians had been almost total until the 1140s, when Peter the Venerable (d. 1158), abbot of Cluny, commissioned a translation of the Koran with the intention of educating Christians about the religion he called the "greatest of heresies." The inscription around the door at Le Puy is typical of the way in which European artists assimilated certain aspects of the vocabulary of Islamic art, transforming it into a decorative element, and in the process robbing it of meaning. The confidence with which the artistic vocabulary of an alien culture was imbibed and enframed within a Western context can only be interpreted as a form of artistic imperialism. Pieces of Islamic art were flaunted as trophies of military triumph and trading dominance: the famous bronze griffin brought back by the Pisan navy in the late eleventh century from one of their successful invasions of Islamic territories was later placed on a central gable high in Pisa cathedral.

111. GAUZFREDUS
Infancy doors from Le Puy cathedral, c. 1150.

An inscription records the name of the artist, Gauzfredus, and that of the patron, Peter, abbot of Puy from 1143 to 1155. The scenes on the doors show the Massacre of the Innocents, the Presentation in the Temple, the Magi journeying to Herod's court and the Magi before Herod.

112. The cathedral complex at Pisa: the baptistry (1153-1265), the cathedral (begun 1063) and the belfry or "Leaning Tower" (1174-1271).

In the Romanesque period Pisa was a considerable sea-power with a formidable navy, which in 1062 gained a decisive victory over a muslim force near Palermo. The foundation stone of the cathedral was laid a year later, and work continued on the complex of buildings into the thirteenth century. The buildings are characterised and aesthetically co-ordinated by their white marble exteriors, the use of sequences of simple geometric shapes, and the tier upon tier of open colonnades. Pisa's prosperity at this time was partly due to its trade with the East, particularly the Holy Land, and this link is reflected in the design of the baptistry, which was inspired by the rotunda of the church of the Holy Sepulchre in Jerusalem.

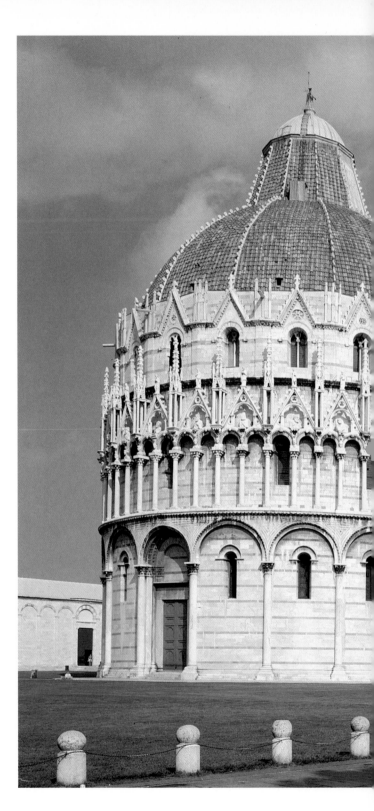

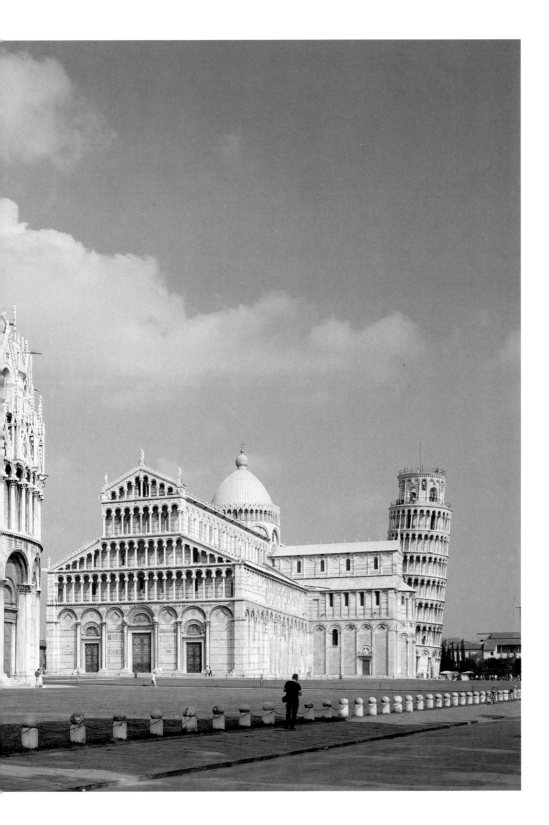

The question of the Islamic influence on Romanesque art is complicated by the fact that Byzantine and Islamic art shared many forms, so that distinguishing between the two influences is often very difficult. However, while Islamic art functioned as a catalyst in itself it remained largely impervious to Western influence − the art of the territories established in the Holy Land by the victorious Crusaders was imported wholesale from the West. This question can be explored by examining examples of European art from three regions under the influence of Islamic culture: southwest and central France, northern Spain, and Sicily.

Perhaps surprisingly, signs of Islamic influence can be seen earlier in southwest and central France than in northern Spain, despite the fact that Spain bordered on Al-Andalus − the name given to the Islamic territories in the south of the Iberian peninsula. Islamic influence even extended as far as Burgundy, as can be seen in the multicolored masonry of the transverse arches at Vezelay and the rows of horseshoe arches used as decoration at Cluny III. It is most marked at Le Puy, where it can be seen not

only in the cathedral, but also in a small chapel dedicated to St. Michael (FIG. 113). Its doorway is surmounted by a recessed arch composed of three horseshoe-shaped lobes, and it is enlivened by multicolored and patterned masonry combined with heavily textured, lace-like ornament carved in low relief (FIG. 114). The doorway has been compared to the tenth-century gate of al-Hakam II from the Great Mosque at Cordova.

114. Doorway to the chapel of St. Michael at Le Puy, c. 1150.

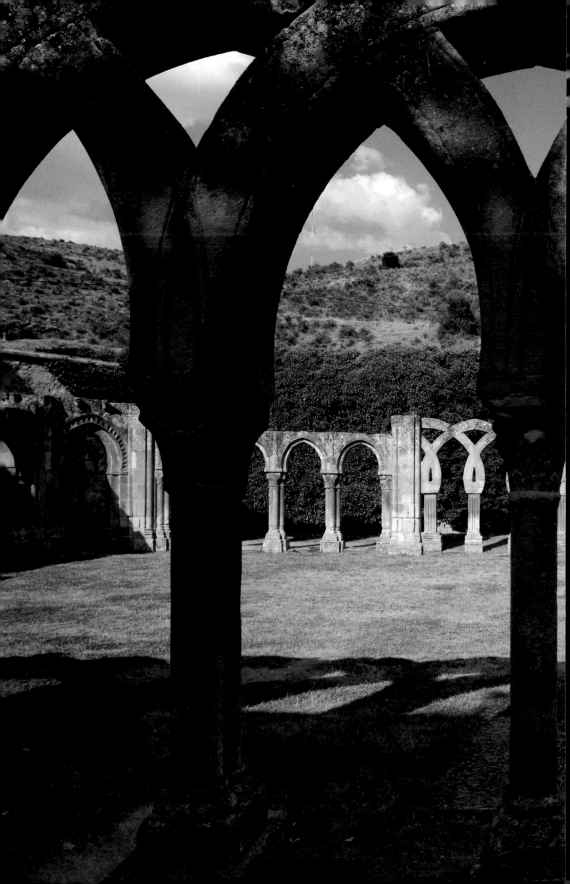

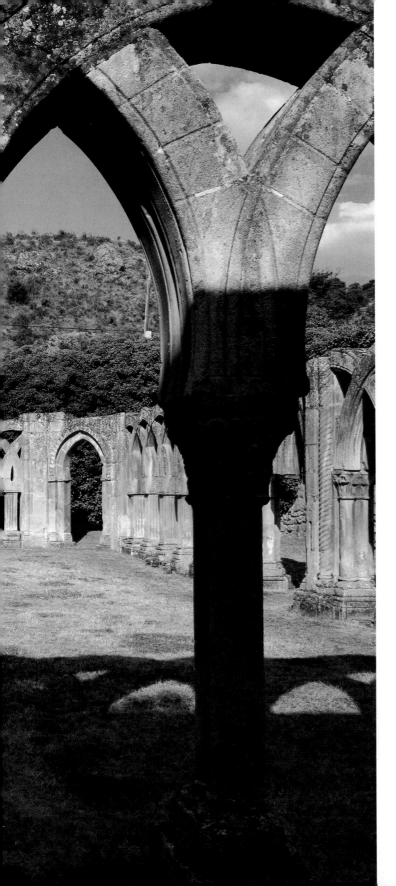

115. View of the cloister of San Juan de Duero, Soria, in Castile, c. 1200.

The infiltration of Islamic motifs into the art of the Christian territories of northern Spain is not surprising. What is unexpected is the fact that this happened only comparatively late in the twelfth century; in general, the art of northern Spain fell under the shadow of French and German influences. A dramatic example of Islamic influence is the arcade of intersecting arches for the cloister of the church of San Juan de Duero at Soria, in Castile, which belonged to the military order of the Knights Hospitallers of St. John of Jerusalem (FIG. 115). Built at the end of the twelfth century, it was probably constructed by Muslim craftsmen under contract to the Christian Hospitallers.

The region under Christian rule in which the presence of Islamic art is most evident is Sicily. After the island was captured by the Normans in the last third of the eleventh century, the indigenous Muslims continued to live in harmony with the Norman population. The Norman rulers forged trade links with the Near East, while at the same time contributing men and money to the Crusades. Islam was renowned for the manufacture of certain luxurious items for which there was no comparable tradition in the West: painted glass vessels, ceramic lustreware, figurative silks, incised bronze sculptures in the form of animals, and carved ivory caskets with secular imagery. The Norman rulers of Sicily encouraged the local Muslim population to manufacture these items; in particular they fostered the silk industry. The supreme achievement among Sicilian silks is the coronation mantle of Roger II, embroidered in gold thread between 1133 and 1134, according to its Islamic inscription, by Muslim artisans in Palermo (FIG. 116). The silk may be Byzantine but the design is typically Islamic. Set against a red background, the color tra-

116. Coronation mantle of Roger II, c. 1133-34. Silk with gold embroidery, 4′ 10½″ x 11′ 6″ (1.4 x 3.4 m). Kunsthistorisches Museum, Vienna.

ditionally associated with kingship, it consists of a symmetrical arrangement of a lion subduing a camel, with a stylised tree at its center.

The Islamic contribution to the development of European art is most marked in these luxurious art forms, which we would nowadays describe as decorative arts. It can be seen in the development of the silk industry for which by the fourteenth century the Italian city-states had become renowned (here again, the Byzantine contribution was equally important), in Limoges enamels, in the bronze *aquamanilias* (water containers) in the form of animals produced in Lower Saxony, and in the painted ceramics of Christian Spain and Italy.

The Jews

The bottom right roundel of the Stavelot Triptych (FIG. 44), where the Empress Helena is shown interrogating a group of Jews as to the whereabouts of the True Cross, contains a feature not found in previous representations of the subject: the fire, with its flickering flames, into which the Jews will be thrown if they do not divulge this information. The fire is a vivid reminder of the virulent anti-Semitism that swept through Europe in the wake of the Crusades, and of the fires used in the forcible conversion of Jews to Christianity.

The Jew's House at Lincoln.

Prior to the First Crusade, Jews had lived in comparative harmony with Christians. But the huge popular army that preceded the disciplined military force led by Godfrey de Bouillon indiscriminately murdered thousands of Jews on its route to the Holy Land through the Rhineland. This was done at least partly to steal Jewish possessions, and was justified on the grounds that the Jews had murdered Christ.

European attitudes towards the Jews in the eleventh and twelfth centuries were not consistently negative. In many regions Jews lived in harmony with the local population and prospered, as is attested by the sturdy townhouses built for them in stone. These survive in England, for example, at Norwich and Lincoln. In 1976 the remains of a handsome stone-built synagogue were discovered underneath the Palais de Justice in Rouen. It is thought to date from the turn of the twelfth century. Its architectural style is akin to that of local Christian churches of the same date. Furthermore, there was a certain respect for Jewish learning.

Stephen Harding, the English abbot of Cîteaux from 1108 to
1133, records that, when collating a reliable text of the Bible for
his community, he consulted "certain Jewish experts in their
own [Hebrew] writing"; and the Hebrew alphabet is rendered in
gold as part of the embellishment of a late twelfth-century Eng-
lish Bible from St. Albans (FIG. 117).

Anti-Semitism gave birth to new images. The Jewish religion
had been traditionally represented since the ninth century by the
female figure of Synagogue in Crucifixion scenes. It had no neg-
ative associations at that time, and had, as its pair, a similar per-
sonification of the Christian Church. But during the twelfth
century the figure of Synagogue assumed increasingly negative
attributes. This anti-Semitic imagery introduces us to one of the
saddest chapters in European history and reminds us of the
potency of images in forming public attitudes, and of the func-
tion of images in the Romanesque period in general. In the
Stavelot portable altar of the mid-twelfth century, she is blind-
folded, symbolic of her refusal to recognise Christ, and she holds
the instruments of Christ's Passion – the crown of thorns, the
spear, and the sponge – in her hands. The responsibility for
Christ's crucifixion is laid upon her (FIG. 118).

119. *Synagogue Spearing the Lamb of God*, detail from the Cloisters Cross, c. 1130-70. Walrus ivory with traces of original polychromy, 23 x 14¹/₂″ (58 x 36 cm). Metropolitan Museum of Art, New York.

The Cloisters Cross is the most impressive altar cross to survive from the Romanesque period. In the central medallion on its back is the Lamb of God as described in the Book of Revelation. It is pierced by a lance brandished by the figure of Synagogue. Behind Synagogue stands the grieving St. John the Evangelist. These figures are surrounded by others with scrolls of speech issuing from their mouths. The Cloisters Cross is either linked with the style of Master Hugo and consequently dated about 1130, or seen as an example of early Transitional art and dated about 1170.

A negative representation of Synagogue is also found in the central medallion on the back of the Cloisters Cross (FIG. 119). She is shown brandishing a spear with which she pierces the Lamb of God, and is thereby identified with Longinus, the Roman centurion who pierced Christ's side on the cross. This image has been related to anti-Semitic feelings in England, where a number of Jews went to live after the Norman Conquest. Jews were distrusted as moneylenders and vilified in popular folklore. They were accused of ritual murder and the desecration of the host, the consecrated bread used in the Eucharist as the symbol of Christ's body. Reference to this belief is made in the lintel of the tympanum at Autun, where a figure digs into what appears to be a large host.

Jews are frequently singled out for specific punishment in Last Judgement scenes. This can be seen in an illustration to the *The Garden of Delights*, in which a group of Jews, naked but for

their pointed hats, are thrown by demonic, grimacing figures into a burning cauldron neatly labeled *Judei* (FIG. 120). Such imagery, devised by the church, provided an ideological justification for violence against the Jews.

In the religious thought and imagery of this period Jews were identified in particular with the disgraced disciple, Judas Iscariot. In a capital at Autun the fate of Judas is shown: he is hung from a tree and strangled by two demons, while clutching in his hands the purse containing the thirty pieces of silver mentioned in the Bible – a reminder of one of the most important functions of Jews in the economy of the time as moneylenders (FIG. 121).

120. *The Garden of Delights*, detail of the group of Jews.

121. *The Suicide of Judas* Pilaster capital from Autun cathedral, c. 1130. Musée Lapidaire, Autun cathedral.

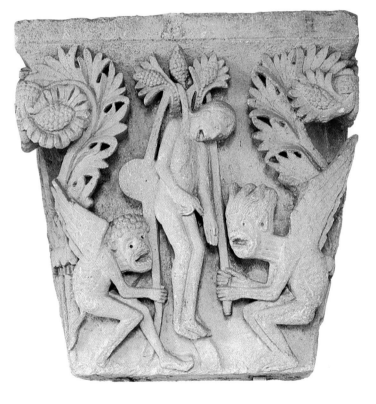

The Legacy
of the
Romanesque

In 1906 the French Fauve artist André Derain painted a work entitled *Dance* (FIG. 123). The pose of the central figure of Eve in this painting, with her legs crossed and her arms swung to the left in an ecstatic movement, is directly based on a Romanesque sculpture of the prophet Isaiah from the church at Souillac in southwest France (FIG. 122). This practice of adapting figure types from earlier art and incorporating them into a composition is frequently found in Romanesque art itself.

The source of Derain's inspiration was probably the cast of the Souillac figure in the Musée de Sculpture Comparée (Museum of Comparative Sculpture) in the Trocadero in Paris. This museum survives today under the name of the Musée des Monuments Français, and in it are strangely juxtaposed under one roof plaster casts of many of the most famous monuments of French Romanesque art. Founded in 1882 under the initiative of Eugène Viollet-le-Duc, the French architect responsible for the restoration of many Romanesque buildings (the abbey of Vézelay is an example), it bears testimony to the nineteenth-century interest in the Romanesque and to the pride of the French in their medieval monuments. Those keen to revive interest in the Romanesque in the nineteenth century believed that it was a truly Christian form of architecture; their enthusiasm generated a whole series of churches built in a neo-Romanesque style, particularly in England, France, Germany, and North America.

Fauvism was the first of a series of artistic movements in the twentieth century that indirectly led to a better understanding of the aesthetic qualities of Romanesque art. The Fauves radically challenged the academic tradition of illusionistic painting, dominated by the convention of one-point perspective, which

122. Figure of Isaiah from Souillac, c. 1140-50.

123. ANDRÉ DERAIN
Dance, c. 1906. Oil on
canvas, 6' x 7'6" (1.8 x 2.3 m).
Fridart Foundation, London.

124. SAN CLEMENTE MASTER
Detail of Christ in Majesty
from the wall-painting in the
apse of San Clemente de
Tahull, 1123. Museo de Arte
Cataluna, Barcelona.

This wall-painting originally
came from the church of San
Clemente de Tahull in the
lower Catalan Pyrenees, but
like many wall-paintings from
this region it was transferred
to the museo de Arte
Cataluna in Barcelona for
safekeeping in the 1930's.
Pablo Picasso was
particularly struck by the
highly idiosyncratic and
distinctive style of the San
Clemente Master, and kept a
poster of this image in his
house at Mougins in Southern
France.

went back to fifteenth-century Tuscany. Their work was characterised by formal dislocations in the use of space and the rendering of areas of light and shade by means of pure, highly saturated color. There are obvious parallels between these aims and ideas and the use of color and form in Romanesque art. Other artists who were visually stimulated by Romanesque art include Henry Moore, Auguste Maillol, Le Corbusier, and Pablo Picasso (FIG. 124). One of the most influential of twentieth-century art historians, the American Meyer Schapiro, combined critiques of avant-garde art in New York in the 1930s and 1940s with a series of seminal studies on French and Spanish Romanesque art. Schapiro analysed Romanesque art not only in terms of its formal qualities, but also in relation to its social and political context. One of his most important studies considers the sculpture at Souillac.

Souillac boasts one of the most compelling of all Romanesque sculptural groups in its trumeau, the central support for the tympanum. This has now been removed from its original setting and placed on the internal west wall of the church, so that only three of its sides can be seen. It is one of the most extraordinary objects to survive from the twelfth century: a dense, chaotic mass of writhing, devouring animals and clinging human figures that for over eight hundred years has defied common sense by not collapsing into a heap on the ground (FIG. 125). The influence of secular Islamic art has been discerned in the criss-cross arrangement and characterisation of the animals, while the density and

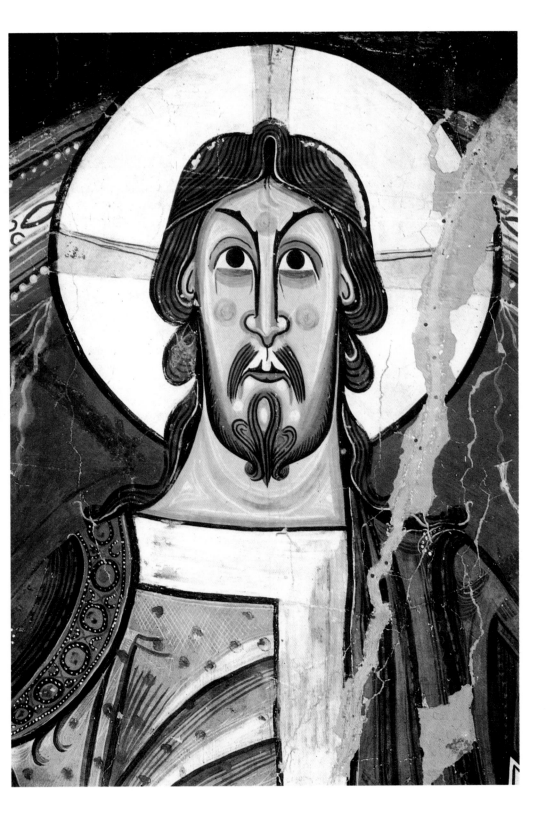

intensity of the composition may be paralleled with vernacular poetry of the period – Schapiro himself compared the greater autonomy of the sculptor in this period with the freedom of the roving troubadour poets.

There are elements in the Souillac trumeau that are plainly based on Biblical narrative (the most conspicuous being Abraham about to sacrifice Isaac), but as a whole it has as yet defied convincing explanation. Perhaps, as one art historian has recently argued, it cannot be understood within the confines of traditional iconography, which deciphers visual imagery by means of textual sources, but reflects instead oral traditions of learning. However much previous centuries may have dismissed this type of work as barbaric, or at best curious, it appeals greatly to the sensibilities of a modern audience. Conditioned by movements such as Surrealism with its exploration of the mysteries of the unconscious, the theories of Freud, and the semi-abstract dream imagery of Miró or Dali, we are better able to appreciate what St. Bernard would no doubt have described as the "marvellous deformed beauty" of the fantastic trumeau at Souillac.

The sculpture at Souillac is another example of Romanesque works of art having been removed from their original setting. Did the fragments there originally form part of a porch ensemble, as at nearby Beaulieu, or did the Benedictine monks of the abbey of St. Marie at Souillac simply lose nerve and abandon the project? We see the ghosts of Romanesque art dimly, through a darkened and distorted glass.

Just as the great portal of St. Gilles-du-Gard, with which this book opened, signaled many of the key issues discussed in it, so the sculptural group at Souillac provides a fitting coda and summation of its main themes. The fantastic imagery and capricious virtuosity of the trumeau are inexplicable as the results purely of a patron's written or verbal brief; they surely reflect instead the greater autonomy and increased status accorded to the artist during this period. The central relief panel of Theophilus, with his hands clasped in those of the Devil, grotesquely imitates the ceremony of homage which a vassal made to his feudal lord – the central tie that bound feudal society together. The two grand, hieratic figures of St. Benedict and St. Peter, which flank this central relief, speak of the predominant power and authority of the Church. Their roles as founders of the Christian church and communal monasticism make them pillars of the Romanesque world. The more prominent and conspicuous

role played by women in the period is reflected in the figure of the Virgin Mary, who descends from heaven surrounded by an entourage of angels and frees Theophilus from his bond with the devil – a woman in a positive and active role in relation to a supplicant man. Finally, the trumeau assimilates elements from the alien culture of Islam into the framework of Christian European art.

Recent scholarship suggests that the sculptural ensemble at Souillac, which represents the Romanesque style at its finest and most essential, must have been carved during the mid-twelfth century. By this date, some five hundred miles further north in the Ile-de-France a new style had begun to emerge at St. Denis and Chartres. That style was characterised in art by greater naturalism, and in architecture by the transformation of the wall surface into a skeletal frame. Despite the fact that the two styles continued to be practised alongside one another for at least another fifty years, the era of the Romanesque had ended. For the next 250 years the Gothic style was to predominate.

125. The trumeau at Souillac, c. 1140-50.

Europe, the Mediterranean, and the Near East, c. 1050-1200

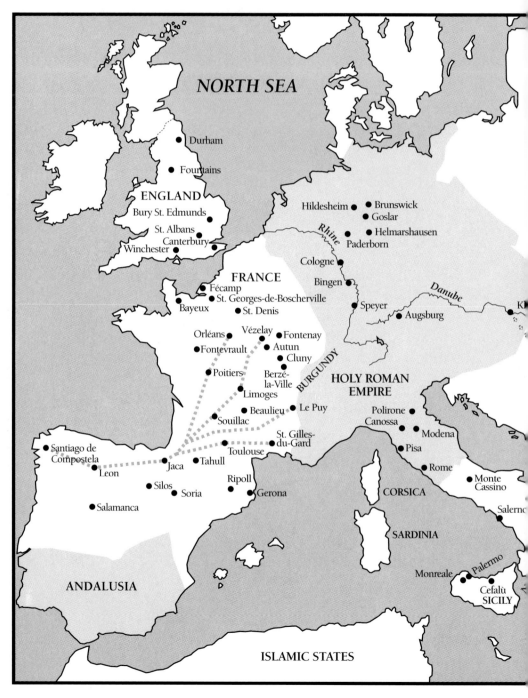

NORTH SEA

Durham

Fountains

ENGLAND

Bury St. Edmunds

St. Albans
Canterbury
Winchester

Hildesheim • • Brunswick
• Goslar
• Helmarshausen
Paderborn
Rhine

FRANCE

Cologne

Bingen

Fécamp
St. Georges-de-Boscherville
Bayeux • St. Denis

Speyer

Danube

Augsburg

K

Orléans • Vézelay • Fontenay
• Fontevrault • Autun
• Cluny
Poitiers • Berzé-
la-Ville
Limoges

BURGUNDY

HOLY ROMAN
EMPIRE

Polirone •
Canossa •
• Modena

Beaulieu • Le Puy
Souillac

St. Gilles-
du-Gard

• Pisa

Santiago de
Compostela
Leon

Toulouse

Jaca • Tahull

Ripoll

Silos • Soria

• Gerona

• Rome

Monte
Cassino

CORSICA

Salerno

• Salamanca

SARDINIA

ANDALUSIA

Monreale • Palermo

Cefalù
SICILY

ISLAMIC STATES

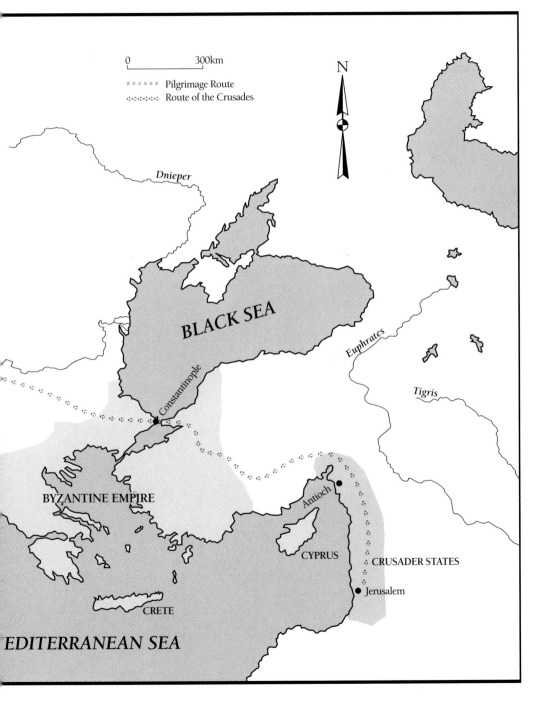

0 300km

▪ ▪ ▪ ▪ ▪ ▪ Pilgrimage Route
◦◦◦◦◦◦ Route of the Crusades

N

Dnieper

BLACK SEA

Euphrates

Constantinople

Tigris

BYZANTINE EMPIRE

Antioch

Antioch

CYPRUS

CRUSADER STATES

Jerusalem

CRETE

MEDITERRANEAN SEA

	Historical Events		Architecture	
1050	1060-91	Conquest of Sicily by the Normans	1062	Construction of church of Sa Miniato, Florence, begun
	1066	Death of Edward the Confessor Battle of Hastings; conquest of England by the Normans	1063	Construction of Pisa cathedr. begun
	1073-85	Pontificate of Gregory VII – the so-called Gregorian reform movement	1066-71	Reconstruction of abbey of Monte Cassino
	1077	Submission of Emperor Henry IV before Pope Gregory VII at Canossa	1077	White Tower, Tower of Lond. under construction
1080	1095-99	First Crusade	1085-1106	Second phase of building of Speyer cathedral
	1098	Foundation of the abbey of Cîteaux	1088-1133	Construction of Cluny III
	1099	Capture of Jerusalem by Christian Crusaders	1093-1133	Construction of Durham cathedral
			1099-1184	Construction of Modena cathedral
1110	1115	Death of Matilda, Countess of Tuscany	1119	Consecration of choir at Fontevrault abbey
	1119	Foundation of the Knights Templar	1120-32	Construction of Autun cathed
	1122-51	Suger, Abbot of St. Denis	1120-40	Vézelay-narthex and nave constructed
	1125-53	St. Bernard, Abbot of Clairvaux	1125-50	Construction of Hedingham ca
	1130-54	Roger II King of Sicily	1135	Foundation of Fountains abb
			1139-47	Construction of the abbey of Fontenay
1140	1142-95	Henry the Lion, Duke of Saxony and Bavaria	1140-50	Palatine chapel, Palermo
	1147-48	Second Crusade	c. 1140	Construction of west front an east end of St. Denis
	1152-90	Reign of Emperor Frederick Barbarosa	1150-1200	Construction of the Old Cathedral of Salamanca
	1152	Marriage of Henry of Anjou to Eleanor of Aquitaine	1153	Construction of Pisa Baptistry begun
	1154-59	Pontificate of Adrian IV	1154-66	Construction of royal palace, Palermo
	1154-89	Henry of Anjou becomes King Henry II of England	c. 1160	Construction of Temple Churc London
	1166-89	Reign of King William II of Sicily		
1170	1170	Murder of Thomas à Becket, Archbishop of Canterbury	1174-89	Construction of Monreale cathedral
	1173	Canonisation of Thomas à Becket		
	1179	Death of Hildegard of Bingen		
	1189-92	Third Crusade		
	1194	Hohenstaufens replace Normans as rulers of Sicily		

Arts of Colour

Metalwork and Sculpture

1073-87	Wall paintings of Sant' Angelo in Formis, Naples, under the patronage of Abbot Desiderius of Monte Cassino.	**c. 1050**	Herimann Cross
		c. 1065	Wooden doors of St. Maria im Kapitol, Cologne

c. 1080	Bayeux Tapestry	**c. 1096**	Relief at St. Sernin, Toulouse
c. 1100	Wall paintings of Berzé-la-Ville	**c. 1100**	Historiated cloister, Moissac
	Wall paintings in the crypt of St. Savin-sur-Gartempe		Roger of Helmarshausen active – portable altar of SS. Kilian and Liborius
	Creation Tapestry, Gerona		
	Augsburg windows		Canterbury crypt capitals
1109-33	Cîteaux illuminated manuscripts	**1107-18**	Liège font by Rainer of Huy

1111	Gregory the Great's *Moralia in Job*	**c. 1110**	Wiligelmo's frieze, Modena cathedral
1115	Illustrated Life of Matilda, Countess of Tuscany	**c. 1115**	Externsteine relief, Horn
1120-30	St. Albans Psalter	**c. 1125**	Capital from cloister of cathedral at St. Etienne
1130	Illustrated Life of St. Edmund	**1125-35**	Tympanum – St. Foy, Conques
1131-43	Melisende Psalter	**1135-40**	Tympanum – Vézelay
1133-34	Coronation mantle of Roger II	**c. 1140**	Tympanum – Autun
c. 1135	Bury Bible		Tympanum – Beaulieu-sur-Dordogne

1140-50	Mosaics for the Palatine chapel and the Martorona, Palermo	**1140-50**	Souillac sculpture
1140-45	Stained-glass windows, St. Denis	**c. 1150**	Stavelot Triptych
1140-43	St. Maria in Trastevere, Rome – mosaics		Le Puy wooden doors
		1150-1200	St. Gilles-du-Gard facade
1150-60	Gerlachus's stained glass for the abbey of Arnstein	**c. 1158**	Geoffrey of Anjou enamel tomb-plaque
1160-75	Winchester Bible	**c. 1160**	Portal at Ripoll
1163-65	Otranto floor mosaic		Stavelot portable altar
1165-70	Crucifixion window at Poitiers cathedral	**1166**	Henry the Lion monument, Brunswick

1170	York Psalter	**1177-1233**	Career of Benedetto Antelami
c. 1180	*Garden of Delights* of Herrad of Hohenberg	**c. 1175**	Domed head reliquary made for Henry the Lion
c. 1188	Gospelbook of Henry the Lion	**c. 1180**	Limoges casket
1200	Arlanza wall paintings	**c. 1181**	Klosterneuburg altar-frontal
		c. 1190	Thomas à Becket *chasse*

Bibliography

GENERAL

The following is a short list of standard works on aspects of Romanesque art and its historical background.

AVRIL, F., X. BARRAL I ALTET, AND D. GABORIT CHOPIN, *Le Monde Roman, 1066-1220: Les Royaumes d'Occident* (Paris: Gallimard, 1983)

—, *Le Monde Roman, 1066-1220: Le Temps des Croisades* (Paris: Gallimard, 1982)

BARBER, M., *The Two Cities. Medieval Europe 1050-1320* (London: Routledge, 1992)

CLANCHY, M. T., *From Memory to Written Record: England 1066-1307* (2nd ed. Oxford: Blackwell, 1993)

CONANT, K., *Carolingian and Romanesque Architecture, 800-1200* (2nd ed. Harmondsworth: Penguin, 1978) is the standard work, but in need of updating.

DEMUS, OTTO, *Romanesque Mural Painting* (New York: Thames and Hudson, 1970)

DODWELL, C. R., *The Pictorial Arts of the West, 800-1200* (New Haven and London: Yale University Press, 1993)

English Romanesque Art 1066-1200 (exh. cat., London: Hayward Gallery, 1984)

GRABAR, O., AND C. NORDENFALK, *Romanesque Painting* (Skira, 1958)

LASKO, P., *Ars Sacra, 800-1200* (Harmondsworth: Pelican History of Art, 1972)

LE GOFF, J., *Medieval Civilisation 400-1500* (Oxford: Blackwell, 1988)

Ornamenta Ecclesiae: Kunst und Künstler der Romanik (exh. cat., Cologne: Schnutgen Museum, 1985)

Rhein und Maas: Kunst und Kultur 800-1400 (exh. cat., Cologne: Kunsthalle, 1972)

SNYDER, JAMES, *Medieval Art* (New York: Abrams, 1989)

The Art of Medieval Spain, AD 500-1200 (exh. cat., New York: Metropolitan Museum of Art, 1996 (?); New York: Abrams, 1993)

INTRODUCTION

DEMUS, OTTO, *Byzantine Art and the West* (London: Weidenfeld and Nicolson, 1970)

KITZINGER, E., *The Art of Byzantium and the Medieval West: Selected Studies* (London: Indiana University Press, 1976)

O'MEARA, C. FERGUSON, *The Iconography of the Façade of Saint Gilles-du-Gard* (New York: Garland, 1977)

SCHAPIRO, M., "On the aesthetic attitude in Romanesque art," *Romanesque Art: Selected Papers* (London: Chatto and Windus, 1977) is a classic study.

CHAPTER ONE

ALEXANDER, J. J. G., *Medieval Illuminators and their Methods of Work* (New Haven and London: Yale University Press, 1992)

BARRAL I ALTET, X. (ed.), *Artistes, artisans et production artistique au Moyen Age* (3 vols., Paris: Picard, 1986-90)

CAMPBELL, M. L., "'Scribe faber lima,' a crozier in Florence reconsidered," *Burlington Magazine*, CXXI, 1979, convincingly argues for an inscription referring to the donor and not the artist.

ENGEN, J. VAN, "Theophilus Presbyter and Rupert of Deutz: The Manual Arts and Benedictine Theology in the Early Twelfth Century," *Viator*, II (1980)

THEOPHILUS, *De Diversibus Artibus* (ed. and trans. by J. Hawthorne and C. S. Smith; 2nd ed. New York: Dover Publications, 1979)

CHAPTER TWO

Architectural Sculpture

HEARN, M. F., *Romanesque Sculpture* (Oxford: Phaidon, 1981) concentrates primarily on France.

KAHN, D. (ed.), *The Romanesque frieze and its spectator: the Lincoln Symposium Papers* (London: Harvey Miller, 1992)

Mosaics

BORSOOK, EVE, *Messages in Mosaic: The Royal Programmes of Norman Sicily* (Oxford: Clarendon Press, 1990)

KITZINGER, E., "A Virgin's face: Antiquarianism in twelfth-century art," *Art Bulletin*, LXII (1980)

Champlevé Enamel

GAUTHIER, M., *Emaux du Moyen Age occidental* (Fribourg: Office du Livre, 1972) is the standard work.

VOELKLE, W., *The Stavelot Triptych. Mosan Art and the Legend of the True Cross* (Oxford: Oxford University Press, 1980)

Stained Glass

GRODECKI, L., *Le Vitrail Roman* (2nd ed. Fribourg: Office du Livre, 1983)

CHAPTER THREE

Art and Society

BERNSTEIN, D. J., *The Mystery of the Bayeux Tapestry* (Chicago: University of Chicago Press, 1986)

Peasants

ALEXANDER, J. J. G., "Labeur and Paresse: ideological representations of medieval peasant labour," *Art Bulletin* (1990) is important for the Gothic period.

CAMILLE, M., "Labouring for the Lord: the Ploughman and the social order in the 'Luttrell Psalter'," *Art History*, X (1987)

MANE, P., *Calendriers et techniques agricoles: France-Italie xiie-xiiie siècles* (Paris: Sycamore, 1983)

CHAPTER FOUR

Monasticism

DONOVAN, C., *The Winchester Bible* (London: British Museum Press, 1993)

FORSYTH, I., "The monumental arts of the Romanesque period: recent research, the Romanesque cloister," in E. C. Parker and M. B. Shepard (eds.), *The Cloisters: Studies of the Fiftieth Anniversary* (New York: Metropolitan Museum of Art, 1992)

SCHAPIRO, M., *The Sculpture of Moissac* (New York: Thames and Hudson, 1985)

The Cistercians

DUBY, G., *Saint Bernard: l'art Cistercian* (Paris: Flammarion, 1979)

FERGUSSON, P., *Architecture of Solitude: Cistercian Abbeys in Twelfth-Century England* (Princeton, N.J.: Princeton University Press, 1984)

ZALUSKA, Y., *L'enluminure et le sciptorium de cîteaux au xiie Siècle* (Paris: Nuits-Saint-Georges, 1989)

Pilgrimages

BELTING, H., *The Image and its Public in the Middle Ages: Form and Function in the early Paintings of the Passion* (New York: 1990) is to be consulted for the cult of relics.

GAUTHIER, M., *Les Routes de la Foi: Reliques et reliquaires de Jérusalem à Compostela* (Paris: Bibliothèque des Arts, 1983)

Cult of the Saints

ABOU-EL-HAJ, B., "Bury St Edmunds Abbey between 1070 and 1124: A history of property, privilege and monastic art production," *Art History*, VI (1983)

KAUFFMANN, C. M., *Romanesque Manuscripts 1066-1190* (London: Harvey Miller, 1975)

CHAPTER FIVE

FÜHRKÖTTER, A., *De Miniaturen van het boek Scivias: ken de wegen van de heilige Hildegard van Bingen uit de verluchte prachtkodex van de Rupertsberg* (Leiden: 1977) has facsimile illustrations of the original manuscript of Hildegard of Bingen's *Scivias*.

GOLD, P., *The Lady and the Virgin: Image, attitude, and experience in twelfth-century France* (Chicago: University of Chicago Press, 1985)

GREEN, R., M. EVANS, AND C. BISCHOFF, *Herrad von Landsberg, Abbess of Hohenbourg* (London: Warburg Institute, 1976) should be consulted for the *Hortus Deliciarum*.

PAECHT, O., C. R. DODWELL, AND F. WORMALD, *The St Albans Psalter* (London: Warburg Institute, 1960)

SEIDEL, L., "Salome and the canons," *Woman Studies* (1984)

WERCKMEISTER, O., "The lintel fragment representing Eve from St. Lazare, Autun," *Journal of the Warburg and Courtauld Institutes* (1972)

CHAPTER SIX

BENSON, R., AND G. CONSTABLE (eds.), *Renaissance and Renewal in the Twelfth Century* (Oxford: Clarendon Press, 1986)

BLUMENKRANZ, B., *Juden und Judentum in der mittelalterlichen Kunst* (Stuttgart: W. Kohlhammer, 1965)

CAHN, W., *The Romanesque wooden doors of Auvergne* (New York: New York University Press, 1974), is good on the doors at Le Puy.

REVEL-NEHER, E., *The Image of the Jew in Byzantine Art* (Oxford: Pergamon Press, 1992)

SEIDEL, L., *Songs of Glory: the Romanesque Façades of Aquitaine* (Chicago: University of Chicago Press, 1981)

Picture Credits

Museums and libraries have supplied their own transparencies, unless indicated otherwise. Numbers to the left refer to figure numbers unless otherwise indicated.

Title page: photo Paul M.R. Maeyaert, Mont de l'Enclus-Orroir, Belgium
page 7 detail of 6.
1 By Permission of the British Library, Ms.Egerton 1139, f.12v
2 photo Paul M.R. Maeyaert
3 Fototeca Unione, Rome
4 Foto Ritter, Vienna
5 The Trustees of the Victoria and Albert Museum, London
6 The Master and Fellows of Corpus Christi College, Cambridge, Bury Bible 281 v
7 By special permission of the City of Bayeux.
9 St. Maria im Kapitol, Cologne; photo Rheinisches Bildarchiv, Cologne
10, 11, 12 photo Paul M. R. Maeyaert
13 Diözesanmuseum, Paderborn
page 25 detail of 15.
14 photo Paul M.R. Maeyaert
15 Westfälisches Landesmuseum für Kunst and Kulturgeschichte Münster, Dauerleihgabe aus Privatbesitz
16 Stadt und Universitätsbibliothek Frankfurt am Main
17 Herzog August Bibliothek, Wolfenbüttel. Cod. Guelf. 105 Noviss. 2. The Gospelbook of Henry the Lion is jointly owned by the Bundesrepublik Deutschland, the Landes Niedersachsen des Freistaates Bayern, and the Stiftung Preussischer Kulturbesitz
18 Diözesanmuseum, Paderborn
19 St. Godehard's Church, Hildesheim; photo Herzog August Bibliothek, Wolfenbüttel
20 Winchester Bible, f.169, The Dean and Chapter of Winchester; photo Miki Slingsby
21 Kupferstichkabinett Staatliche Museen, Berlin, Codex 78 A6, f.10; photo Bildarchiv Preussicher Kulturbesitz, Berlin
22 photo Paul M.R. Maeyaert
23 photo G. Dagli Orti, Paris
24 © British Museum, London
25 Biblioteca Apostolica, Vatican Cod.Lat.4922, f.49.
26 The Pierpont Morgan Library, New York M.492 f.84
27 photo Paul M.R. Maeyaert
28, 29 photo Angelo Hornak, London
page 45 detail of 39.
31 photo Florian Monheim, Düsseldorf
32, 33 photo Paul M.R. Maeyaert
34 Foto Iotti, Modena
35 photo Paul M.R. Maeyaert

36 Musée des Augustins, Toulouse; photo Bernard Delorme
page 54 photo Arxiu MAS, Barcelona
37 photo Claus Hansmann, Munich
38 photo Robert Harding Picture Library, London © Walter Rawlings
39, 40 photo Scala, Florence
41 photo André Held, Lausanne
42, 43 © British Museum, London
44 The Pierpont Morgan Library, New York
45 photo courtesy Dr Gotfried Frenzel, Institüt für Glasgemaldefroschung und Restaurierung, Nuremberg
46, 47 photo Paul M.R. Maeyaert
48 photo Michael Jeiter, Morschenich Germany
page 71 photo Paul M.R. Maeyaert
49 President and Fellows of Corpus Christi College Oxford, MS.157, p.382
50, 51 photo Paul M. R. Maeyaert
52 photo Peter J. Terry, Bexleyheath
53 By special permission of the City of Bayeux
54 photo Angelo Hornak, London
55 Musées du Mans, France
page 79 photo Giraudon, Paris
56, 57, 58 By special permission of the City of Bayeux
59, 60 Scala, Florence
61 Hirmer Fotoarchiv, Munich
62 photo Bildarchiv Preussicher Kulturbesitz, Berlin
63 Herzog August Bibliothek, Wolfenbüttel. Cod. Guelf. 105 Noviss. 2. The Gospelbook of Henry the Lion is jointly owned by the Bundesrepublik Deutschland, the Landes Niedersachsen des Freistaates Bayern, and the Stiftung Preussischer Kulturbesitz.
64 photo Michael Jeiter, Morschenich Germany
65, 66 photo Paul M.R. Maeyaert
67 Koninklijke Bibliotheek, The Hague MS 76 F 13 fol.10v
68 Glasgow University Library, MS. Hunter 229 (U.3.2), f.8r
69 Scala, Florence
70 photo Paul M.R. Maeyaert
page 101 detail of 90.
71 Calmann & King Archives, London
72 photo Paul M.R. Maeyaert
73 photo John Ferro Sims, London
74, 75, 76 photo Paul M.R. Maeyaert
77 The Metropolitan Museum of Art, The Cloisters Collection, 1931. (31.38); photo Lynton Gardiner
78 Winchester Bible, f. 148. The Dean and Chapter of Winchester; photo Miki Slingsby
79 Winchester Bible, f.169, The Dean and Chapter of Winchester; photo Miki Slingsby

80 Bibliothèque Municipale, Dijon, Ms. 173, f.41.
81 Jean Duret © Compagnie du Livre d'Art, S.A.
82 photo Paul M.R. Maeyaert
83 photo Robert Harding Picture Library © Adam Woolfitt
84, 85, 87, 88 photo Paul M. R. Maeyaert
86 Jean Duret © Compagnie du Livre d'Art, S.A.
89 The Pierpont Morgan Library, New York M.736 f.12v.
90 © British Museum, London
91 Schutgen Museum, Cologne; photo Rheinisches Bildarchiv, Cologne
page 123 detail of 96.
92 photo Paul M. R. Maeyaert
93 Musée Rolin, Autun
94, 95 photo Paul M. R. Maeyaert
96 Würtembergische Landesbibliothek Stuttgart, Cod. bibl. 2 56, 15r.
97 Bibliothèque Municipale, Dijon, Ms.641, f.40v.
98 Glasgow University Library, MS. Hunter 229 (U.3.2) f.19v.
99 photo Paul M.R. Maeyaert
page 132 photo Giraudon, Paris
100 photo Paul M.R. Maeyaert
101 Biblioteca Apostolica, Vatican Cod.Lat.4763
102 St. Godehard's Church, Hildesheim; photo Herzog August Bibliothek, Wolfenbüttel
103 Bayerisches Staatsbibliothek, Munich, MS Clm.935, f.24f.
104 Biblioteca Statale, Lucca. Ms.1942, f.1v.
105 Bibliothèque Nationale, Paris
106 Erzbischöfliches Diözesanmuseum, Cologne
107 photo Michael Jeiter, Morschenich Germany
108 photo Paul M.R. Maeyaert
109 Museu Frederic Marès, Barcelona
110, 111 photo Paul M.R. Maeyaert
112 photo Scala, Florence
113, 114, 115 photo Paul M.R. Maeyaert
116 Kunsthistorisches Museum, Vienna; photo Ali Meyer, near Vienna
page 155 photo A.F. Kersting, London
117 The Master and Fellows of Corpus Christi College, Cambridge, Ms.48, f.121
118 Musées Royaux d'art et d'histoire, Brussels
119 The Metropolitan Museum of Art, New York. The Cloisters Collection, 1963. (63.12)
120 Bibliothèque Nationale, Paris
121, 122 photo Paul M.R. Maeyaert
123 Fridart Foundation, Amsterdam © ADAGP, Paris and DACS, London 1995
124 photo André Held, Lausanne
125 photo Paul M.R. Maeyaert

Index

Adam and Eve *98*, 99, *99*, 123
 see also Eve
Adam of Scotland (monk) 141
Adoration of the Magi (carved
 whalebone) 11, *11*, 129
Adrian IV, Pope 28
Aelfgyva 85, *85*
Aelfric's Pentateuch 84
Ailred, Abbot of Rievaulx 136
Alberti, Leon Battista: *De Pictura* 35
Alexis Master 119
Amalekite Master 108
ambulatories 104, 116, *116*
Annunciation, The (from St. Albans
 Psalter) *136*, 136-37
Antelami, Benedetto 25
anti-Semitism 22, 23, 155, 156, 158-59
Apocrypha Drawings, Master of the 108
arches: pointed 13-14, 46, 113, 114, 143
 triumphal (Roman) 7, *8*, 15, 51-52
Arnstein, Germany: stained-glass
 panel 27, *27*
ashlar masonry 18
*Assumption and Burial of the Virgin
 Mary* (from York Psalter) 131, *131*
Augsburg cathedral, Germany: stained-
 glass windows 66, *66*, 69
Augustine, St. 56
Autun cathedral, France 13, 96
 Eve (Gislebertus) 124-25, *125*, 143
 Last Judgement tympanum
 (Gislebertus) 25, *26*, 28, 54-55,
 115, *115*, 158
 nave 46, 102, 105, 143, *143*
 Suicide of Judas (capital) 159, *159*

Baldwin II, King of Jerusalem 79
Baptism of Christ (illumination) *35*
Barfreston church, Kent 54
Bayeux Tapestry 13, *13*, 61, 75, *76*,
 79, 80-81, *81*, 84-85, *85*, 98, 115
Beaulieu-sur-Dordogne, France: church
 21
Benedict, St. 106
 Rule of 20-21, 102, 106, 109
Benedictine Order 20-21, 37, 63, 76,
 114, *131*, 164
Bernard of Angers 118
Bernard of Clairvaux, St. 21, 37, 43,
 79, 106, 112, 131, 164
 Apologia for Abbot William 21, 37,
 60, 111
Berzé-la-Ville, France: priory

(wall-painting) *101*, 102
Besalu church, Catalonia 54
Bibles: Bury 11, *12*, 13, 30, 31, 141
 St. Albans 156, *156*
 Winchester 33, *33*, 39, 43, 60,
 107-9, *109*, *111*
biographies 34, 35, 39, 119-20, *120*,
 135
Book of Divine Works, The 137-38, *138*
Books of Hours 97
Bourges, France: St. Ursin (tympanum)
 93, 96, 97, 143
Bridekirk, Cumbria: font 35
Brunswick, Germany: lion monument
 to Henry the Lion 89, *89*, 143
 St. Blaise (cathedral) 36, 89, 91
Burgos, Spain: San Pedro de
 Arlanza (wall-paintings) *89*, 106,
 108
Bury Bible 11, *12*, 13, 30, 31, 141
Bury St. Edmunds: abbey 119-20
Byzantine art and influences 7, *12*,
 12-13, 34, 56, 60, *65*, 69, 86, *101*,
 109, 130, *130*, 131, 138, 144, 145,
 150, 155

Cabestany, Master of 33
 (attrib.) *Christ Walking on the
 Water* 33, 143, 144, *144*
calendars: liturgical 96-97
 see also months, occupations of the
Canterbury, Kent:
 abbey of Christ Church 31, 121
 cathedral 31, 43, *43*, 53, 71, 120-21
capitals: decorated 43, *43*, 49, 53, *54*
 historiated *53*, 53-54, 106, 125, 143,
 159, *159*
Carolingian art 96, 144
castles 75, *75*
Catalonia 33, 53, 54; see also Gerona
 paintings on wood *132*
Cefalù cathedral, Sicily (mosaics)
 34, 60, 109
champlevé enamel *10*, 18, 39, *39*, 61,
 62, 62-63, *63*, *65*, 66, 79, *79*, *90*,
 121, *121*, 132, 143, 156, *156*
chapterhouses 33, 105, 106, *107*, *112*
Charlemagne, Emperor 17, 79, *79*, 92,
 96
Christina of Markyate 28, 31, 135-36,
 139
Christ Walking on the Water (Master
 of Cabestany) 33, 144, *144*

Church, the 19, 71, 72, 73; see also
 monasticism; papacy
Cistercian Order 21, 35, 76-77, 101,
 106, 109, 111-14, *130*, 131
Cîteaux, monastery of 77, 109, 111,
 130, 131, 156
Cleansing of the Temple, The (from
 Gospelbook of Matilda) 40, *41*
cloisonné enamel 61-62, 63, *65*
cloisters *54*, *104*, *105*, 105-6, *106*, 111,
 112, *153*, 154
Cloisters Cross 158, *158*
Cluniac Order 21, 40, 104, 106, 109,
 111
Cluny, abbey, France 13, 21, 37, 43,
 54, 102, *102*, 104-5, 106, 107, 150
Cologne, Germany 62, 89
 St. Maria im Kapitol 15, *16*
Compostela, Spain see Santiago
 de Compostela
Conques, France: St. Foy (frontis.),
 55, 74, 74-75, 92, 116, *116*, *117*, 118,
 118
Constantine, Emperor 65
Constantinople (Istanbul) 12, 56, 89
Coronation of the Virgin (painting on
 wood) 131, *132*
courtly love, cult of 22, *63*, 132
Creation Tapestry see Gerona
Crispin, Gilbert, Abbot of
 Westminster: *Dialogue between a Jew
 and a Christian* 54
crosses, stone 46
Crusades 12, 22, 37, 79, 115, 146, 150,
 154, 155

Dance (Derain) 161, *162*
Denis, St. 37, 86. 119
Derain, André: *Dance* 161, *162*
Descent from the Cross (at Extern-
 steine) 55, *55*
Desiderius, Abbot of Monte Cassino 56
Dionysius, St. 86
documents 29; see also manuscripts
domes *48*, 49
Donizo: *Life of Matilda of Canossa*
 39-40, *40*
Durand, Abbot 106, *106*
Durham cathedral, England *45*, 48-49

Edmund, St. 35, 119, 120, *120*
Edward the Confessor 80, 81, *81*,
 84, 120

Eilbertus of Cologne 26
Eleanor of Aquitaine 17, 34, 36, *36*, 69, 133
 tomb *132*
Elizabeth of Schonau *131*
embroidery 28, 80, *see also* Bayeux Tapestry; Creation Tapestry
Emilia, Italy 29, 34, 39, 40
enamels *see* champlevé; cloisonné
Eve (as archetype) 123, 124-25
Eve (Gislebertus) 124-25, *125*, 143
Externsteine, Germany: *Descent from the Cross* (rock carving) 55, *55*

Fauvism 161-62
Fécamp Psalter 97, *97*, 98, 135
feudalism 19, 37, 71, 73-74, 75-76, 79
Florence of Worcester 71, *72*
Fontenay abbey, France *112*, 112-13, *113*
Fontrevault abbey, France 49, 133, *133*
 tomb of Eleanor of Aquitaine *132*
Fountains abbey, Yorkshire 111, 114, *114*
Foy, St. 116
Frederick Barbarossa, Emperor 86, 92
friezes 50-51, *51*, 53, 99, *99*, 143, 144, *144*

Gabriel Chapel Master 43, *43*, 53
Garden of Delights, The (Herrad of Hohenberg) 138, *139*, 158-59, *159*
Gauzfredus: Le Puy cathedral doors 146, *146*
Gelduinus, Bernardus: St. Sernin marble relief 49-50, *50*
Genesis Initial Master 108
Geoffrey, Abbot of St. Albans 135
Geoffrey of Anjou 79, *79*
Gerlachus: stained-glass panel 27, *27*
Gerona cathedral, Catalonia 54, 66
 Creation Tapestry 96, *96*
Gervase of Canterbury 31
Gilabertus: capital (St. Etienne) *53*, 53-54, 125
Gislebertus: *Eve* 124-25, *125*
 Last Judgement tympanum (Autun cathedral) 26, *26*, 28, 54-55, 115, *115*, 158
Godefroid de Claire of Huy 26
Godfrey de Bouillon 155
goldsmiths 26, 30, 39, 66, 89
Gospelbooks: of Henry the Lion 29, *29*, 36, 90, *91*, 91-92
 of Matilda 40, *41*
Gospels of Otto III 90
Gothic art and architecture 9, 11, 13, 17, 34, 37, 48, 49, 69, 80, 165

Gothic Majesty Master 33, 108
Gregorian reform movement 19, 56, 76
Gregory I (the Great), Pope 45, 135
 Moralia in Job 111, *111*, 112
Gregory VII, Pope 19, 39, 40, 56, 76
Gregory, Master: *Marvels of Rome* 89, 143
Gregory of Nazianzus, St. 89
Guda: illuminated initial 28, *28*
Gunzo (monk) 104

Harding, Abbot Stephen 111, 156
Harold, Earl of Wessex 80, 81, *81*, 84, 85
Hastings, Battle of 75-76, *76*, 79, 80, 84
Hedingham castle, Essex 75, *75*
Helena, Empress *65*, 155
Helmarshausen, Germany: monastery 29, 90; *see also* Roger of Helmarshausen
Helmold of Bosau 86
Henry I, King of England 37, 71, 120
Henry II, King of England 17, 28, 34, 36, *36*, 69, 79, 91, 92, 120-21
Henry IV, Emperor 19, 39, 40, *40*
Henry de Werl, Bishop of Paderborn *25*, *36*, 55
Henry of Blois, Bishop 39, 49, 75
 enameled plaques 39, *39*
Henry the Lion, Duke of Saxony and Bavaria 85, 86, 89-90, 92
 Gospelbook 29, *29*, 36, 90, *91*, 91-92
heraldry 79-80, 92
Herimann, Archbishop of Cologne 141
 Herimann Cross *141*, 141-42
Herimann (monk) 29
Herrad of Hohenberg 138, 139
 The Garden of Delights 138, *139*, 158-59, *159*
Hezelon 104
Hildegard of Bingen 28, 137-38, 139
 Prayer Book of *137*
Hildesheim, Germany: St. Michael's (wooden ceiling) 71, 92, *92*
Hirsau, Passionary of *129*, 129-30
Hodegetria, the 131
Holy Roman Empire 17, 19, 48, *166-67*
Honorius of Autun *130*
Hortus Deliciarum see Garden of Delights, The
Hosea (stained glass) 66, *66*
Hugh, Abbot of Cluny 21, 40
Hugo, Master 31, 33, *158*
 Bury Bible 11, *12*, 30, 31
Hugues de Payns 79

Ile-de-France 9, 17, 69, 165
illuminated manuscripts *see* manuscripts, illuminated
Ingeborg Psalter 135
Innocent II, Pope 57, 86, 104
Insular art 11, *109*
Isidore of Seville 43
Islam (Muslims) and Islamic art 12, 13-14, 17, 22, 23, 53, 86, 146, *148*, 150-51, 154-55, 162

Jerusalem 22, 23, 79, 89, 115
Jews, the 22, 23, 146, 155-56, 158-59
John of Salisbury 93
 Policraticus 72
John of Worcester: Chronicle 71, *72*

Kells, Book of 11, *109*
Klosterneuburg abbey, Austria: altar frontal (Nicholas of Verdun) *10*, 11, 26, 36
Knights Hospitallers 22, 154
Knights Templar 22, 77, 79
Know the Ways of God 137

Leaping Figures, Master of the 108-9, *109*
Le Corbusier (Edouard Jeanneret) 162
Leo III, Pope 17
Leo of Ostia 56
Leon, Spain: San Isidoro 54
Le Puy, France: cathedral doors 146, *146*
 St. Michael's chapel *150*, 150-51, *151*
Liège, Belgium: church of St. Barthélémy (font) 144-45, *145*
Limoges enamel 62, *63*, 79, *79*, 121, *121*, 132
Lincoln: The Jew's House 155, *155*
liturgical calendars 96-97
London: Temple Church 77, 79
 Tower of London 75
Lothar Cross 141-42, *142*
Louis VII, King of France 37, 39

Maillol, Auguste 162
manuscripts, illuminated 19, 28, 34, *35*, 106-7, 109, *111*, 111-12, 119, *120*, *137*, 137-38, *138*, *139*, 156, *156*; *see also* Bibles; Gospelbooks; psalters
Martin, St. 86
Mary *see* Virgin Mary
Mary the Egyptian 128
Mary Magdalen *33*, 123, 124, 125, 128, 137
Mary of Bethany 125

Mary of Magdala 125, 128
Matilda (wife of Henry the Lion) 36,
 89, 91, *91*, 92
Matilda of Canossa, Countess 35, 39-40,
 40
 Gospelbook of 40, *41*
Melisende Psalter 7, 135
Modena, Italy 29, 40
 cathedral 25, 29, 40, 50-51, *51*, 99, *99*,
 143
Moissac, France: abbey church 72-73,
 73, 105, 106, 106
monasteries and monasticism 20-21, 33,
 53, 73-74, 76, 101, 106-7; *see
 also* Cistercian Order; Cluny
 and women 21-22, 133-39
Monkwearmouth, Northumbria 66
Monreale cathedral, Sicily *10*, 37, *39*,
 60, *104*, 105
Monte Cassino abbey, Italy 20, 56
months, occupations of the 53, 93, *93*,
 96, 97, *97*, 98
Moore, Henry 162
Moralia in Job (Gregory the Great) 111,
 111, 112
Morgan Leaf, Master of the 33-34, 108,
 109
 Winchester Bible 33, *33*, 109, *111*
mosaics 13, 18, 19, 34, 37, *39*, 56-57, *57*,
 60, 60-61, 86, *88*, 96, 109
Mosan region 11, 26, 29, 34, 39, 62,
 63, 66, 69
Moses on Mount Sinai (Nicholas of
 Verdun) *10*, 11
Muslims *see* Islam

naves, cathedral 45, 46, *46*, 48-49, *102*,
 104, 113, *113*, 116, *116, 117, 125*, 133,
 133, 143, *143*
Neuilly-en-Donjon, France: church of
 La Madelaine (tympanum) 123, *124*
Niccolò, Master 25
Nicholas of Verdun 26
 Klosterneuburg altar frontal *10*, 11,
 26, 36
Normans: in England 17, 48, 75, *75*,
 80-81, 84, 85
 in Sicily 13, 14, *39*, 57, 60, 61,
 85-86, 154
Novgorod, Russia: St. Sophia 28, *28*

Odo, Bishop 75-76, *76*, 80
Otranto cathedral, Italy: floor
 mosaics *60*, 60-61, 96, 97

Palermo, Sicily: church of Santa Maria
 (La Martorana) 60, 86, *88*

palace mosaics *58*, 60
 Palatine chapel 34, 86, *86*
papacy 19, 40; *see also* Gregorian
 reform movement
patrons 18, 36-37, 39, 40, 42-43, 62
 women 39-40
pattern books 34
peasants 19, 71, 73, 75, 93, 96, 97-99
Peter of Bruys 20
Peter the Venerable, Abbot of Cluny
 42, 43, 146
Petrobusians 20, *21*
Picasso, Pablo 162, *162*
pilgrims and pilgrimage routes 21, *26*,
 37, 62, 115, 116, 143, 146
Pilgrim's Guide, The 128
Pisa cathedral 146, *148*
plainsong 102
Poitiers cathedral, France:
 Crucifixion window 36, *36*, 69, *69*
portraits: artists' 26-27, *27*, 28, *28*
 donors' *36*, 36-37, 39, *39*
psalters 31, 97, *134*
 Fécamp 97, *97*, 98, 135
 Ingeborg 135
 Melisende 7, 135
 St. Albans 31, *33*, 135, *136*, 136-37
 York *98*, 99, 131, *131*

Rainer of Huy 26
 baptismal font 144-45, *145*
Ralph Glaber 18
relics, cult of 21, 37, *61*, 63, 89, 101,
 115, 116, *116, 118*, 143
reliquaries 63, *65*, 89, *90*, 116, 118, *118*
Ricardis (nun) 137
Ripoll, Pyrenees: Santa Maria 51-53,
 53, 96
Riquin (bronze-founder) 28, *28*
Roger II, King of Sicily 60, 85-86, *88*,
 92
 coronation mantle *154*, 154-55
Roger of Helmarshausen 26, 30, 33
 portable altar 25, 30, *30*, 36
Roman art and influence 7, *8*, 11, 15,
 22, 40, 46, 49, 50, 51, 141, *141, 142*,
 142-44
Rome 101-2, 115, 142-43
 Arch of Constantine 7, *8*
 San Clemente (mosaics) 56
 Santa Maria in Trastevere (mosaics)
 56, 57, *57*
Rouen, France: synagogue 155
Ruthwell Cross, England 46

St. Albans 156, *156*
 abbey 143

St. Albans Psalter 31, *33*, 45, 135, *136*,
 136-37
St. Denis, abbey 9, 33, 34, 37, 86, 165
 stained glass *67*, 69, 141
St. Gilles-du-Gard, France 22
 abbey 7, *8, 9,* 14-15, *15*, 18, 20, 21,
 22, 23, *23*, 45, 51, 116, 164
 town house 18-19, *19*
St. Martin-de-Boscherville, France:
 abbey chapterhouse 106, *107*
St. Martin-du-Canigou, France:
 monastery church 46
saints, cult of 119, 120-21
St. Savin-sur-Gartempe, France:
 wall-paintings 60, *61*
Salamanca, Spain: Old Cathedral 48,
 49
Salerno, Italy: Cathedral 56
 ivories 40
San Clemente Master: wall-painting
 162
Santiago de Compostela 21, *26*, 62, 115,
 116
Saxony, Lower 9, 62, 86, 155
 see also Hildesheim
Schapiro, Meyer 162, 164
sculpture, architectural 18, 46,
 48-56; *see also* capitals;
 trumeaux; tympana
Sicily 13, 14, 17, 34, 57, 60, 85-86,
 109, 150, 154; *see also* Monreale
Siegburg Madonna *123*, 128, 131
signatures, artists' 18, 25, 26, 28-29,
 34-35
silk industry 154, 155
Silos, Spain: abbey of Santo Domingo
 (pier reliefs) 23, 115, *115*
Song of Roland, The 79, 92
Song of Songs 131
Soria, Spain: San Juan de Duero *153*,
 154
Souillac, France: figure of Isaiah
 from 161, *161*
 Theophilus relief *128*, 129, 164
 trumeau sculptural group 162,
 164-65, *165*
Spain 13, 17, 49, 53, 62, 150, 154
Speyer Cathedral, Germany *46*, 48
stained-glass windows 18, 27, *27*, 36,
 36, 66, *66, 67*, 69, *69*, *79*, 111
Stavelot, Belgium: abbey 30
 portable altar 30, *156*
 Triptych 63, *65*, 66, 155
Suger, Abbot of St. Denis 33, 34, 37,
 39, *67*, 69
Surrealism 164
Sutton Hoo treasure 11

Synagogue 23, *23*, 156, 158, *158*

tapestries *see* Bayeux; Gerona
Theophilus [?]: *Of the Various Arts*
30, 35, 66, 69
Theophilus (priest) *128,* 129, 164–65
Thomas à Becket 92, 120–21
chasse 62, *62*, 121, *121*
Toulouse, France: counts of 17, 18, 22
St. Etienne (capital) *53*, 53–54, 125
St. Sernin 49–50, *50*, 54, 116, 143
Transitional style 9, 11, 69, 109, *158*
Tree of Jesse *67, 71*, 92, *92*, 130
Très Riches Heures of Jean de Berry 97
Triumph of the Virgin, The (mosaic)
57, *57*
troubadour poets 15, 132
trumeaux *21*, 162, 164–65, *165*
Tuscany, Italy 9, 29, 34, 39, 40, 72
tympana 14–15, *15, 21*, 22, 23, *23*, 25,
26, 28, *42*, 42–43, 54–55, *73, 74*, 74–75,
93, 96, *115*, 123, *124*, 143
typology 62, *130*

Urban II, Pope 146

Vasari, Giorgio: *Lives of the Artists* 34
vaulting: barrel 46, *46*, 102, 114
groin *46*, 48, *125*
rib *46*, 48, *48*
tunnel 113
Venice 13, 57
San Marco basilica 60
Vézelay, France: church of Sainte-
Madeleine *42*, 42–43, 96, 115–16, *125*,
128, 150, 161
Viollet-le-Duc, Eugène 161
Virgin and Child (from the Passionary
of Hirsau) *129,* 129–30
Virgin and Child with Saints (from
c. 1200 psalter) *134*
Virgin Mary, the 22, 57, 123, 124,
128–32, 165
Volmar (monk) 137

wall paintings 19, 33, 60, *61, 101*, 102,
106, *108, 162*

westranges 111, 114
Wibald, Abbot of Stavelot 63
Wiligelmo 25, 28–29
frieze (Modena cathedral) 40, 50–51,
51, 99, *99*, 143
William I ("the Conqueror") 17, 75,
80, 81, *81*, 84, 85
William I, King of Sicily 60
William II, King of Sicily 34, 37, *39*,
60
William the Englishman 31
William of Sens 31
Winchester Bible 33, *33*, 39, 43, 60,
107–9, *109, 111*
women 71, 85, 98, 165
artists 28, *28*
Biblical archetypes 123–25, 128–32
patrons 39–40
religious 21–22, 133–39

York Psalter *98*, 99, 131, *131*

Zamora, Spain: church 49